A City of Gardens

WASHINGTON WEEKENDS
Capital Book's regional travel series focusing on adventures in and
around Washington, D.C.

Other titles in the series:

Breaking Away to Virginia and Maryland Wineries
by Elisabeth Frater

Historic Hotels & Hideaways
by Trish Foxwell

A City of Gardens

Glorious Public Gardens
In and Around the
Nation's Capital

Barbara H. Seeber

CAPITAL
BOOKS, INC.
Sterling, Virginia

Capital Books, Inc.
P.O. Box 605
Herndon, Virginia 20172-0605

Design and illustration by Karen Thompson

Photography by Judy Karpinski

Cover photo: Chris Quinn, Dumbarton Oaks, Research Library and
Collection, Washington, DC

Library of Congress Cataloging-in-Publication Data

Seeber, Barbara H.
 A city of gardens: glorious public gardens in and around the
 Nation's Capital / Barbara H. Seeber.
 p. cm. -- (Washington weekends)
 Includes bibliographical references and index.
 ISBN 1-931868-40-9 (alk.paper)
 1. Gardens--Washington (D.C.)--Guidebooks. 2. Washington (D.C.)
 --Guidebooks. I. Title. II. Series.

SB466.U65W3838 2004
712'.5'09753--dc22
 2003017133

Printed in the United States of America on acid-free paper that meets
the American National Standards Institute Z39-48 Standard.

First Edition

10 9 8 7 6 5 4 3 2 1

*To my grandmother, Pearl Lay Donegan,
who taught me to love plants*

Contents

HISTORIC ESTATES

BOTANIC GARDENS

CONTEMPLATION GARDENS

PARKS

Foreword

A City of Gardens succeeds in capturing the essence of Washington's green spaces. It will give you an irresistible urge to visit and revisit the gardens Barbara Seeber describes. And when you trek through a garden with book in hand—as I did with my family (including my teenage kids)—you will have a wonderful time.

The book focuses mainly, though not exclusively, on plants. But you don't have to be a botanist to "get it." Using a consistent format to describe twenty-three gardens, Barbara examines collections different in size, scope, and purpose, communicating the fundamental spirit—and the magic—of each.

Each chapter begins with an Introduction that entices you to learn more about the garden. A History section places the garden in context and explains dreams and schemes of the garden's creators. The Tour, the heart of the narrative, is as much fun to follow in an armchair as on a trip through a garden. As Barbara leads you through the main attractions, she shares insights into plant material, ecology, horticultural regimen, architecture, and ornamentation. She looks at the garden from different perspectives. She takes you up in a Bird's Eye View, leads you somewhere you might have missed in Off the Beaten Path, and shares memorable facts in Garden Notes. At the end of each chapter, she supplies basic information needed to plan a visit.

The charm of *A City of Gardens* is Barbara's passion for plants and gardens. You will be fascinated by the story of Walter Shaw's water lily industry at Kenilworth Aquatic Gardens. You will share her enthusiasm for the bigleaf magnolia *(Magnolia macrophylla)* at McCrillis Gardens in Bethesda. And you may be surprised to learn that George Washington redesigned his garden twice—in between fighting the American Revolution and getting elected President.

Through the richness of her observations, Barbara reveals the wealth available to us in Washington gardens.

> —*Gail Griffin*
> *Superintendent of Gardens and Grounds*
> *Dumbarton Oaks*

Acknowledgments

Many kind and knowledgeable people helped me put
this book together. The horticulturists and staff at the
gardens featured in the book are a cadre of plant lovers
and experts. Every day they share their knowledge and
experience with visitors to the great gardens they have
designed and developed. I am extremely grateful to them
for their generosity and good will. I want to thank Gail
Griffin at Dumbarton Oaks; Christine Jirikowic and
David Reese at Gunston Hall; Liz Dolinar, Dan Paterak,
Missy Snelling, and Judy Stembel at Hillwood; Phil
Normandy at McCrillis Gardens; Dean Norton at
Mount Vernon; Karen Mazza and Carolyn Barnett at
Oatlands; Peggy Bowers at River Farm; Elizabeth
Brewster at Tudor Place; Stephanie Oberle, Kerrie
Nichols, and Ellen Hartranft at Brookside Gardens;
Keith Tomlinson and Bill Folsom at Meadowlark
Botanical Gardens; Mary Anne Jarvis, Nancy Luria,
Robin Everly, Sue Martin, Joan Feely, Kevin Tunison,
Jim Adams, and Jack Sustic at the United States
National Arboretum; David Vincent at the National
Agricultural Library; Christine Flanagan, Robert
Pritchard, Kyle Wallick, Dale Lane, and Bill McLaughlin
of the United States Botanic Garden and Bartholdi Park;
Ray Mims and Joe Luebke at the Bishop's Garden;
Shelley Gaskins at the Enid Haupt Garden; Wolfgang
Oehme, landscape architect for the Federal Reserve
Board Garden; Francie Owens at the Folger Shakespeare
Library's Elizabethan Garden; Joe Arsenault and Brother

Roger Petras at the Franciscan Monastery Gardens; Ried Zulager at the Old Stone House; Beverly Magruder and Anna Moline of the National Park Service at the Old Stone House; Steve Coleman of Washington Parks and People involved in restoring Meridian Hill Park; Steve Syphax, Jim Rosenstock, and Kate Bucco of the National Park Service at Kenilworth Park and Aquatic Gardens; Robert DeFeo, Helen Matthews, and Perry Wheelock of the National Park Service; Sean Philpotts and Peter Winkler of the National Geographic Society; and master gardener Henry Ozga, my neighbor, friend, and gardening mentor for three decades.

I am most grateful for the wordsmithing and generous collaboration of researcher/writers Joan M. Mitric, Amy Sarver, and my son, Jason Molin; the photography of award-winning photographer Judy Karpinski; and the design and illustration magic of Karen Thompson. Their talents grace every page.

Introduction

I came to gardens and gardening by a common route. I bought a house on a hillside and acquired the plants and plans that go with owning your own plot. Instantly rich in dirt and dreams, I looked around for inspiration—and discovered how *uncommonly* fortunate I was to be a gardener in Washington, D.C.

Few cities can boast the rich history and diversity of gardens particular to the nation's capital. They range from cottage garden to historic showplace, from medieval contemplation garden to world-class botanic garden, from walled enclave to national arboretum—each wrought unique by the whims and schemes of the gardeners or designers or restorers, by its location in the nation's capital, and by the march of history itself.

The public gardens of the capital chronicle some three centuries of garden history. In the 1750s George Washington was planting kitchen and flower gardens at Mount Vernon, and Virginia statesman George Mason was designing a boxwood allée at nearby Gunston Hall. In the early1800s the founding Scottish merchants of Georgetown built grand houses with knot gardens on promontories overlooking the Potomac. In the early 1900s the owners of Dumbarton Oaks led a revival of formal gardening in Georgetown.

The last half of the twentieth century witnessed the real transformation of the capital from a city of muddy roads and swampland to a city of gardens. The last few decades have seen the establishment or restoration of every imaginable kind of garden—Victorian gardens and evening gardens, Asian gardens and children's gardens,

and the continuing restoration or redesign of historic estates and showplaces. Perhaps the biggest change has been the transition to a more leisurely and naturalistic style of gardens and gardening—a style that goes with gardeners' more relaxed lifestyles. In the last decade gardening has become America's number-one hobby, and the popularity of visiting gardens has grown proportionately. Visitors to the capital come for botanical and

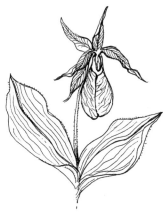

Native lady's-slipper orchid
(*Cypripedium acaule*)

horticultural history and for landscape architecture as much as for monuments and U.S. history. Home gardeners roll botanic names and new varieties off their tongues as they stroll through Bartholdi Park and the United States Botanic Garden. Hikers take note of the lady's-slipper orchids growing in the Potomac Valley native plant collections at Meadowlark Botanical Gardens. And environmentalists trek to Kenilworth Aquatic Gardens across the Anacostia River to see the only remaining tidal marsh in the city. They all are filled with green thoughts—of trees and shrubs through the centuries and of seasons and gardens different from, and similar to, their own.

The variety in Washington gardens engages on many levels: the aesthetic pleasures of sensuous plants and graceful designs; the human stories and surprising histories; the attention to new cultivars and species

preservation. Yet in the many varieties of bedding schemes and borders and biota, there is a commonality for gardeners and garden lovers—a shared delight in digging in the dirt, a rhythm that tunes in to seasons rather than the nightly news; a joy in the natural world that is our heritage as well as history. Even George Washington himself acknowledged that he'd rather be gardening.

"Leisure, slowness, contemplation, these amateur virtues are perhaps despised, but they may underlie the greatest joys of gardening and of life," wrote *Washington Post* garden columnist Henry Mitchell in 1978 in the preface to *The Essential Earthman*, a collection of his gardening columns. Mitchell, who gardened in Washington for several decades, was a leader in the renascence of interest in horticulture and gardens. He knew that growing things makes people feel better, and that gardens are places where gardeners can mull things over, take things into their own hands, perfect their own visions. He celebrated the enormous richness of plants along the avenues and in the alleys, backyard plots, and gardens of Washington.

A City of Gardens is a guide to these riches.

Dumbarton Oaks
Mrs. Bliss's Renowned Grounds

C ombine Mildred Bliss's fortune and vision with Beatrix Farrand's landscape design and you get Dumbarton Oaks—"the jewel in the crown" of Washington gardens. One of the world's great gardens, it couples exquisite design and taste with horticultural genius. Bliss and Farrand worked together for nearly three decades, from 1921 through 1948, to design a garden that epitomized an Old World sense of beauty and leisure in an American setting. Their plan included several important principles: a progression

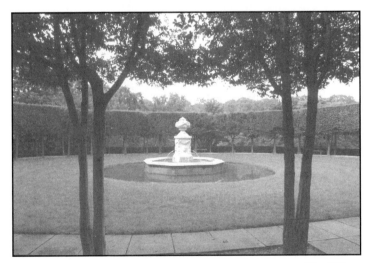

The Ellipse

*from formality to informality down the slope of a hill
that drops 100 feet to the north and 50 feet to the east;
plantings that offer year-round interest; and a classical
Roman idea of gardens as enclosed areas, or garden
rooms, to be lived in as much as the rooms of a house.
Farrand artfully leads you through each room. Garden
areas beckon, one after another, offering glimpses of the
view ahead. Architectural features—terraces, walls,
balustrades, gates, pavements, pools and fountains,
benches, and ornaments—create a hardscape equal in
importance to the plantings. The effect is one of serenity
and unity in what is actually a tour de force of invention.*

HISTORY

Originally granted by Britain's Queen Anne to Scotsman
Ninian Beall in 1702, the property was first named
the Rock of Dumbarton after a landmark near Beall's
Scottish home. Throughout the next few centuries a
series of nine owners lived here. In 1920 Mildred and
Robert Bliss bought the neglected house and property,
by then known as The Oaks. At that time the land still
had barnyards and cow paths, a peacock that patrolled
the grounds, and the magnificent oaks that gave it
its name. Although situated on the highest hill in
Georgetown, in 1920 this setting was rural and pastoral
enough to satisfy the Blisses' desire to have what they
called "a country place in the city."

The vision and lifestyle that Mildred and Robert Bliss
brought to Dumbarton Oaks was born in the Gilded
Age. Mildred Barnes was the daughter of one of
America's wealthiest families. The source of the Barnes
family fortune was Fletcher's Castoria, a laxative for
children. Mildred, born in 1879, was an only child

whose mother, Anna, was widowed early. Anna Barnes was married again in 1897, this time to attorney William Henry Bliss; her stepson, Robert Woods Bliss, later became her daughter Mildred's devoted husband.

By the time Beatrix Farrand and Mildred Bliss met in January 1921 to discuss the design of the gardens, Farrand was a well-established landscape designer with many prominent clients and a charter member of the American Association of Landscape Architects. Farrand was also the niece of novelist Edith Wharton, a Bliss family friend and the owner of estates in Paris and on the Riviera with gardens admired by Mildred Bliss.

The collaboration of Bliss and Farrand turned into a friendship—and a project that took nearly thirty years to realize. In 1940 the Blisses gave the house and gardens to Harvard University to serve as a cultural research center and museum to house their Byzantine and pre-Columbian art collections. They also gave twenty-seven acres to the United States Park Service to be used as a public recreation center. Before her death in 1969 Bliss also established garden study fellowships to encourage the study of landscape design. Today garden superintendent Gail Griffin and a staff of twelve continue to interpret Bliss's and Farrand's vision in the evolution and management of the garden.

Red oak
(*Quercus rubra*)

The three plants most commonly used at Dumbarton Oaks are yew, holly, and boxwood—and all of these are present along the **South Front** lawns and near the entrance to the house. An important part of Western garden history, these plants embody the garden's traditional Old World style. Additionally, the use of native magnolias and oaks along with exotic species underscores Farrand's willingness to feature a wide variety of plants. Two of the most dramatic along the South Front are a huge katsura tree *(Cercidiphyllum japonicum)* with branches almost parallel to the ground, and a Japanese maple *(Acer palmatum)* next to it. These dignified old residents were a part of the scene in the 1920s when Farrand began to add to the screen of trees lining the gates. At the entrance Farrand created a sense of privacy and seclusion with boundary plantings and evergreens, such as the deodar cedars *(Cedrus deodara)*. The sweep of the lawns adds to the grandeur of the South and East Lawns, the largest garden area in the entire estate.

Begin your tour at the **Orangery**, which was built about 1810. There you will find one of the most famous plants—and one of the oldest—in the garden. The creeping fig *(Ficus pumila)*, which dates to the 1860s, now covers the interior walls of the Orangery and frames four oval medallions of the seasons. It gets severely pruned twice a year, in early spring and fall. In 1983, when

The Orangery

4

a new ceiling was installed, the creeping fig had to be removed and then retrained along the current concrete rafters—an ordeal both for the gardening staff and for a 120-year-old plant. Along with the creeping fig, pot plants live in the Orangery during the winter. Huge myrtles, Ponderosa lemons, orange jasmine, winter jasmine, mandarin oranges, agapanthus, and other hothouse varieties fill the south-facing Orangery, with its seven tall windows along the south wall. In spring the exterior walls of the Orangery are covered in blossoming wisteria and climbing roses.

Start your outdoor tour at the east end of the Orangery. As you exit, take a moment to admire the magnolia tree *(Magnolia denudata)* just south of the Orangery. In spring the shiny leaves and white blossoms provide a soft contrast to the brick hardscape of the house. Continue to the **Green Garden**, just north of the Orangery. The enclosed garden terraces—from the Green Garden terrace to the Rose Garden—were the first to be laid out by Farrand, and they form the heart of this many-chambered garden. With a succession of enclosed areas, Dumbarton Oaks has often been referred to as a "chambered nautilus of a garden," and the center of the metaphorical nautilus starts here.

The Green Garden is a large, formal terrace, where the Blisses did much entertaining. That tradition continues today with parties for the scholars and students of the academic symposia on the pre-Columbian and Byzantine art collections and on the history of landscape design. Appropriately named, the garden is planted with grass and trees, with a red oak *(Quercus rubra)* at its center. The walls enclosing the terrace—arcs of terra-cotta mortared together in a scalloped design—give both enclosure and airiness to the area. The stone walls and

ornamentation, as Farrand instructed, are only "slightly hidden by carefully trained creepers" such as winter jasmine, ivy, and roses. In the north wall of the garden, the Blisses erected a plaque in 1935 commemorating Farrand's friendship and work. The Latin inscription reads (in translation): "May kindly stars guard the dreams born beneath the spreading branches of Dumbarton Oaks." Stand in front of the plaque and you will enjoy one of the greatest views in the garden: To the northeast, over the woods of Rock Creek Park, rises the minaret of the mosque on Massachusetts Avenue less than a mile away. Here at the highest point on the property, the enclosure of the carefully structured garden opens up to the dome of sky above and the gardens below. It is Farrand's signature preview of what lies ahead.

Continue to the **Star Garden,** named for the ten-pointed star in the paving, at the southwestern corner of the Green Garden. Designed in 1931 for quiet family meals, this small bower is surrounded by mature azaleas *(Rhododendron mucronatum)* grown as a low hedge. In spring the white azalea blossoms reinforce the serenity of the adjacent Green Garden. This small circle is wrapped around with Chaucer's Old English translation of a text by fourth-century Roman philosopher Boethius: "O thou maker of the whele that bereth the sterres and tornest the hevene with a ravisshing sweigh." Set in the corners are figures of the constellations Aries, Capricorn, Pegasus, and the Phoenix. On the wall a figure of Aquarius, the water bearer, spouts water into a stone trough. The zodiac figures come from illustrations in old astronomy books. Despite the celestial setting, Farrand's instructions for maintenance were entirely practical: The azaleas should be controlled, she noted, "so that the little Star and its seats are not sunk at the bottom of a tall azalea."

Retrace your steps through the Green Garden to the
Beech Terrace. The beauty of the terrace centers on
the magnificent American beech *(Fagus grandifolia)*,
dramatic in every season. This beech tree, which domi-
nates the terrace, is not the original planting. It replaces
the original copper beech that died in the 1950s.
Farrand notes that since it is "notoriously hard to make
anything grow under a beech tree," the groundcover
should be replaced when necessary. Today it is mostly
grass. From February through April, delicate sapphire
blue Siberian squills *(Scilla siberica)* and snowdrops
(Galanthus nivalis) sparkle among the muscular out-
croppings of aged beech roots.

East of the Beech Terrace walk lies the **Urn Terrace.** It is
intended as an introduction to the Rose Garden. Hence,
it is narrow and restrained to give greater space to the
Rose Garden. In fact,
Farrand often referred to
it as an "anteroom." The
design of the original Urn
Terrace was quieter and
simpler, more closely
resembling the small box-
wood terrace on the south
side of the steps leading
down to the Rose Garden.
The Urn Terrace on the
north side of the steps was
redesigned by Ruth Havey,
the landscape designer
who succeeded Farrand.
Working with Mildred
Bliss, she created the
fanciful scrolls of ivy and
pebble mosaics.

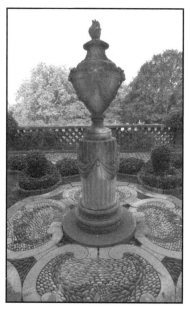

The Urn Terrace

Continue down the steps to the **Rose Garden,** the largest and flattest terrace in the constantly changing levels of Dumbarton Oaks. Welcoming you, atop the gate, are pineapple finials, the centuries-old symbol of hospitality in both Old World estates and New World houses, such as Mount Vernon and Monticello. The Rose Garden offers a blaze of color, ending a progression from gardens of cool greens and shade to warm colors and sunlight. This complex formal garden is laid out in four quadrants at each end surrounding a central spiral boxwood topiary amid eight parterres of roses. The dark green of the specimen English and American boxwood provides a dramatic contrast and formal setting for the beds of white, red, pink, and yellow roses. About a thousand roses bloom here from May almost to Christmas, depending on the weather. In Farrand's original scheme there were more boxwoods to give "enduring outlines" in winter as well as summer. Today the roses are mulched in winter, pruned in early spring, and carefully tended through the blooming season. Here among the roses, marked by a lead canopy in the west wall, are the ashes of Robert and Mildred Bliss with names and dates inscribed in sandstone. Along the east wall is one of the most formal of the stone benches in the garden topped by a sheaf of wheat, the family symbol. Above it, the family motto reads: *Quod Severis Metes*—You shall reap what you sow.

Down a flight of steps east of the Rose Garden lies the **Fountain Terrace.** Farrand wanted this terrace to be a "very much less prim design" than the Rose Garden. It is also the one real flower garden among all the terraced gardens east of the house. Farrand recommended tulips of "approximately even heights" in spring, summer-flowering annuals and perennials, and chrysanthemums in fall. (This garden is especially spectacular in fall.) She also recommended that the pools on either side of the

terrace—said to be inspired by pools in her aunt Edith Wharton's garden in France—should "have the effect of seeming to be considerably older than they actually are." As usual, she had a practical suggestion: let the pools' stone edges "become as mossy as possible." To enhance the less formal atmosphere of the garden, Farrand used vines, ivy, and autumn-flowering clematis (considered invasive and even weedy today) to cover the stone walls. Just outside the southeast corner of the Fountain Terrace is one of the garden's great trees, a huge English European beech (*Fagus sylvatica* 'Riversii') that dates to the nineteenth century. The purple beech was once considered a tree for the elite—those with properties large enough to accommodate such size and grandeur.

Through the gate to the north and a few steps beyond lies another alluring view: the **Arbor Terrace**. It is named for the sixteenth-century-style cypress arbor at the west end. The Arbor Terrace was not intended as a display garden. It is a container garden—filled in summer with tubs of gardenias, lantana, and citrus trees. The teak and iron bench and the shaded seating under the arbor create a quieter mood than that of the Fountain Terrace. The arbor also camouflages the retaining wall on the west end. This is a spot for contemplation: enjoy the bees amid the panicles of wisteria that drape the arbor in spring. It also offers an overlook with a kaleidoscope of views. Here you can look through the trunks of pear trees (*Pyrus lecontei* 'Kieffer'), trained as an aerial hedge, to both the upper and lower levels. Below the Arbor Terrace the enclosed gardens come to an end and the informal and naturalistic gardens begin. Retrace your steps through the Fountain Terrace and follow the path eastward to Lovers' Lane Pool. As you descend to the lower hillside, you pass a quince tree *(Pseudocydonia sinesis)* and a sycamore *(Platanus occidentalis)*. Their mottled barks add to the show the natural world offers here.

Lovers' Lane Pool, designed in 1923, is one of the most romantic areas of the garden. Farrand used the pool here as a mirror, which today reflects the English European beech on the slope above. Interestingly, the water also reflects back on the bark of the beech as it catches the morning light. Other graceful, shiny-leaved plants—bamboo, aucuba, and periwinkle—border the pool and add to the shimmering effect. Patterned on an open-air theater in Rome, the grassy slopes, which are bordered with brick, seat about fifty people. In the Blisses' time it was used for plays and concerts. In spring, bright blue Siberian squills and glory of the snow *(Chionodoxa luciliae)* cover the grassy terraced seating area. To emphasize its Roman origins, the eastern and southern edges are enclosed with fifteen stone columns. This is the perfect place to observe what Farrand's mentor, Charles S. Sargent, taught her. His advice: "Make the plan fit the ground and don't twist the ground to fit a plan." As in many places in the garden, Farrand chose to keep the plantings in place as she designed on a natural slope that plunges more than fifty feet from the Orangery at the east end of the house.

As you continue north beyond the pool, the woodland becomes **Mélisande's Allée** (named after a Debussy opera based on an 1892 play by dramatist Maurice Maeterlinck). Here Farrand transformed what were once cow paths and a watering hole into a thirty-five-foot-wide avenue of narcissus, crocus, wild violets, and honeysuckle. High-branching, graceful silver maples *(Acer saccharinum)* arch over the path.

Daffodil
(Narcissus)

Farrand was influenced in her design by British land-scape designer William Robinson, who championed the use of natural plantings and woodland flowers. She used these trees and the wide avenue of maples to give distance and perspective to the Lovers' Lane Pool. This long winding brick path is a major north-south axis in the garden.

Continue north along Mélisande's Allée and you will come to the **Herbaceous Border** on your left. Enter the elegant anteroom (with benches in each corner looking as though they were made for the Queen of Hearts) planted with evergreens, and you will see tall Irish yews (*Taxus baccata* 'Stricta') at either end. These two garden markers were affectionately referred to as Mr. and Mrs. Yew by Bliss and Farrand. Though the long border has the proportions of a Gertrude Jekyll perennial border, it is deeper and not designed with the gradual succession of colors that the English landscape designer favored. It is planted seasonally with tulips, fritillaria, and other spring bulbs; summer annuals such as hollyhocks and lantana; and fall mums and asters.

In the middle of the Herbaceous Border, go north and follow **Prunus Walk**, another north-south axis. This lane of plum trees *(Prunus x blireiana)* blooms in late February or early March in a glorious display. The walkway separates the upper and lower growing gardens, where cut flowers as well as mums for the Herbaceous Border and other gardens are grown. In the Cutting Garden and to the east below Prunus Walk are three pavilions topped with handmade terra-cotta tiles overlapping like fish scales. Distinctive in appearance, their ogee-shaped rooflines suggest an Oriental pagoda. Mrs. Bliss had them built to store tools and today they are used for the same purpose.

Prunus Walk

Just beyond Prunus Walk lies **Cherry Hill**. Planted on the lower hillside, the dark trunks of slender single-flowered Japanese Yoshino cherries *(Prunus x yedoensis)* spread down the hill. The trees light up the hill with their pink blooms in late March and early April. Later in the year the cherries blend with the woods and ravine below. At the bottom of the steep hill runs a tributary of Rock Creek—near the boundary for the twenty-seven-acre section the Blisses turned over to the National Park Service in 1940. The cherry trees link the garden to the park on the north and east and merge with Forsythia Hill on the west.

On the path to Forsythia Hill you pass **Catalog House**, built in memory of Charlotte and Vernon Kellogg, close friends of the Blisses. Here in the most naturalistic and informal part of the garden, the octagonal shelter houses a photographic history of the making of the garden: photos of the Blisses, sketches of mock-up designs that eventually became ornaments and hardscape, austere

poses of Farrand, group shots with a perfectly poised Mildred Bliss (aka Perfect Bliss) at the center. And at the top of the Catalog House, two roof-ornament squirrels survey the scene.

Follow the path skirting the hillside to **Forsythia Hill.** The forsythias are the harbingers of spring. For several weeks in March the arching forsythia branches become an ocean of yellow cascading down the steep hill. "The onrush of Spring at Dumbarton Oaks leaves one breathless," Mildred Bliss wrote in response to this mass of pure gold. Farrand recommended that only one variety of forsythia be planted here to ensure the showers of bloom be kept to all the same shade of gold and growth habit. She also recommended that the hillside of plants be carefully pruned each year to keep the forsythia from becoming too massive or tangled. In the maintenance of the garden today, the forsythia are cut back periodically, not annually, in keeping with the naturalistic, informal feel of this part of the garden and to shelter the birds and chipmunks and foxes that make their homes in the thicket of branches.

Steps leading up Forsythia Hill follow an old steep path. Along the steps sits **Crabapple Hill,** a wedge of hillside beautiful with bearded iris in spring, daylilies in summer, and crabapples in fall.

To the east is the **Ellipse.** This is one of the few sites in the garden that was redesigned after Farrand's death. In the 1950s boxwood originally placed here by Farrand was removed, and the garden was redesigned by landscape architect Alden Hopkins. He put in a double row of American hornbeams *(Carpinus caroliniana)*, which are kept trimmed as an aerial hedge sixteen feet high. Farrand called this area the quietest and most peaceful part of the garden, and it is still so today. This is also

13

another spot that invites you to look beyond—in this case to Forsythia Dell. In the middle of the Ellipse is an antique Provençal fountain, purchased by the Blisses in 1927 and moved here in 1967.

From the Ellipse, follow the brick path up **Box Walk**. Lined with boxwood (*Buxus sempervirens* 'Suffruticosa') planted as mature specimens in the Blisses' time, parts of the hedge are about a hundred years old. The good health and lush growth of these very old plants is due in part to the shady location. The patterned path climbs 214 feet and is the main north-south axis through the center of the garden. Note the ellipse and diamond shapes in the brick paving, based on designs used at Barrington Court, a Gertrude Jekyll-designed National Trust garden in Somerset, England. You are now entering the last part of the tour and returning to the heart of the garden. About halfway up Box Walk, turn into the Pebble Garden.

Mildred Bliss called the **Pebble Garden** her "bang-up finale." Conceived in the last years of her life, it is the most consciously "designed" and fantastic in the entire garden. The garden was completed in 1961. Originally a tennis court, it was converted by Bliss and Ruth Havey, Farrand's successor, into a pebble mosaic garden. The mosaic of pebbles—in the form of the wheat sheaf family emblem flanked by two stone-carved cornucopias and planted with sedum and thyme—glistens in the shallow covering of water. The cornucopias, notes garden writer Susan Tamalevich, seem a perfect symbol of the Blisses' bountiful life. Another commentator on the Bliss lifestyle added his own observation below a Bliss family photo, picturing Henry du Pont and Mildred Bliss in the Pebble Garden. Underneath, the observer has scrawled: "The last of the Medici."

Before you leave the garden, take a moment to stop at the **Horseshoe Steps** (named for their shape). Continue past the Pebble Garden and Swimming Pool loggia west toward the steps. Stand at the bottom to observe one of the most graceful of the architectural designs in the garden. These steps were originally straight; however, when they needed repair, Mildred Bliss decided to replace them with a more elegant design. This curving staircase and fountain, with a foliage motif for the steps and fountain, was the result. Rushes and cattails, carved into the fountain, echo designs in the Arbor Terrace and provide a stone background for low, lacy ferns growing in the basin. Here, where the hillside drops steeply, once again Farrand and Bliss not only camouflaged the shift in levels but also seized the chance to create harmonious lines, enduring beauty, and a glimpse of the terrace and of the Orangery at the top of the stairs.

BIRD'S EYE VIEW

Continue up the stairs and go west, on beyond the Green Garden and Star Garden to the **North Vista** behind the house. Four grassy terraces extend the perspective from the house, narrowing as they descend. In 1920, when the Blisses bought the property, this greensward was mostly rutted roads leading to the old farmyard, where the swimming pool is located today. Farrand originally enclosed the North Vista with boxwood. In the 1940s the existing walls and pillars were erected. Deodar cedars were added along thesecond terrace in the sweeping view to the west, probably in the 1950s. Continue to the far end and look back, and you will see that the fourth terrace is as long as the previous two. This exercise in false perspective was employed to great advantage. From the house the

North Vista appears as a vast stretch of green lawn stretching toward the woods beyond. And from the far end of the lawn, the grassy steps and surrounding landscape come into focus, giving a view of the house framed in its setting. Weeping cherries (*Prunus subhirtella* 'Pendula') at the far end and wisteria *(Wisteria floribunda* and *sinensis)* growing along the brick wall are spectacular in spring. Beyond stretches Rock Creek Park, and below—more views of the garden. The North Vista incorporates the essence of what makes this great garden work: a neoclassic design with panoramic views. This plan, at once infinitely complex and elegantly simple, led to one of the last great garden estates created in America in the twentieth century.

GARDEN NOTES

The Oldest Plants — The oldest plant at Dumbarton Oaks is probably the creeping fig *(Ficus pumila)*, which dates to the 1860s. The vine covers the walls of the Orangery. Trees of great age include the Japanese maple *(Acer palmatum)* and the katsura tree *(Cercidiphyllum japonicum)* on the East Lawn and the copper beech *(Fagus sylvatica)* southeast of the Fountain Terrace. These trees were here when Farrand began designing the garden in the 1920s, as was the Yulan magnolia *(Magnolia denudata)* outside the east door of the Orangery. The magnolia is also one of the earliest bloomers in spring.

Sitting Pretty — Dumbarton Oaks is famous for its benches. Take time to look for them and to sit on them. There are more than fifty scattered in appropriate places around the grounds. Beatrix Farrand designed most of them. Her successor, Ruth Havey, also designed a number of them.

Arts and Crafts Movement — Inspired by the art and architecture criticism of the Victorian writer and thinker John Ruskin and the decorative arts of British designer William Morris, artisans and workshop groups around America began producing their own arts and crafts designs in the late 1800s. This movement influenced many of the stonemasons, sculptors, and other artisans who created the finials, benches, and carefully detailed stonework that adorn Dumbarton Oaks.

Earliest and Latest Bloomers — Dumbarton Oaks's earliest bloomer is the yellow-flowering winter jasmine *(Jasminum nudiflorum)*, which arches and twists over some of the walls closest to the house, and can bloom as early as December. The latest bloomers are roses in the rose garden, which can bloom right up until Thanksgiving and sometimes even until Christmas.

The Oldest Artifacts — The oval medallions of the Four Seasons in the Orangery and the Ellipse Fountain are probably the oldest artifacts in the garden.

Dumbarton Oaks Park — Tucked away behind the formal gardens are twenty-seven acres of woodland, meadow, and stream known as Dumbarton Oaks Park. Head down R Street toward Montrose Park and you'll find the entrance at Lovers' Lane. (On the other side on the fence is the Lovers' Lane Pool.) In 1940 this naturalistic garden was given to the National Park Service—but without an endowment. Though the National Park Service minimally maintains the area, Dumbarton Oaks Park has reverted to woodland and is today much more wilderness than garden. For dogwalkers and joggers, however, its paths are sanctuary. The park offers many special fea-

Snowdrop
(Galanthus nivalis)

17

tures: a stone bridge, a series of eighteen dams and water-falls splashing down the stream, grand rhododendrons along the stream bed, a stone bench covered with a plush upholstery of moss. It is a fine shortcut for those trekking between Massachusetts Avenue (at the end of Whitehaven Street past the Italian Embassy) and Georgetown—where Farrand's legacy of snowdrops, crocuses, scilla, and daffodils still carpets the valley each spring.

Size: Ten acres
Hours: Open daily from March 15 until October 31, 2 P.M. until 6 P.M. and from November 1 until March 14, 2 P.M. until 5 P.M. Closed on national holidays and on December 24.
Admission: $5 for adults; $3 for seniors and children (from March 15 until October 31).
Telephone: 202-339-6410
Distance from Capitol: Four miles
Address: R Street at 31st Street, NW, Georgetown
Web site: www.doaks.org

DIRECTIONS

BY SUBWAY AND BUS: Take the Metrorail to Foggy Bottom (orange and blue lines). Walk one block north to Pennsylvania Avenue, NW, at Washington Circle and take a 30S Metrobus. Get off the bus at R Street and Wisconsin Avenue, NW, and walk a block and a half east on R Street to the entrance gates of Dumbarton Oaks.

BY CAR: From Virginia, take Key Bridge into Georgetown. Go east on M Street to Wisconsin Avenue, NW, north on Wisconsin to R Street, NW, and east on R Street a block and a half to the entrance. From Maryland, take Route 355 south (Rockville Pike), which becomes Wisconsin Avenue, in the District. Continue on Wisconsin to R Street, then turn east on R Street and go a block and a half to the entrance. In Washington, take Wisconsin Avenue to R Street and go a block and a half to the entrance.

Gunston Hall

Digging Into a Garden's Past

What you see is not what you get at Gunston Hall. The current research into the past on the garden at Gunston Hall is considerably more fascinating than what first meets the eye. *The home and gardens of Virginia planter and statesman George Mason, Gunston Hall was the centerpiece of a 5,000-acre plantation in the eighteenth century. Lying just around the bend from George Washington's Mount Vernon, Gunston Hall sits on Mason Neck on the banks of the Potomac. As a*

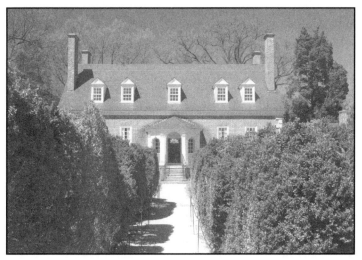

The Boxwood Allée

champion of human rights, George Mason played a critical role in the founding of our nation. Ultimately, the U.S. Bill of Rights, added to the Constitution in 1791, was based on the Virginia Declaration of Rights written by Mason. Today the mission of Gunston Hall is to interpret George Mason and his life in eighteenth-century Virginia. Although research and preservation of the mansion's architectural details have been in progress for decades, historical records of the garden were extremely limited. Recollections, *written by Mason's son John in 1839, is the only surviving document that provides a glimpse of Gunston Hall's eighteenth-century landscape. To obtain a reliable picture of the original garden, staff archaeologists and a crew of trained volunteers have been excavating the site since 1997, seeking primary data on the physical remains of George Mason's eighteenth-century design.*

HISTORY

George Mason inherited nearly 5,000 acres on Dogue's Neck (now called Mason Neck) in Fairfax County, Virginia, and moved there to the southern shore of the Neck in 1749. He selected the high ground near the northern edge of his land as a site for a home in 1750, the same year he married Ann Eilbeck. Work on the mansion probably began in the summer of 1755. The thirteen-room house, built of brick and local stone, was one of Virginia's "great houses"—a sign of wealth and status for one of Virginia's wealthiest citizens. During Mason's life there, Gunston Hall was no doubt a lively place—the home of Ann and George Mason and their nine children and the headquarters of a thriving planta-tion, served by a workforce of slaves and indentured

servants. After the mansion was completed in 1759, Mason probably turned to the creation of the gardens and grounds as a formal setting for his new home. Whatever plans were carried out, all that remains visible today is a boxwood allée that is the north-south axis of the garden. George Mason died in 1792 leaving no records on the garden. It is from son John Mason's descriptions in *Recollections* that researchers have put together the general outlines of the garden.

By the end of the nineteenth century the entire upper garden, except for the lane of boxwoods, had been plowed under. In 1911 Louis Hertle purchased the property. He undertook his own restoration of the house and gardens, which resulted in the installation of a Colonial Revival garden in the mid-1930s, complete with a pergola and intricately designed boxwood beds. Following Hertle's death, Gunston Hall became the property of the Commonwealth of Virginia under the custodianship of the Board of Regents of The National Society of The Colonial Dames of America. The Garden Club of Virginia hired landscape architect Alden Hopkins to restore the formal garden in 1954. Hopkins made changes to Hertle's garden, restoring its basic look and eliminating statuary and pools, which were then considered inappropriate for a Colonial Revival garden.

In the mid-1990s a program of archaeological and historical research was initiated to gather as much information as possible about the eighteenth-century garden of George Mason. What is visible in the garden today, as research continues, are remains of the original boxwoods, a central pathway, and remnant plantings and beds from the Colonial Revival garden. The garden surely contains the buried remains of older features, but they are not visible. And so the archaeology continues.

In a tour of the grounds you will have to exercise your imagination—and your mind's eye—to see what *was*, as well as what is today. The best way to do that is to look from the house to the garden and beyond to the Potomac River, just as an eighteenth-century visitor would have. If you begin with the house tour, pause in the central hall of the mansion to look out the south door toward the garden. You will see immediately that the garden path straight ahead, and lined with box-woods, is an extension of the house and the twelve-foot-wide central passage or hallway. A view from the second floor of the house also gives an overview of the garden.

The tour of the garden begins outside on the **South Portico,** which leads directly into the Central Axis of the garden. Today the boxwood path is narrower and more constricted by the 250-year-old boxwoods than it was in the eighteenth century. In Mason's time the boxwoods may have been planted as edgings or topiaries and would have marked and defined this path as a wide avenue or, as it was more likely called then, a "great walk." Archaeological excavation has revealed that this avenue, like the central hallway of the house, was also exactly twelve feet wide—a crowned path of pebbles on a clay base.

From the South Portico of the mansion, gaze down the **Central Axis** of the garden toward the river and imagine an open, expansive vista. Though that view has long since disappeared, there is evidence for its existence. John Mason reported that the mansion "commanded a full view of the Potomac," and early photographs show that a far greater portion of the river was visible from the mansion and garden when the surrounding land was cleared. The central walkway leading from the house

would have directed the eye toward this view of the river and the world beyond. From the opposite direction—from the river entrance—the garden would have focused the eye of the beholder on the mansion. "As a foreground to the mansion," former staff archaeologist Christine Jirikowic says, the garden "would have had the effect of magnifying the house, lending it grandeur and mass." Clearly, George Mason was keenly aware of the principles of perspective and proportion in his design of this formal landscape.

Originally designed as a garden pavilion, the Portico was created by master carpenter William Buckland, who was indentured to Mason from 1755 to 1759. He selected the design of the Portico, borrowing it from a design in an eighteenth-century pattern book and adapting it for use as a porch or portico. The pavilion creates a transition between house and garden.

Boxwood
(*Buxus sempervirens* 'Suffruticosa')

Archaeological excavation also has revealed evidence of planting beds on either side of the avenue between the Portico and a line of boxwoods (called the boxwood tee) crossing the Central Axis from east to west just below the Portico. These beds would have effectively directed the visitor into the garden and restricted access to other possible destinations, such as the kitchen yard. Excavations have revealed evidence of a path that led from the Portico to the kitchen—but that path dates to the nineteenth century. By that time, ideas about symmetry and control in the landscape were no longer such important considerations.

From John Mason's descriptions, the general outlines of the original garden can be discerned. Beginning at the mansion, one could step directly into the garden from the South Portico. Then heading south, one crossed a level "platform," which measured one acre in area and was laid out in squares and gravel paths. At the south end of the platform was a walk along the brow of the hill looking out toward the Potomac. It is a view that no doubt delighted many a guest to Gunston Hall—and one that today we can only imagine.

In *Recollections,* John Mason described a "spacious Walk running eastward and westward" at the south end of the garden. Although that walk has disappeared from the present-day landscape, archaeological testing has revealed its remnants. This gravel path measured nine feet in width. This walk at the crest of the hill along with the Central Axis linked the mansion, the garden platform, and the overlook—the elements around which the garden was designed.

Make your way down the Central Axis to the walk and overlook at the south end of the garden. From here it is easy to imagine the platform that Mason describes as "one acre in area and . . . laid out in simple squares and gravel paths." Excavation has shown that two additional eighteenth-century gravel paths crossed this platform. These help to confirm the garden as a one-acre expanse laid out in four parterres.

View from the South Portico

24

The archaeological excavation along with the historical documentation from John Mason and knowledge of eighteenth-century gardens make it clear that the real purpose of the garden was to enhance every view of Gunston Hall. The garden functioned as a lens to frame the mansion. While the basic structure of the garden has endured, the details are buried and no longer make a statement about Mason's standing in his world. In order to eventually recapture that eighteenth-century view, the archaeological data are key. David Reese, director of Gunston Hall, underscores the importance of the archaeological clues in proceeding with a reliable restoration. "We continue to interpret the garden as the garden of George Mason and to move ahead with replicating those original features in the landscape."

OFF THE BEATEN PATH

From the land side of the house, Gunston Hall's north front, a carriage road once cut straight to the house. It was flanked on either side by double rows of black heart cherry trees. (Today the drive is planted with cedars and magnolias.) Perfectly pruned, the trees provided an ideal scene for a trick George Mason liked to play on guests.

John Mason notes in his *Recollections* that "when one stood in the center of the door to the mansion only the first four trees were visible." He reports that this optical illusion was carefully arranged and preserved by his father, who took delight in showing the view to guests. Archaeologist Jirikowic adds that "this elaborate optical trick attests to Mason's familiarity with principles of perspective and proportion and his willingness to play with such principles in the design of the formal land-scape around his house."

John Mason's *Recollections* also describes the landscape beyond the brow of the hill and descending to the river. He notes that on the upper portion of the hillside, below the brow of the hill, there were several "falls," or terraces, and then a steep drop to the deer park on the plain below. Records indicate that George Mason kept a herd of deer on this plain along the Potomac River. Located on either end of the terrace top are mounds, which are prominent features of the landscape today. Mounted with tall gazebos built in the 1950s, they seem to mark the garden's edges, 120 feet east and west of the Central Axis. Yet documents from the nineteenth century and John Mason's casual descriptions of this area as "some falls on the Brow of the Hill," along with the excavations, lead archaeologists and researchers to suspect that these markers may not have been part of the original garden. Today's altered view from the brow of the hill—with the Potomac River barely visible and the deer park transformed into a wetland—is a dramatic reminder of the difficulty of recapturing the past.

GARDEN NOTES

The Boxwood Allée — Look closely at the trunks of the boxwoods along the central walkway, and you will notice that the largest trunks are located farthest from the pathway. Some of these shrubs have been tree-ring dated and found to be more than 250 years old—and thus part of the original garden. The smaller trunks located closer to the path are offshoots of the originals, and over time they have engulfed the original twelve-foot walk. Also notice that some of the largest and oldest trunks are twisted. This was likely the effect of how original boxwood plants were grown. Individual boxwoods were planted at regular intervals along the

walkway. The main trunks and lower branches of these young plants were then trained—in a spiral fashion—around vertical and horizontal wires, to create a compact, billowy mass of foliage. Such training would control the spread of the shrubs and concentrate their growth in a small area. This tells us that the original intent was to keep these plants low to the ground, very likely so as not to obstruct the views through the garden. Certainly, they were never meant to reach the proportions they have reached today.

An Eighteenth-Century Fence? — Excavating along the east and west edges of the garden, archaeologists have found evidence of vertical posts set at ten-foot intervals. These posts may have been part of fences or trellises that ran along the edges of the garden platform. Archaeological evidence tells us that these posts were erected in the eighteenth century, either as part of the original garden or as an early addition. The evidence also shows

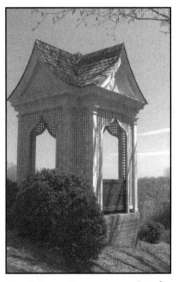

Gazebo

that each post was carefully charred at the bottom, presumably to delay the effects of decay and to prolong its usefulness. The extra effort of treating each post in this manner is a good indication that this was a formal construction that was meant to last, as opposed to a casual structure that was either temporary or expected to be repaired or replaced.

A Social Structure Revealed? — As you return to the mansion, turn your attention to the west side of the house facing the schoolhouse. Here the evidence of the previously described posts continues north, beyond the east-west line of boxwoods. Excavations along this alignment showed that this structure—fence or trellis—then turned ninety degrees and joined the mansion just south or behind the door on this side of the house. This door leads to the cellar and would have been used primarily by slaves and servants in George Mason's time. It is probably not a coincidence that this fence or trellis was positioned so as to exclude direct access from the cellar to the formal garden. This single detail provides us with one tantalizing glimpse of the real people who lived and worked in this landscape. And it serves to remind us that this garden was created in the context of a social world very different from our own.

Size: About an acre (garden only)
Hours: 9:30 A.M. until 5 P.M. daily, except Thanksgiving, Christmas, and New Year's Day.
Admission: $8, adults; $7, seniors; $4, students, grades 1–12
Telephone: 703-550-9220
Address: 10709 Gunston Road, Mason Neck, VA
Distance from Capitol: Twenty-three miles
Web site: www.gunstonhall.org

DIRECTIONS

BY CAR FROM WASHINGTON, D.C.: Take exit 163 off Interstate 95. Turn left onto Lorton Road. Turn right onto Armistead Road. At the light, turn right onto Route 1 south. At the third light, turn left onto Gunston Road (SR 242). The Gunston Hall entrance is 3.5 miles on the left.

Hillwood

Garden Riches

What kind of garden would you create if you had, as the saying goes, "all the money in the world"? Hillwood is the way Marjorie Merriweather Post, one of the twentieth century's wealthiest women, answered that question. At Hillwood she created more than a half dozen garden "rooms" to extend and enhance the mansion where she lived from 1957 until her death in 1973. It is especially interesting that she moved to this sprawling property when she was seventy years old and in the

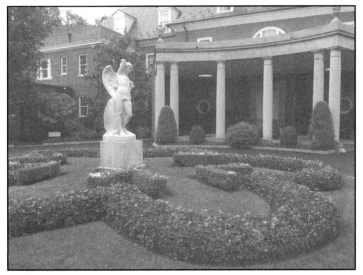

The Motor Court

ensuing years not only re-created the house and gardens but also made preparations for the museum that Hillwood was to become after her death. In September 2000, after an extensive three-year restoration and renovation, the house and gardens were reopened to the public. Spring and fall were the seasons she spent here—and those are the seasons the gardens are at their best.

HISTORY

Born in 1887, Marjorie Merriweather Post inherited the Post cereal empire in 1914 when she was twenty-seven years old. In addition to leaving her one of the largest fortunes in America, C. W. Post also instilled in his daughter a keen business sense and a passion for collecting. In the 1920s she became a serious collector of French decorative arts. At about the same time, she and her second husband, financier E. F. Hutton, were transforming the family company into the General Foods Corporation. After her marriage to third husband Joseph Davies, the second U.S. ambassador to Russia, she and Davies lived in Moscow from 1937 to 1938. There she developed an avid interest in Russian art and began collecting the paintings, porcelain, icons, Fabergé eggs, and other pieces that have made her Russian collection famous. In 1955, after her divorce from Davies, she purchased Hillwood, a suburban Washington estate built in the 1920s. Overlooking Rock Creek Park, the twenty-five-acre estate became the setting for her extraordinary lifestyle and art.

While reconstructing and renovating the mansion, Mrs. Post also created the formal gardens. Redesigned to extend the mansion's living and entertaining space outdoors, the gardens were planted with many mature specimens. They became a showcase for some of the

leading landscape architects of the day. Like the collections inside, they display a world of treasures. Today the gardens at Hillwood are planted and maintained to preserve, as closely as possible, the look Marjorie Merriweather Post established in the 1950s and 1960s when she was in residence here.

TOUR

Marjorie Merriweather Post's home was undeniably her castle. It was also her theater. When guests arrived, they were greeted by Mrs. Post's butler in the circular courtyard (known as the Motor Court) where a statue of Eros, god of love, is shown pulling an arrow from his quiver. It is probably no coincidence that a statue of Eros also stands in the middle of Piccadilly Circus, the heart of London's theater district. From this very first encounter at Hillwood, guests were on notice that they were in for a good show.

The gardens surrounding the **Motor Court** are spectacular in fall. Not one but *three* dawn redwoods *(Metasequoia glyptostroboides)* frame the drive around the courtyard. Their feathery cinnamon-colored foliage creates a striking contrast to the pair of

Dogwood *(Cornus florida)*

Colorado blue spruces (*Picea pungens* 'Glauca') that stand on either side of the entrance to the Motor Court. Interestingly, at the time these trees were planted in the mid-1950s, the dawn redwood had been rediscovered as a species thought to have become extinct. (After a 15-million-year hiatus, dawn redwoods were once again growing in the United States!) Bright green in spring, the dawn redwoods, currently more than sixty feet tall,

make dramatic companions to the understory trees, spring-flowering dogwoods and purpleleaf plums (*Prunus cerasifera* 'Hollywood') as well as a stunning blue-green deodar cedar *(Cedrus deodara)*. Towering over the brick wall at the eastern end of the Motor Court, the deodar cedar produces remarkable oval cones in the fall. Similar in size and shape to the famous Fabergé eggs in Mrs. Post's collection, the cones are referred to by Hillwood's docents as "Fabergé cones."

Facing the mansion, continue to the right and proceed through an arch in the wall into the **French Parterre**. For this area Mrs. Post commissioned the Long Island landscape architecture firm of Innocenti and Webel to design a garden typical of a formal eighteenth-century French garden. Here the French doors of the drawing room open to a terrace balustrade featuring a pink marble swan fountain, female sphinxes, and Parisian urns. As in most of Mrs. Post's gardens, more is more ("less is more" was never a part of her thinking). This small garden overflows with ornamentation, though it is uncharacteristically restrained in the use of plant materials. Divided into four quadrants centered on gravel footpaths around a shallow pool, the parterres feature boxwood (*Buxus semperviren*s 'Suffruticosa') clipped into flowing scrolls. But the most remarkable part of the garden is the living green enclosure created by its ivy-covered *(Hedera helix)* walls, which get severely pruned each spring to keep them in perfect condition. The ivied walls flow and curve around the strict geometry and symmetry of the pools and paths. And at one end, Diana, goddess of the hunt, stands in the recesses of that sinuous green wall. Creating a sense of luxury and a flavor of the French aristocracy, this outdoor drawing room seems particularly appropriate to the life and times of Marjorie Merriweather Post.

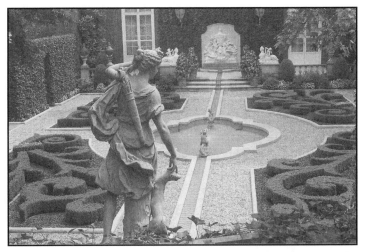

The French Parterre

Continue through the archway to the right of Diana, and then turn left toward the **Rose Garden**. This garden is one of the few places at Hillwood where its pre-Marjorie Merriweather Post history is visible. As she redesigned Hillwood, Mrs. Post decided to keep the circular shape of this garden and the rose-draped pergola built by the estate's original owners. To fashion the garden to her taste, in 1956 Mrs. Post hired Perry Wheeler, a landscape architect who had helped design the White House rose garden. Wheeler created a spring and summer garden. Emperor tulips in the rose beds bloom in April, and the climbing and rambling roses begin blooming in May. Floribunda roses bloom throughout the summer. And Wheeler's intricate pavings and crown-shaped beds add to the beauty and interest in every season. In the shade of the pergola, mahogany benches offer visitors a place to relax and smell the roses. In May and June the creamy white flowers of the Southern magnolia *(Magnolia grandiflora)*, earthy smells of boxwood *(Buxus sempervirens* 'Aureovariegata'), and

the perfume of the lilacs *(Syringa vulgaris)* make this a wonderful place to be. Later, the summer-blooming alyssum adds its own sweet smells. In the center bed Mrs. Post placed her memorial monument, which today houses her ashes in its base.

Continue beyond the pergola toward the black iron gates that lead toward **Friendship Walk**. Created in 1957 by some of Mrs. Post's closest friends, the garden was built to honor her lifelong generosity to others. (In her obituary, the *New York Times* noted that "while she always lived like a queen, she has given like a philanthropist.") Landscape architect Perry Wheeler and Mrs. Post's head gardener worked with her friends to create a birthday surprise, which was dedicated to her in October of that year. Follow the red cement path that winds through a magnificent collection of woody shrubs and trees. The yellow-flecked leaves of aucubas *(Aucuba japonica* 'Variegata'), the creamy panicles of flowering andromedas *(Pieris japonica)*, and the white clusters of tiny spirea flowers *(Spirea x vanhouttei)* provide the creams and golds that Mrs. Post favored. Camellias, abelias, and azaleas bloom in spring. The berried trees and shrubs that she loved are here also: American hollies *(Ilex opaca)* and yews *(Taxus x media* 'Viridis'); the dramatic Yoshino cherry *(Prunus x yedoensis)* and native red buckeye *(Aesculus pavia)* that flower in spring; and the crape myrtle *(Lagerstroemia indica)* with bright pink summer flowers. The threadlike yellow flowers of the witch hazel *(Hamamelis virginiana)* and the pungent thorny Elaeagnus *(E. pungens)* add color and perfume in the fall. Not only is there great variety among these healthy specimen plants but also great gardening. Perfectly pruned and vigilantly maintained, the plants offer year-round interest along Friendship Walk. And at the end of the walk, there is an overlook

with four statues, representing the four seasons. The bases of the statues contain the names of those friends who contributed to the garden.

Continue down the path to the fork that leads to the **Putting Green**. The closely clipped turf is enclosed with Japanese hollies that keep golf balls from rolling away. Here Mrs. Post practiced her golf game and enjoyed the viburnums *(Viburnum x burkwoodii)*, magnolias, honeysuckle *(Lonicera mackii)*, and other flowering and fragrant plants with friends and guests.

Follow the path that borders the vast lawn in front of the mansion and head toward the **Japanese-style Garden** south of the lawn. To get the full effect, follow the steps down to the bottom of the garden—and look up. What you see is a minimountain built with more than five hundred rocks and boulders to recall terraced mountain hillsides of Japan. Mrs. Post and landscape architect Shogo Myaida combined Japanese and native plant materials to create a hybrid garden typical of the 1950s and 1960s. Cascading water and meandering trails invite you to wander along the pools and bridges and take note of the sculptural features. These paths wind and circle for good reason. According to Japanese legends, a garden should have no straight lines—so that the evil spirits can't find you. Goldfish and koi swim from pool to pool. A stone tortoise and Hotei, the Japanese god

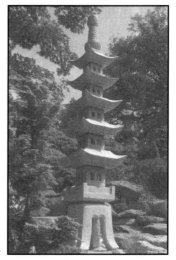

Pagoda

35

of happiness and prosperity, add typical features to the garden. Japanese pines, maples, azaleas, false cypress, and Japanese cherry trees ornament the garden through the seasons. Perhaps the most impressive plant in the garden is the perfectly shaped evergreen Japanese cedar (*Cryptomeria japonica* 'Yoshino') with bluish-green foliage that turns to bronze in winter. Though sometimes touted as the ideal evergreen, it will have to be replaced here, as it quickly outgrows the low plantings characteristic of a Japanese garden. Original plants surviving since the 1950s include dwarf Kingsville boxwood and dwarf junipers, an Alberta spruce, and a variegated juniper.

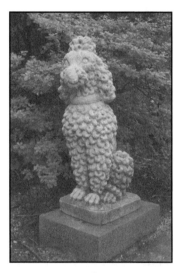

The Pet Cemetery

Return to the terrace at the entrance to the garden and head down the opposite steps and along the path. Ahead you will find two limestone poodles guarding the entrance to the **Pet Cemetery**, another of the gardens designed by Perry Wheeler. Spaniels and hounds greet you in this secluded little spot. Perhaps the most notable occupant of the cemetery is Scampi, a schnauzer whose tenure at Hillwood coincided almost exactly with Mrs. Post's. One of her favorites and her last dog, Scampi died in 1972 just a year before her mistress. The plant names in this garden reflect the sweetness of owning a pet and the grief of losing one. In the center bed are weeping dogwoods (*Cornus florida* 'Pendula'), and scattered among

the markers are dogtooth violets (*Erythronium revolutum* var. Pagoda); sweetbox *(Sarcococca hookeriana* var. *humilis)*, a groundcover that is intensely fragrant in early spring; bleeding hearts *(Dicentra eximia)*; and forget-me-nots.

From the entrance of the Pet Cemetery follow the walk up to the mansion and the **Lunar Lawn**. The site of Mrs. Post's annual garden party—a premiere social event in Washington in the years she lived here—the lawn was her favorite spot for entertaining. Surrounding the lawn were masses of tulips in spring, wax begonias in summer, and chrysanthemums in fall. A garden feature typical of the 1950s and 1960s, Mrs. Post's crescent-shaped Lunar Lawn is about as spectacular as American lawns get. Even more impressive are the dozen or so American elms *(Ulmus americana)* that border the lawn and frame the view. Symmetrical and vase-shaped, with spreading branches, these trees predate even Mrs. Post's time at Hillwood. And they all survived the Dutch elm disease that devastated many of the elms across the nation in the last half-century. Probably seventy to eighty years old, these giants tower about eighty feet and are among the oldest trees on the estate. Larger than they were in Mrs. Post's day, the trees create much more shade today—and special problems for the gardeners. As they try to replicate what was in Mrs. Post's garden, based on photos from garden parties and other events, they struggle with the shade. "We have lost many of the perennials that were here," says Liz Dolinar, chief horticulturist at Hillwood. Using photos and other records, the gardeners have mapped this section of the garden as it was in Mrs. Post's time. Plants they plan to replace include azaleas and rhododendrons as well as popular '50s and '60s varieties of peony, daylily, and iris.

Before you leave Hillwood, take time to visit the
Greenhouse. Rebuilt in 1996, it looks much as it did
when Mrs. Post lived here. Inside, a collection of more
than two thousand orchids, along with other flowering
and tropical plants in winter, are grown to provide fresh
flowers for the house and Visitor Center. Mrs. Post
devoted her greenhouse to orchids—often considered to
be the most regal of flowers—and she came here often
to enjoy the orchid collection in bloom.

As greenhouses go, this one is huge (about 20 feet wide
by 150 feet long) and is divided into five rooms. Plants
in each room require different growing conditions, and
so the rooms are categorized by winter temperatures—
Orchid West includes the Cold and Cool Rooms (from
fifty degrees at night to sixty-five degrees during the
day); the Entrance has intermediate temperatures (sixty-
degree nights and seventy-degree days); Orchid East
houses the warm growers (sixty-five-degree nights and
seventy-five-degree days). At the eastern end of the
Greenhouse is the Tropical Room, which houses plants
such as bromeliads, begonias, and bird of paradise
(Strelitzia). It overwinters here and will return to its
regular post at the porte cochere (aka the Motor Court)
entrance to the house in April. Here, too, are gardenias
and Christmas cactus and other pot plants that get
distributed around the house from spring through fall.

"The Greenhouse is a *working* greenhouse," says orchid
curator Dan Paterak. "We pay attention to the condi-
tions for growing plants rather than the ways they are
displayed." Though he has been growing orchids for
fifty years, he acknowledges that it took six years for
him to learn how to grow them. Here he grows about

twelve hundred different species and hybrid orchids. Genera include *Cattleya, Cymbidium, Dendrobium, Miltonia, Vanda, Odontoglossum, Oncidium, Phalaenopsis*, and many hybrids.

The entrance to the Greenhouse is also the *Cattleya* house. *Cattleya* (often called the "corsage orchid") along with many genera that are related to and cross easily with this genus flourish here. Several specimens of Paterak's favorite, the white, colored-lip *Cattleya*, in bloom around the room, perfume the air with their intense fragrance. Here, too, in the corner is a *Laeliocattleya* Molly Tyler 'Black River,' with a big, dark rose-purple flower, that dates to Mrs. Post's time. Fewer than a dozen of those originals survive in the Greenhouse today.

In the Cold House—filled mostly with *Dendrobiums*, the largest and most diverse genus of orchids, and *Cymbidiums*, known for their variety of colors and long-lasting flowers—there is a white *Cymbidium* Egret, unusual for its pure white petals. Another eye-catcher is the salmon-orange colored C. Clarice Austin. This handsome plant at peak bloom is displayed in the Visitor's Center, where it blooms for up to three months. In the Cool Room of Orchid West (next to the western-most Cold Room) are *Miltonia*, sometimes called "pansy orchids" for their pansylike flowers, and

Cymbidium 'Flirtation'

Paphiopedilum, the popular lady's slippers—with their cuplike lip and glittering jewel colors—which can bloom for a couple of months. Their low-light requirements and long bloom period make them excellent subjects for the indoor orchid grower. Native lady's slippers *(Cypripedium)* also grow wild in the woods and parks of Washington, D.C. At the end of the Cool Room long grayish beards of Spanish moss *(Tillandsia usneoides)* hang from the ceiling (as they do from trees in the South)—a ready supply available for the tops of pots of orchids that will be displayed around the house and museum.

For visitors strolling through the rooms of the Greenhouse, curator Dan Paterak has a few words of wisdom: Take your time and look closely. And if your visit transforms you into an aspiring orchid grower, be patient and "ready to change your life around to satisfy the growing conditions of the orchids you grow!" He points to the image of a white, colored-lip *Cattleya* pictured on a round tin propped in the window of his office. "That was my first orchid—on the lid of my mother's button tin."

BIRD'S EYE VIEW

Near the portico of the mansion, a lion wearing a crown, possibly carved in England in 1700, sits over-looking the Lunar Lawn. Like the regal elms, the panoramic view from this front side of the house is as grand a view as any estate in America offers. Standing under the mansion's portico and looking straight ahead, you can see the Washington Monument, which rises about four miles straight ahead. Framing the lawn on all sides are many magnificent specimens: masses of

evergreen shrubs, flowering rhododendrons and azaleas, and mature trees, including English and American hollies, Japanese maples, a Canadian hemlock, and a horse chestnut almost as large and about the same age as the American elms. The vista that stretches south toward the Washington Monument contains a number of large flowering shrubs: mock orange, viburnum, and weigela repeated in rows down this long sweeping expanse. Horticulturist Dolinar calls them "some of the estate's greatest treasures. Like the elms, they were popular in America in past centuries," she says, "and few people have space to grow them today."

GARDEN NOTES

The Oldest Tree — The ginkgo tree *(Ginkgo biloba)*, growing opposite the Greenhouse, is probably the oldest tree at Hillwood. It is one of the only trees mentioned on the inventory at the time of Mrs. Post's purchase of the property, and it was specimen-sized even then. The ginkgo is sometimes called the maidenhair tree because its leaves are similar to those of maidenhair ferns. Curiously, in fall, its leaves all drop at the same time.

Fresh Flowers — Eight fresh arrangements are created for the house each week in the style of Mrs. Post's era. From June through frost, the Cutting Garden provides all the materials needed to create the arrangements.

Unusual Plant — Although it's not uncommon in warmer climates, the loropetalum *(Loropetalum chinense)*—found in a sheltered spot behind the Putting Green—is an evergreen shrub with dark green, glossy foliage and spidery white flowers not often seen in local gardens.

Size: Twenty-five acres
Hours: Open from 9:30 A.M. to 5 P.M. from February through
December on Tuesdays through Saturdays, and also on select
evenings and Sundays. Hillwood is closed on holidays except
Veteran's Day.
Admission: By reservation only.
Telephone: Reservations: 202-686-5807; Toll-free 1-877-HILL-
WOOD; Office: 202-686-8500
Distance from Capitol: Five miles
Address: 4155 Linnean Avenue, NW, Washington, DC
Web site: www.hillwoodmuseum.org

DIRECTIONS

BY SUBWAY: Hillwood is a twenty-minute walk from the Van
Ness/UDC Metrorail station on the red line. From the Metrorail,
exit on the east side of Connecticut Avenue, NW, walk south and
turn left on Upton Street, NW. Turn right onto Linnean Avenue, NW.
The entrance gate is on your left.

BY CAR: From downtown in the District of Columbia, take
Connecticut Avenue north and turn right onto Tilden Street. Take
the second left onto Linnean Avenue. The entrance gate is on your
right. From the Capital Beltway, take the Connecticut Avenue exit
south. Proceed about five miles on Connecticut and turn left onto
Tilden Street. Take the second left onto Linnean Avenue. The
entrance gate is on your right.

BY BUS: Take the L1 or L2 Metrobus to the corner of Connecticut
Avenue and Tilden Street. Walk east toward Rock Creek Park on
Tilden. Turn left on Linnean Avenue. The entrance gate is on
your right.

McCrillis Gardens
Dappled Shade and Grassy Glade

The story of McCrillis Gardens is the saga of the birth of a public garden. This once-private collection of specimen plants has been transformed into a premier shade garden over the last two decades. The first azaleas flower in mid-March. Peak bloom is usually the first week of May. In addition to the outstanding azalea and rhododendron collection, choice ornamental trees and shrubs extend the flowering season. Annuals, bulbs, ferns, hostas, grasses, and shade-loving perennials add color and texture throughout summer and fall. These five acres dispel all the myths about limited choices for gardens that are made in the shade.

Dawn redwood *(Metasequoia glyptostroboides)*

In March 1941, William and Virginia McCrillis bought the house and a parcel of land that formed the core of McCrillis Gardens. William McCrillis served as assistant to Secretary of the Interior Harold Ickes in a career that spanned the administrations of Presidents Roosevelt, Truman, and Eisenhower. At about the same time, Mr. McCrillis joined the Men's Garden Club of Montgomery County. As his interest in gardening grew, so did his acquisition of land and plants. Over several years the McCrilllises bought additional adjacent lots to add to the garden. And through a friendship with George Harding, chief horticulturist for the National Park Service (Capital Region), William McCrillis began to acquire a remarkable collection, including a number of rare and unusual shrubs and trees, and extensive holdings of azaleas, some of which are no longer commercially available.

In 1978, after four decades of gardening here, and with no immediate heirs, William McCrillis left the property to the Maryland-National Capital Park and Planning Commission (to be administered by Brookside Gardens), so that the collection would be preserved. It was given to Brookside Gardens to maintain because of the rare azaleas and trees and because of Brookside's expertise in azaleas as well as in shade gardening.

The transition from private to public garden was not instantaneous. Opened to the public in 1980, McCrillis Gardens had no endowment and no gardener. For the next few years it was kept going only by the resources of Brookside azalea expert Emile Deckert, who excelled at development, and Brookside's gardening staff. Where there were woods, Deckert created paths. In reshaping the densely planted Upper Area and completely planting

the Lower Area, he moved azaleas and thinned woods. Not until 1985 did McCrillis get its first full-time gardener, Brian Barr, who was interested not just in maintaining but also in planting and in educating visitors. He was succeeded in 1990 by Pete Kapust from the staff of Brookside Gardens. Having worked earlier in the garden as Brookside's azalea gardener and as part of a roving crew, Kapust knew the garden well. He began to widen and stabilize the paths, upgrade the lawn, and work with the garden's curator, Phil Normandy of Brookside, to extend the garden season. They added color with bulbs, annuals, and perennials, and texture and contrast with grasses, shrubs, and other plants. They also

Variegated Japanese forest grass (*Hakonechloa macra* 'Aureola')

continued Deckert's and McCrillis's efforts to manage the canopy, thinning out some trees and limbing up others so that new understory trees, shrubs, and the perennials could flourish. Opening up the space, they enhanced the subtleties a shade garden has to offer—the light, the leaf patterns, the shadows, and the effects of color.

TOUR

To enjoy this shady enclave, just ramble the winding paths and trails. Look at the specimen trees. Observe the infinite shades of green. And go where the bursts of color lead you. Banks of azaleas—the oldest and most impressive planted closest to the house—flank many paths. Currently, there are more than 750 varieties of

azaleas, representing choice native deciduous species and other major hybrids, including the evergreen Glenn Dale, Gable, Kurume, Pericat, and Satsuki groups. Azaleas at McCrillis bloom early, mid-, and late spring and into June and July. Of the four thousand individual woody plants now in the garden, 60 percent are rhododendrons and azaleas—the bountiful legacy of William McCrillis. Remarkably, almost all of those are identified because Mr. McCrillis labeled all his plants.

A handy map, which can be acquired on site, will point you in the right direction for viewing some of the outstanding specimens found here. The garden is divided into two major sections: the Upper Area, which is the flat region to the left as you enter the drive, and the Lower Area, which slopes downhill to the

Hosta 'Hadspen Heron'

right. Begin your tour in the **Lower Area**. There you will find bold blooms in every season. Next to the stone walk, you'll find low-growing azaleas interplanted with shade-loving epimediums and the crinkly blue leaves of 'Hadspen Heron' hostas. Venture a bit farther into the beds beyond the house, and then head off toward the gazebo (close to number 3 on the map).

This is one of the most magical spots in the garden. Commanding attention, the Japanese umbrella pine *(Sciadopitys verticillata)* near the gazebo (number 2 on the map) is large and rare, a slow-growing symmetrical evergreen planted by Mr. McCrillis that has doubled in size in the last twenty years. Still not fully mature, this distinctive deep-green conifer is named for its needles

arranged around the branches like tiny umbrellas on a stem. Other plants nearby are also noteworthy: Across the grass path are variegated white daphnes (*Daphne odora* 'Variegata') that are exquisitely fragrant in late winter and early spring. Crossing back and proceeding a bit farther, you will find a Japanese andromeda (*Pieris japonica* 'Variegata') that is unusual because of its white-patterned leaves (number 3 on the map). Look behind it at the standard andromeda, which has attained impressive size. Close by are Kingsville Dwarf box-woods (*Buxus microphylla* 'Compacta') with densely packed leaves (number 4 on the map); at more than forty years of age they are still only about 2 x 2 feet. (In fact, this compact, slow-growing variety is often used in bonsai for exactly this reason.) The soft new golden growth on the nearby yews (*Taxus baccata* 'Aurea') in spring is yet another reason to stop and enjoy this special enclave.

A natural sculpture also occupies this corner of the garden. Where a 105-foot-tall Montgomery County champion dawn redwood once was, a jagged obelisk now stands, carved in 1993 by a bolt of lightning. (Appreciating its rough beauty, curator Phil Normandy decided to let it stand.) Proceed along the path, turning left and then right, and you will find a grove of kousa dogwoods *(Cornus kousa)*. This species offers a variety of interesting features: bark, fruits, and pointed white flower bracts (instead of rounded ones) are all distinctly different in appearance from the native dogwoods *(Cornus florida)* common to the area. The later-blooming kousas bloom and leaf out simultaneously, another difference from the natives, in mid-May. From one tree planted more than forty years ago, ten seedlings sprouted to form the lovely grove flourishing here today.

As you continue your ramble, immediately adjacent on the right are several additional specimen trees worth searching out, such as the snowbell *(Styrax obassia)* (number 6 on the map). When it blooms in late May, its fragrance is as impressive as its drooping, wisteria-like white blossoms. Take the mulched path to the left and you'll come to perhaps the rarest plant (number 7 on the map) on the whole property. The native Virginia, or silky, stewartia *(Stewartia malacodendron)* is rarely offered for sale and, unlike the Japanese stewartia, is more shrubby than treelike.

Continue forward and downhill and you will soon find a stand of trees—two large ones and some younger seedlings across the path—with huge leaves, green above and silvery underneath, and huge seed pods. These bigleaf magnolias *(Magnolia macrophylla)*, which are labeled (number 30 on the map), were an unusual acquisition for Mr. McCrillis, who seemed to prefer dogwoods. But few trees in the garden are more astonishing. In fact, one reference calls this native magnolia "the most spectacular flowering tree in the temperate zone." When you see the large white blossoms, which appear in May and June, and the out-landish leaves that can grow to more than two feet in length, you will wonder if you *are* in the tropics—and understand that these trees are not for smaller gardens. Underneath the magnolias, flowering begonias *(Begonia grandis)* offer pale pink, delicate blooms in August, when many gardens are looking past their prime. These begonias are valuable additions to the shade gardener's perennial plant list as well as being happy spreaders and easy to maintain. Hardiest of the begonias, they can endure for many years if planted in a shaded, protected place.

Farther downhill on the left (number 28 on the map) is a huge pawpaw tree *(Asimina triloba)*, which also looks like a tropical tree growing in a temperate forest. The

48

pawpaw's edible yellow mango-shaped fruits were once prized by Native Americans and are regularly enjoyed by raccoons, possums, and other woodland creatures. This native tree is frequently seen as an understory plant forming thickets in forests of the Mid-Atlantic area.

Across the garden drive lies the **Upper Area**, where photo ops for tree lovers continue. Search out the pavilion that is used for weddings, and you will enter a grassy glade. ("Glade" may seem distinctly British, rather than American, but when you see this one, you'll agree it is unquestionably a glade—a shaded, open area in the midst of dense plantings.) In the middle of that clearing (see number 54 on the map) stands a 105-foot dawn redwood *(Metasequoia glyptostroboides)*. Probably planted by Mr. McCrillis in 1952, and presumed to be a sister to the one lost to lightning (as noted earlier), it towers over all the other trees. It is remarkable not just for its age—it is perhaps among the first generation of this species distributed to private citizens—but for its extremely tall clear trunk devoid of lower limbs (the effect of having been grown in the shade). Another star stands close by. The garden's other Japanese umbrella pine *(Sciadopitys verticillata)* stands next to the wedding pavilion. Even larger (and presumably older) than the one mentioned earlier, it is perhaps the most impressive conifer in the garden and among the largest in the Washington area. Next to it, a blue China fir (*Cunninghamia lanceolata* 'Glauca') competes for that distinction (number 49 on the map).

Continue beyond these trees to the next island bed at the northern edge of the clearing, and you'll find two more uncommon sights. First, stop to observe the paired Hicks yews (*Taxus x media* 'Hicksii') in the middle of this island bed. A common foundation plant, the yews here have not been sheared or pruned as yews usually

are, and these have grown to small trees at maturity. They are grand old plants—multibranched, wide, and about twenty feet tall. Nearby is a mature leather-leaf mahonia *(Mahonia bealei)*. With sweetly scented yellow flowers in upright clusters in late winter and early spring and clusters of blue berries in May (before the birds get them), this coarse-textured evergreen is a standout. Take a right on the grass path and you'll find a rare yellow-berried American holly (*Ilex opaca* 'Boyce Thompson Xanthocarpa') (51 on the map).

Many of the most reliable of shade garden perennials thrive here, too, ringing the lawn that features the dawn redwood. Hostas, such as 'September Sun,' 'Blue Mammoth,' and 'June,' offer a range of blues and greens and golds. And the minileaved 'Ground Sulphur' is a nice contrast to the big-leaved varieties. The hellebores *(Helleborus orientalis* and *H. foetidus)* with their broad, deep green leaves provide early and long-lasting blooms from February to June. (The ferns, hostas, and hellebores found here are staples of the shade garden. With the inherent diversity of these three plants alone, a resourceful gardener could create anelegant shade garden.) Additional perennials and shrubs that give variety to any shade garden include varieties of heuchera, pulmonaria, epimedium, begonia, hydrangea, astilbe, and boxwood—all represented at McCrillis Gardens.

For a special treat, check out two exceptional new additions to the garden tucked under the trees on the side of the clearing opposite the Hicks yews: shade-loving Japanese woodland peonies *(Paeonia japonica* and *P. obovata)* brighten up the shade with their pink or white single blooms in May and attractive fruits in fall. Before you turn back to the house, look under the Serbian spruce (number 56 on map) at the corner of this bed for

the leathery evergreen fronds of the Japanese holly fern
(Cyrtomium sp.)—it's one you've probably not seen,
and it is flourishing here in its shady nook. As you
proceed back toward the house, search out the elegant
Japanese stewartia *(Stewartia pseudocamellia)* at the far
corner of this bed (number 58 on the map). Its white
camellia-like flowers appear in early summer. With an
attractive peeling bark that forms a mosaic of grays and
browns on a muscular trunk and leaves that turn gold-
orange in fall, this medium-sized tree is a prize among
understory trees.

OFF THE BEATEN PATH

Take time for a detour behind the house to see some of
the rhododendrons and azaleas that were Mr. McCrillis's
favorites. This strip of land extends to the far back edge

of the property, and as you
explore, you may feel as
though you've entered the
deep woods of the Pacific
Northwest. As you move
toward the back of the
property, you'll encounter
on your right a thicket of
tall native rhododendrons
(Rhododendron maximum).

Native rhododendron

Planted by Mr. McCrillis, these were probably dug from
the wild in the Appalachian Mountains and sold locally.
These, which tend to be fairly heat-tolerant, bloom in
mid-June. If you continue directly back to the end of the
property, you'll come to a fine specimen kousa dogwood
(Cornus kousa). As you saw in the grove of kousas in the
Lower Area, the muscled mottled bark and the tapered
white bracts (leaves modified to resemble petals) make
this a distinctive tree. The white bracts, like stars in a
patch of dark sky, last for up to six weeks—another

reason that this is such a useful landscape specimen. Near the kousa dogwoods is a tall flame azalea *(Rhododendron calendulaceum)*—another of the native species planted by Mr. McCrillis that has attained uncommon size. In May the bright yellow-orange blooms of this fifteen-foot-high azalea illuminate this shady secluded spot.

Continue beyond the compost pile to the little path that has been made by visitors from the neighborhood who take regular walks here. The path doubles back in front of a line of ten dawn redwoods, a colonnade of red single straight trunks topped by feathery green foliage. This little path under the redwoods has the character of a secret garden and too soon ends with a return to the open area where you entered.

BIRD'S EYE VIEWS

To get a view of the dawn redwoods from farther away, stand on the back terrace of the house and look toward the back of the garden. From this more distant view you'll appreciate again this stately row of trees reaching toward the sky and the splashes of color that turn on and off throughout the seasons on this garden peninsula.

For an equally dramatic view of the Lower Area, leave this flat section by the house and walk to your right down the hill along the curving path. As the slope becomes steeper, you'll find on your left a rock pile created by all the gardeners at McCrillis—treasures unearthed while planting. Climb to the top of the pile and you'll see that the land falls away and the garden extends before you. Straight ahead (number 9 on the map) is a rare variegated pagoda dogwood *(Cornus controversa* 'Variegata'), one of the most striking trees in the garden. Its horizontal branches spread wide and bear white flowers in spring; in summer its ghostly

foliage lends contrast to the green landscape. Follow the path a bit to the right and you will enter a little cul-de-sac full of perennials, autumn ferns, summer-blooming hydrangeas, and spring-blooming epimediums.

This small window into the Lower Area underscores the scope of this extraordinary shade garden. It is a garden to return to in every season—for fragrance, bloom, texture, and variety. Though it is small, you have barely begun. The many mysteries of the garden await you.

GARDEN NOTES

The Rarest Plant — The Virginia stewartia *(Stewartia malacodendron)* is a native of the forests of the south-eastern United States found mainly along the Coastal Plain. Seldom available commercially, it is a plant found mostly in the private gardens of horticulturists. Its white flowers with dark purple insides are part of its allure, despite its sometimes finicky growing habits. Found in the Lower Area, it is number 7 on the garden map.

The Tallest Tree — The 105-foot dawn redwood *(Metasequoia glyptostroboides)* growing in the Upper Area is at least fifty years old. This species, once thought extinct in its native China, was found to exist only as a very small grove in a remote area during World War II. The size of this specimen—for its age—attests to its speed of growth. It is number 54 on the map.

Daffodil Library — Daffodils are classified according to the shape of their flowers: trumpets, large cups, small cups, and so on. In the garden's Daffodil Library in the Lower Area, there are more than fifty cultivars from divisions planted along the path that parallels Greentree Road. The library begins with cultivars from Division 1,

the trumpet daffodils, (such as 'Las Vegas') and extends to Division 11, the so-called butterfly or split-corona daffodils. These drifts of daffodils bloom in mid-April, and they are surrounded by a sea of Virginia bluebells *(Mertensia virginica)*, probably "rescued" from the wild by Mr. McCrillis.

New Genus — A perennial that blooms in May or June, Solomon's seal is a favorite of East Coast wildflower lovers. Growing in moist, shady woods, it is a thing of beauty with veined leaves and arching stems lined with bell-shaped flowers. It turns golden yellow in fall and disappears after frost. At McCrillis Gardens you can now see an evergreen version: *Disporopsis pernyi* (Bill Baker Form). It is planted underneath the Japanese stewartia. Look for it near number 58 on the map.

Size: Five acres
Open: Daily, 10 A.M. to sunset
Admission: Free
Distance from Capitol: Eighteen miles
Telephone: For more information, call the Visitor's Center at Brookside Gardens, 301-962-1400.
Address: 6910 Greentree Road (off Old Georgetown Road), Bethesda, MD
Web site: www.mc-mncppc.org/parks/brookside/mccrilli.shtm

DIRECTIONS

BY CAR: From downtown Washington, take Wisconsin Avenue north to Old Georgetown Road. Go left on Old Georgetown Road to Greentree Road on left. Follow Greentree Road to the garden, across from Woods Academy School. Parking is available evenings and weekends across the street at the school or on adjacent residential streets where posted. From Maryland and Virginia, take the Beltway to Old Georgetown Road and follow directions above.

Mount Vernon
A Great Garden, By George!

For George Washington, cultivating the earth was not only "more rational" than politics but also more rewarding. "I think . . . the life of a Husbandman of all others is the most delectable. It is honorable. It is amusing and, with judicious management, it is profitable," he wrote in 1788. Designing the gardens and landscape around "Home House," as Washington called the Mount Vernon mansion, occupied him to the end of his life. There he gardened, planted, and shaped the landscape for forty-five years, beginning about 1754. Trained as a surveyor, he

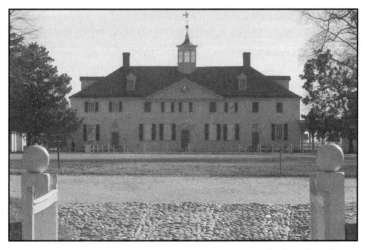

Entrance gates to the Bowling Green

*brought that eye for geometry to his own personal land-
scape. In the acres immediately adjacent to the house, he
planned the shrubberies and the groves, the lanes and
walks, the prospects up to the house and the views down
to the wide Potomac. "The curved line is Nature's gift"
was the maxim of naturalistic landscape designers of the
time, and Washington took it to heart. Influenced by
leading British landscape designer Batty Langley, author
of* New Principles of Gardening, *and his advice and
drawings on naturalistic landscapes, Washington
redesigned Mount Vernon. He rebuilt rectangular walls
into more sinuous lines, repositioned outbuildings, and
replaced the straight path leading to the house with
serpentine lanes. By the time of his death in 1799, he
had transformed Mount Vernon into a country estate
that rivaled, according to one European visitor, "the
most beautiful examples" in eighteenth-century England.*

HISTORY

George Washington was three years old in 1735 when
his father moved his family to Mount Vernon for a few
years. In 1743 Lawrence Washington, George's elder
half-brother, settled there and renamed the plantation
(previously known as Little Hunting Creek) after
Admiral Vernon under whom he served. In 1759, after
Lawrence's death, Washington leased the plantation
from his widowed sister-in-law and settled his new wife,
Martha Custis, and her two children there. Two years
later he inherited Mount Vernon following the death of
Lawrence's widow, Anne. In the 1760s he renovated the
house and developed the gardens and grounds.

In 1774 Washington launched his ambitious second remodeling of the house, which he continued despite being called away to command the Continental forces in 1775. During the eight long years of the American Revolution, Washington was at Mount Vernon for only ten days. During those war years, he corresponded regularly—often from the battlefield—with his cousin Lund Washington, who managed the plantation during his absence. At last, in 1783 Washington retired to Mount Vernon, or so he thought. For the next six years, until he was elected president, Washington applied his special talents to his own domestic scene: The house was raised to three stories; outbuildings were rebuilt; his botanical garden was started; the straight entry through the Bowling Green was reshaped into a serpentine drive; U-shaped ha-has, or sunken retaining walls, were put in; a new fruit garden below the Lower Garden was planned; and the greenhouse was built in the Upper Garden. Here at his beloved Mount Vernon, the hero who had won independence for the colonies received hundreds of visitors each year—all eager to see for themselves the great man and his country estate on the shining Potomac.

Following Washington's death Mount Vernon remained in the family for three generations—until it was bought by the Mount Vernon Ladies Association. Founded by Ann Pamela Cunningham in 1853, the MVLA recruited members to raise money for the cause. In December 1858 Mount Vernon was purchased for $200,000. With the goal of preserving the house and grounds as they existed in 1799, the year of Washington's death, the Mount Vernon ladies launched the restoration.

Begin your tour on the **West Front** of the mansion at the Circle—surveyed by Washington himself. The Circle affords not only an excellent view of the approach to Mount Vernon but also a sense of Washington's master plan. At this spot the work and leisure worlds of eighteenth-century Mount Vernon intersected. The lanes to the north and south housed the outbuildings of the working plantation—including a gardener's house, overseer's quarters, storehouse/clerk's quarters, smokehouse, washhouse, kitchen, servants' hall, and more. The vista to the west swept down the **Bowling Green** toward the entrance gate beyond. The elegant design is a tribute to Washington's vision, merging well-landscaped pleasure grounds and well-screened work buildings into a balanced and picturesque whole. Trees and shrubberies enhance the plan—making walls that create a serene and yet dramatic view.

In the eighteenth century, visitors approached Mount Vernon from the west through heavy woods, arrived at the gate, and then passed through to encounter a full view of the house from about a half-mile away. Nearing the house they passed through another gate and then continued along a serpentine drive that encircled the Bowling Green. In 1799 Reverend John Latta, a minister from Pennsylvania who visited Mount Vernon, described the Bowling Green this way: "Immediately [in] front [of] the house on the west side is a large green, containing perhaps two acres, interspersed with delightful walks and very handsome trees. From the door set out spacious serpentine walks handsomely gravelled. The one inclining to the right leads to the flower garden. The left leads to the vegetables and fruit garden. I take to the right. . . ."

As a twenty-first-century visitor, you can take that same walk—from the Circle on around the Bowling Green. This central swath of broad lawn in front of the house was one of Washington's first projects when he returned to Mount Vernon in December 1783 after the Revolutionary War. The following spring he began to level and plant the green and add trees around it. Washington secured trees from several places—from plant collector John Bartram's nursery in Philadelphia and from two other nurseries in New York. But getting trees and shrubs to Mount Vernon from that distance was chancy. Loaded and unloaded from wagons and barges, they often arrived at Mount Vernon barely alive.

So Washington had to devise other strategies to create the shaded, leafy drive he wanted. (He was no doubt prompted by Langley's advice in *New Principles of Gardening* that "without [shade] a garden is nothing.") An avid observer and collector of trees, Washington's daily ride around his five farms afforded him the chance to observe many fine specimen trees. A January 1785 journal account notes that he rode out "in search of the sort of Trees I shall want for my walks, groves, and Wildernesses." He even resorted to having trees dug out of the frozen ground—an arduous task—to keep the root balls intact and thereby increase the survival rate of the trees. He wrote in that year that he had snow shoveled away to get started with "the grading and planting" and that a muddy spring slowed down the transplanting schedule. Nevertheless, transplanting projects continued year by year. By 1789 the 417-foot-long Bowling Green was effectively framed with hundreds of trees, as well as shrubberies that filled in between the road and the garden walls on each side.

Today about a dozen of those two-hundred-year-old trees survive in the Bowling Green, including seven American hollies, a pair of tulip poplars towering about 130 feet above the green, two white ash trees, a white mulberry standing at the west corner of the Upper Garden, and a Canadian hemlock. During Washington's time hundreds of trees flourished here, lining the West Front vista and shading all who bowled or strolled on the Green. At present, about fifty species mentioned on his shrubs and trees list—including flowering dogwoods, redbuds, locusts, and buckeyes—are represented here.

To the south of the Bowling Green lies the **Lower, or Kitchen, Garden**. Just opposite the entrance to the garden a dramatic stand of English boxwood (*Buxus sempervirens* 'Pendula') marks the path. Planted in 1786, the boxwoods were probably sent to Washington by "Light-Horse Harry" Lee (Revolutionary War hero and father of Robert E. Lee). The boxwood is a reminder of Washington's reputation as a plantsman who greatly

Apple tree espaliered in the Lower Garden

enjoyed the cuttings and gifts sent to him by admirers and friends. Inside the gate another stand of English boxwood dating from the eighteenth century greets visitors. Curiously out of place in a utilitarian kitchen garden, the boxwood underscores the fact that Washington was not always ruled by practicality.

The Lower Garden, first mentioned in records of 1760, was enclosed with brick walks to protect it from deer. Later extended and reshaped into curving lines as part of Washington's redesign, the new walls were completed in 1786. In the 1930s landscape designer Morley Jeffers Williams (who restored Colonial Williamsburg gardens) re-created the Lower Garden as it was thought to be in 1799. Williams employed edgings commonly used in the eighteenth century: boxwood, along with herbs such as rosemary, santolina, lavender, and germander. On top of the brick wall are octagonal dependencies, one used for storing seeds and the other as a privy in the eighteenth century. The dipping cisterns—one round and one rectangular—were added to the garden in the 1930s because they made sense as part of the garden plan. According to garden manuals of the day, water warmed by the sun was better for plants than was cold well water—"by no Means proper for any sort of Plants."

Other aspects of Washington's efficient design are apparent here, too. Close by are kitchen, washhouse, and stable. The stable was handily situated to provide a convenient source of manure for preparing the soil and fertilizing the plants. And herbs from the Lower Garden, such as lavender for blueing and freshening dingy linens and laundry, were no doubt put to good use in the washhouse. Though the garden was sited and designed by George and his predecessors, it was Martha Washington who kept track of what was planted here in

the yearly cycle of gardening. One of her primary concerns was supplying food for the tables of a plantation that numbered several hundred, including more than 200 slaves by 1786. Additionally, she extended the full bounty of her table to a steady stream of guests. (In one year alone, 677 were counted as overnight visitors to Mount Vernon.)

The Lower Garden

In early March, gardeners were sowing carrots, leeks, onions, turnips, parsnips, beets, kidney beans, and peas. Soon artichokes were dug, and cabbage, cauliflower, and celery sown. In May strawberries were gathered. Harvesting took place through the summer and fall. Today these same vegetables and herbs are grown here along with fruit trees espaliered along the wall and cordoned onto fences to save space. Like hedgerows in British landscapes, the cordons provide an efficient and attractive living fence for garden plots. Laid out in a southeastern exposure, the grassy terraces and open beds catch available sun for most of the day.

Across the Bowling Green, the **Upper Garden** seems almost a mirror image of the Lower Garden. But records indicate that the two did not start life at Mount Vernon together. The essential Lower Garden was operating by 1762. Though mentioned as early as 1763, the walls of the Upper Garden were not finished until 1776. Like the Lower Garden, the Upper Garden is enclosed by a curved wall shaped like a cathedral window and topped with white picket fences and octagonal buildings used for storage. In his redesign of the garden, Washington

moved these octagons about 150 feet to their present positions at the apex, or pointed end, of the wall. The curved lines of the walls, so central to Washington's re-created naturalistic landscape, transformed a formal and symmetrical plantation scene into one more fashionable and picturesque—as advocated in Langley's landscape design manual. The new walls in both the Upper and Lower Garden were created in harmony with the serpentine drive around the Bowling Green and in accord with the idea that irregular and random Nature does not love a straight line.

Washington also added a **Greenhouse** or conservatory, completed in 1787, a rare addition for even the grandest estates. (It burned in 1835 and was rebuilt on the old foundations in 1951.) Holding exotics of the day, such as lemon and orange trees and oleanders, the tubs of plants were taken outside in May and returned to the greenhouse in September, as they are today. Visitor John Latta described the garden as "handsomely laid out in squares and flower knots, and [containing] a great variety of trees, flowers and plants . . . English grapes, oranges, limes and lemons in great perfection as well as a great variety of plants and flowers wonderful in their appearance, [and] exquisite in their perfume." In front of the greenhouse, two rectangular plots contain box-wood planted in a fleur-de-lis pattern, as intricate as needlepoint, and set in crushed oyster shell—a popular eighteenth-century paving. Though this formal pattern seems odd in a garden that had become much more nat-uralistic by the 1790s, a line in the papers of Federalist architect Benjamin Latrobe documents the existence of these fleur-de-lis patterns: "I saw here a parterre, . . . trimmed with infinite care into the form of a richly flourished Fleur de Lis."

Today the beds of the Upper Garden have been restored to their original locations, based on archaeological excavation. The beds hold an interesting mix: flowers, herbs, vegetables, fruit trees, boxwood parterres and hedges, and topiaries. The boxwood, originally intended as edging, has now grown to hedges—much higher than in Washington's day. The ornamental plantings are representative of what was planted here—cockscomb *(Celosia cristata)* and crown imperial *(Fritillaria imperialis),* cardinal plant *(Lobelia cardinalis)* and rocket larkspur *(Consolida ambigua)* to mention a few—though exactly what went where is not known. Though he originally grew fruit and nut trees here, Washington removed many of them to his orchard. Soon the Upper Garden came to be called the Pleasure Garden or the Flower Garden, and today it is filled with the same fragrant "lilies, roses, and pinks" exclaimed over by Reverend Latta and others in the eighteenth century.

The Upper Garden

From the Upper Garden, follow the serpentine path back to the Circle and then around the covered wings or walkways to the **East Front** of the house. A visitor of 1789 taking in this scene commented that "on either wing is a grove of different, flowering forest trees." First set out in 1776 to provide a majestic setting for the house, the North and South Groves frame the view from the long porch, or piazza. The grounds closest to the house and sloping down to the river form one of the most spectacular vistas in this or any other garden in the nation. Visitors from England who gazed down the slope to the Potomac were astonished at the wide river—so different in scale from English rivers—and "the hanging wood" poised below the house and carefully planted and maintained so as not to interfere with the amazing view. Visitor Jedediah Morse commented that "the whole assemblage . . . when seen from the land side, bears a resemblance to a rural village, . . . laid out somewhat in the form of English gardens, in meadows and grass ground, ornamented with little copses, circular clumps and single trees."

At the sides of the house, the **North and South Groves** were planted according to Washington's instructions "without any order or regularity (but pretty thickly . . .) and to consist that at the North end of locusts altogether, and that at the south end of all the clever kinds of trees (especially the flowering ones) that can be got." Today locust trees still grow in the North Grove. Near the South Grove, one of the loveliest trees is a blue atlas cedar *(Cedrus atlantica)*, planted in honor of MVLA founder Ann Pamela Cunningham when she retired in 1874. Planted irregularly, "as if Nature had placed them there with her own hand," the groves also served another important purpose: they acted as screens to all the

traffic of the north and south lanes. The ha-has, or sunken retaining walls, also separated the mansion grounds from the surrounding fields and kept cattle, pigs, and horses away from the manicured lawn. As part of his master plan, Washington could have four gates closed in the evening and protect the "pleasure grounds" and mansion from hungry wildlife, grazing livestock, and the comings and goings of the working plantation. In 1974, as part of the ongoing preservation and restoration of Mount Vernon, the land across the Potomac was turned into a four-thousand-acre park. Piscataway National Park preserves the view of the Maryland shore—which Washington handily borrowed in his landscaping scheme—so that it will always remain as expansive as it was in Washington's time.

From the Bowling Green, past the Circle, it is a short walk down to the south lane and the **Fruit Garden and Nursery**. On the way, stop to look at the recently excavated and restored Dung Repository—an essential element in cultivating gardens and fields. Then turn down the paddock road and enter the Fruit Garden and Nursery. The largest of Mount Vernon's gardens, these four acres were used for experiments that required "some space before they were adopted on a larger scale." Recently redesigned and replanted, the garden is laid out today in four squares: one of peaches and cherries; one of apples and peaches; and two more devoted exclusively to apples, such as the New Town Pippin, a variety Washington grew here originally.

Before the Revolutionary War, Washington grew grapes here—setting out two thousand grapevine cuttings in late 1771. Native varieties of winter and summer grapes were to be grapes for the table, not for winemaking. But the

grapes did not survive Washington's long absence from Mount Vernon. When he returned from the Revolution to Mount Vernon, the area where grapes had failed became the Fruit Garden and Nursery. In addition to trees and shrubs, he grew grasses and grains for seed collection. Ever frugal, Washington advised a farm manager: "to buy . . . [seeds] after the first year is disreputable."

In 1786 Washington started an orchard on this site. Interested not only in "clever" flowering trees and specimen trees for his "wildernesses" (a term used by Batty Langley to indicate plantings of native shrubs and trees), Washington set out both young saplings sent to him and mature trees from his own gardens. He planted eleven varieties of pears, four of apples, three of peaches, two of cherries, and a number of plums and damsons. The size and protective fencing made this an excellent location for an orchard, and Washington had high hopes for it. In a contract with one gardener, Washington admonished the man to "employ himself" in the grafting, budding, and pruning of the trees here to make this labor-intensive endeavor a success.

The garden was also used for experiments with hedging plants, one of Washington's pet projects. At the front of the garden you can see a "living fence" of locust saplings planted along a hand-dug ditch. The locust cuttings were started in the nursery here and then transplanted to their locations along the ditch. The impetus for living fences came from Washington's concern that "if continued on the extensive scale my farms require, . . . [cutting trees for fencing] must exhaust all my timber." Despite his best efforts and advice to his field hands, however, replacing "dead" fences with live ones never really succeeded.

BIRD'S EYE VIEW

Carefully planned and planted as it was—and continues to be by horticulturist Dean Norton and his garden staff—Mount Vernon offers many extraordinary views and vistas. One not-so-obvious but revealing view can be observed just outside the entrance to the Fruit Garden and Nursery. Standing here below the paddock, you can get a good sense of the topography that makes the Mount Vernon setting so extraordinary. Here, looking up from the road, observe how the Lower Garden rises up in terraces from the slope. Still higher is the rise on which the Bowling Green and house sit. Looking in the opposite direction down toward the Fruit Garden, you can also appreciate the dramatic descent to the river. Sitting high and dry on the wide Potomac, Mount Vernon commands a choice site. This spot demonstrates how the terrain enhances the elegance of the man-made plan. No wonder that Washington in a letter to an English correspondent in 1793 proudly declared: "No estate in America is more pleasantly situated than this."

OFF THE BEATEN PATH

Before you leave the gardens of Mount Vernon, take time for one last stop. From the paddock road, retrace your steps to the Circle and then head north to the **Botanic Garden** on the north lane between the salt house and the overseer's quarters. Tucked between the Upper Garden and the north lane, this tiny enclosure was first mentioned in Washington's accounts in 1785.

As a man of the Enlightenment, Washington believed in science and the benefits of scientific experiment. As a gardener, he needed a place to putter, propagate cuttings, sow seed, and tend new plants. Hence, the Botanic Garden or "my Little Garden," as he called it.

The only garden he actually tended himself, the Botanic Garden played a small part in Washington's grand landscape scheme but a large part in his life as a gardener. Methodical, organized, and curious, Washington used his little laboratory to see for himself what plants worked well in his soil and climate. Here he suffered failures, ran his experiments, and recorded it all in his notes. If plant experiments went well here, he called the plants "Virginia-proof" and concluded that they could survive here in the cycle of seasons and years. In 1979 the garden was researched and filled with specimens from Washington's original plant list, including partridge pea, Kentucky clover, wild oats, birding grass, common privet, acacia, and palmetto. These days the garden is often replanted as it carries on the tradition of experimentation and improvement started in this most personal of Washington's Mount Vernon gardens.

GARDEN NOTES

The Largest Tree — The white ash *(Fraxinus americana)* at the lower corner of the Bowling Green, planted in 1785, is fifteen feet in circumference. As you enter the Bowling Green, it's the first tree to the left. One of the thirteen trees that have survived from Washington's time, its longevity is all the more remarkable because white ash trees are particularly susceptible to a long list of diseases and insect pests. An easily transplanted tree, it is perhaps one of those that Washington moved from elsewhere as a sapling. Whatever its life story, this stout survivor is worth taking a few minutes to admire.

White ash
(Fraxinus americana)

69

The Tallest Tree — The pecan tree, standing next to the mansion, does not date to Washington's lifetime, but he did grow pecan trees here.

Tree-mendous Enthusiasm — In his writings, diary entries, and correspondence, Washington mentioned flowers only a few times. In contrast, his writings contained scores of entries on trees and shrubs. An inveterate planter of trees and a tireless experimenter, he sought out new species, native trees, exotic species, seeds, cuttings, and young specimens. The landscape of Mount Vernon reflects that devotion. In the 1920s there were approximately seventy survivors from Washington's era; today there are only thirteen. But an effort to clone some of these grand old trees is under way. Known as the Champion Tree Project, it is hoped that the clones—with the exact genetic codes of their parents—will replace these senior citizens.

Welcome Mat — George Washington's home has always been open to the public—when he lived here, when his descendants lived here, when the MLVA bought the house and began its restoration, and every day since then. However, 1899 was a watershed year for visitors. That was the year the trolley line began running to Mount Vernon, and people began to visit in greater and greater numbers. In 1932 the George Washington Memorial Parkway was completed and, again, the public took advantage of the opportunity.

View from the Piazza

Size: About sixty-five acres (gardens and grounds)
Hours: Open daily, 8 A.M. until 5 P.M., April through August; 9
A.M. until 5 P.M, March, September, October; 9 A.M. until 4 P.M.,
November through February.
Admission: $9, adults; $8.50, seniors; $4.50, children, ages 6–11;
$15, annual pass.
Distance from Capitol: Sixteen miles
Telephone: 703-780-2000
Address: 3200 George Washington Memorial Parkway, Mount
Vernon, VA
Web site: www. mountvernon.org

DIRECTIONS

BY CAR: From downtown Washington, cross Memorial Bridge or
the 14th Street Bridge and follow signs for George Washington
Memorial Parkway. Continue past Reagan National Airport and
through Alexandria to Mount Vernon. From Maryland, take
Interstate 270 south to the Beltway, and follow south to Virginia.
Take the George Washington Memorial Parkway exit and follow to
Mount Vernon. From Virginia, take George Washington Memorial
Parkway to Mount Vernon.

BY SUBWAY AND BUS: Take the yellow line to Huntington
Station. Then catch the Fairfax Connector bus no. 101, which runs
hourly, to Mount Vernon.

Oatlands

Piedmont Preservation

O atlands Plantation, added in 1965 to the properties of the National Trust for Historic Preservation, was the first garden to be acquired by the Trust. A 330-acre estate just outside of Leesburg, Virginia, Oatlands mingles the characters of two of its former owners. George Carter designed the house and garden in 1804 and grew fruit, flowers, and vegetables for his household. Edith Eustis, the estate's turn-of-the-century owner, restored its walls and walks—and transformed it into an ornamental garden. The two bequeathed different legacies: Carter determined the site and

Peonies in the Short Terraces

design, and Eustis set the style. The result was a 4.5-acre
walled and terraced English-style garden of boxwood
parterres. After Eustis's death, the garden slowly declined.
In 1982 the Oatlands directors, following the advice of
garden design experts, decided that the 1930s "Eustis
spirit" of the garden should be restored and preserved.
That year they hired horticulturist Alfredo Siani to lead the
restoration. Under Siani's direction the garden took on new
life. Cutting back the overgrown boxwood and opening
areas for better visitor access, Siani filled the terraces with
bloom—and visitors—and put Oatlands on the map.

HISTORY

In 1804 George Carter inherited Oatlands, one of the
largest estates in Virginia, from his father. George Carter
designed and built the house and set the garden close by.
Fussy about details, Carter took care with the axial lines
of the garden, the distance between landings, the size
and pacing of the stone steps. He placed the entrance
of the garden at the east side of the house for both
practical and aesthetic reasons. The aesthetic reason
was Carter's desire for a splendid view of the landscape.
He was taken with the beauty of the Virginia Piedmont
and the Blue Ridge Mountains in the distance. He also
had been influenced by English landscape designer
Capability Brown, who cut down trees and terraced
land to bring the surrounding landscape into closer
view. To achieve this effect, Carter had slaves cut and
terrace the hillside to create a gradual descent. (The
terraces drop about two hundred feet through six levels
of steps and landings.) The effect is dramatic: distant
fields and meadows seem to loom just beyond the
garden wall. The practical reason for all this effort was
to flatten the land for vegetable plots. By placing the
garden east of the house and tucking it into the hillside,

Carter could shelter it from the prevailing northwest winds, making it ten degrees warmer and extending the growing season for fruits and vegetables.

A century later, when Mr. and Mrs. William Corcoran Eustis bought the estate in 1903, the garden was overgrown and neglected. "When we bought Oatlands garden," Edith Eustis wrote, "it was falling into ruin. Bricks were crumbling, weeds crowding the flowers, and yet the very moss-grown paths seemed to say we are still what we were." Like her novelist cousin Edith Wharton, Edith Eustis was a gardener, and she indulged her love of gardening here.

By 1982, Head Gardener Siani was walking those paths trying to figure out how to restore the garden to Eustis's plan. For guidance on Eustis's influence on the style of the gardens, he turned to black-and-white garden photographs. But nowhere did he find plant lists to arm him in his formidable task of restoration. He did, however, find two books that proved very useful. The first, *Gardens for Small Country Houses,* written by English garden designers Gertrude Jekyll and Sir Lawrence Weaver, is thought to have been one of Eustis's trusted references. The second, *Historic Gardens of Virginia*, published in 1923, contains a chapter by Eustis in which she wrote about the "flavor of the past" that hovers over Oatlands. In it she recalled the days when America was young and President Monroe "was building his country house just three miles away."

Using the photos and the books, Siani re-created the scale of the garden—trimming back the boxwood so that it didn't overwhelm the ornamentals—and added vines and shrubs Eustis had loved back into the landscape. Today the restoration goes on as the garden staff works to maintain the Eustis spirit of the garden.

The restored gardens of Oatlands sweep down from the front gate on the eastern side of the house. Take a few steps into the garden and stop a moment to look to the east and to the south. At this nexus, you are looking into two-hundred-year-old American boxwood (*Buxus sempervirens* 'Arborescens') planted by George Carter. Along with the wisteria arbor arching over the path ahead, the boxwood shades this central axis leading down to the western wall enclosing the garden. To the south lies the other main axis. This axis borders English boxwood parterres on the left; on the right a series of colorful beds border the walk. From this central overlook you can enjoy a commanding view of the two-hundred-year-old specimen trees that dominate the garden: a pyramidal European larch *(Larix decidua)* with branches reaching up to sixty feet and a gnarled English oak *(Quercus robur)*, one of the largest English oaks in Virginia.

European larch
(Larix decidua)

English oak
(Quercus robur)

As you make your way down the steep stone stairs along the western side of the garden next to the house, look to the **Short Terraces** or small garden "rooms" on the right. They have provided one of the greatest puzzles for restoration in the entire garden. No documentation exists for what was here in Edith Eustis's time. Unlike the gardens at Monticello, for example, where everything is documented, restoring Oatlands allows for some interpretation in its restoration. In Siani's tenure here, he decided to plant the Short Terraces in bold colors. Each

bed is planted in a particular color. The first terrace is filled with orange Icelandic poppies along with boxwoods and a butterfly bush. Yellow plants dominate the second terrace: an unusual yellow butterfly bush (*Buddleia davidii* 'Sun Gold') and golden privet, a favorite of Gertrude Jekyll. The last terrace features red bloomers such as the purple and red cordyline (*Cordyline imperialis*), dark red cannas, and a single red-flowering peony, which blooms brilliantly in May. The Short Terraces stretch some 300 feet down to an old well where three English yews enclose a wide urn.

On the opposite side of this western axis, falling terraces display a series of **Boxwood Parterres**. Originally Carter planted English boxwood (*Buxus sempervirens* 'Suffruticosa') here. Later, in a more formal style, Edith Eustis added parterres of boxwood. Siani spent years trying to restore those boxwood parterres to health. Planted with ornamentals for every season, the aromatic and graceful formal terraces are today a perfect setting for wedding parties and events held in the garden.

At the bottom of the steps the **Sundial Parterre**, planted under the southern magnolias (*Magnolia grandiflora*), is the only parterre with the original Eustis boxwood. The sundial, made of rose marble, sits atop a turtle holding up the pedestal amid fragrant lilies, lush hostas, and stately wands of cimicifuga (*Cimicifuga racemosa*).

The **Mixed Border**, which runs along the southern end of the garden, is very much influenced by Gertrude Jekyll's style of landscape design. Edith Eustis loved Jekyll's naturalistic creations, and here in the Mixed Border a sense of wildness found nowhere else in the garden prevails. Ongoing research by the current staff has led to the planting of many architectural shrubs and

In the Sundial Parterre

woody plants to add interest here through the seasons. Appropriate to the formal spirit of the garden, the blowzy blooms and arching foliage are carefully contained in parterres, but the plants in the Mixed Border soften the straight, narrow path. The Mixed Border is also one of the most rewarding for summer visitors. A plant library of summer bloomers—Japanese anemones, alliums, spicy fragrant phlox, dianthus, and roses—are pruned and tended to make sure something is always flowering. The path stretches between the Teahouse at the southeastern corner and the Venetian Well at the southwestern corner of the garden.

Below the Mixed Border Edith Eustis designed the **Hourglass Parterre**, another boxwood garden in the shape of an elongated hourglass on the lower sunny southern terrace. Today this is one of the most spectacular sections of the garden, with its stately urns, recently replaced boxwood, and 'Emperor' and 'Empress' daffodils that bloomed in Eustis's time and now bloom again each spring.

At the end of the Mixed Border, the **Teahouse** overlooks a grove of oaks that is reminiscent of an English deer park. Edith Eustis called this grove "the living glory of Oatlands." The oaks recall a more pastoral era—and a bucolic countryside rarely glimpsed in this century. To the east, the view from the Teahouse frames an old barn built in Carter's time. Three stories high, it was dug into the bank below. From this viewpoint, the top story is visible. Made of brick and stone and framed in white oak grown on the property, the barn has beaded boards and pegs rather than nails and contains a small room. Edith Eustis used the room as a community clubhouse for boys and in the 1930s took the club members to the White House to meet President Franklin Roosevelt— another of her famous cousins.

Exiting north from the Teahouse, you look down a long row of cedar trees towering over an allée of boxwood. Carter used this space for vegetable gardens. A century later Edith Eustis chose to create this more formal vista, which she called the **Bowling Green.**

Continue down the green and, through a break in the boxwood hedge, you will find the **Rose Garden.** Edith Eustis moved the Rose Garden to this site in 1923. Placing it around the corner and out of the way like this, she made the rosary a kind of subtle surprise rather than a centerpiece—as roses often are in more conventional designs. Since there is little documentation on what roses Eustis grew here, choices have been governed mainly by dependability, color, and length of bloom. Siani added three circles of white, pink, and yellow roses here. Today the circles are filled with rugosas, such as 'Blanc Double de Coubert' and David Austin roses, which provide a continuous show for visitors. Records do note that Edith Eustis grew climbers such as 'Mme.

Alfred de Carriere' and 'Dr. W. van Fleet' when she
started to plant roses at Oatlands, and they are here
along with other climbers. Mrs. Eustis laid out the
rosary into two long borders with a cedar post and
chain support for 'Dorothy Perkins' climbers and
bordered that with tall boxwood. But by the time
Siani arrived, the paths were overgrown with grass.
Today the post-and-chain catenary, a garden structure
that was used in Roman times, encloses the rose garden
with climbing roses growing on three sides.

Edith Eustis built the **Reflecting
Pool** in the 1930s. Alfredo
Siani restored it in the 1980s.
Here he placed teak benches to
complement the Pompeii-style
faun overlooking the pool from
a bower of boxwood. In the
middle of the pool he added
a leaping fish to punctuate the
mood of stillness and quietude.
The bottom of the pool was
painted a restful gray-blue.
English ivy encircles the pool,
providing a frame and a simple
symmetry. Siani's attention
to detail—like Carter's—is

Reflecting Pool

evident throughout the garden and is notable here.
Nearby, winding boxwood paths in the Boxwood Grove
shelter the Carter family tomb and a shrine to one of the
Eustis daughters who died young.

Directly behind the Reflecting Pool, the **North Wall**
protects the garden from north winds and deer. Repaired
by the Garden Club of Virginia, the wall today stands
above an area planted with small flowering perennials.

Follow the path to the west and up the stone steps, and you will come to the **Herb Garden**, which sprawls over the northwest corner of the garden near the main entrance. The Herb Garden is one of the few departures from the past. Neither Carter nor Edith Eustis had a garden devoted to herbs alone, but Eustis's well-known interest in aromatic plants lives on here. Two rectangular beds on either side of the garden contain more than a hundred varieties of culinary and medicinal herbs, among them several varieties of lavender, thyme, and sage. Naturally spreading bee balm, feverfew, heliotrope, and rosemary line the walks, along with artemisia, basil, chives, mint, oregano, and tarragon. Two squares of English lavender (*Lavandula angustifolia* 'Hidcote,' 'Jean Davis,' and 'Silver Frost') attract bees and scent the air with their unmistakable fragrance. The Herb Garden was designed and installed in the 1980s by the Goose Creek Herb Guild. Named for the creek that winds through woods a half-mile away, this local garden group also hosts the annual Herb Fair at Oatlands the first week of May.

BIRD'S EYE VIEW

In this rich and varied garden there are many good vantage points. But perhaps the best and most obvious overlook is the one directly above the garden on the east, looking over the balustrade. From this upper level next to the house, the north and west axial paths of the garden and the precision and symmetry of the boxwood parterres stand out. To the south you behold Bull Run Mountain and the road that winds in fairy-tale fashion beyond the Greek Revival house. From here, too, you can take in the oak grove below the gardens.

Before you leave Oatlands, another section of the garden is worth a few extra minutes. Follow the path on the south side of the Rose Garden through the blue gate to the Cutting and Vegetable Garden. But before you go through the gate, pause a moment to look east toward the mixed wood of maples, dogwoods, and tulip poplars. It is a ten-mile view that is as magnificent today as it was in Carter's time.

Continue through the blue gate to the **Cutting and Vegetable Garden.** Probably used as a kitchen garden by both Carter and Eustis, this flat area stays reasonably wet (unlike the terraces, which dry out quickly) and has long been a favorite planting area. Today heritage tomatoes are planted after May 10, the frost-free date. But primarily

Garden tomato

this area is used to grow cut flowers for the house. In the Cutting Garden a colorful array of zinnias, roses, larkspur, sunflowers, daisies, and yarrow provides flowers for any occasion. The Cutting Garden is at its best from midsummer through early fall. Here, too, is a vine-covered rustic gazebo (made from cedar grown on the property). Resting here you can contemplate the flowers and the middle distance and consider a walk in the oak grove if you want to soak up a bit more of the peace that is Oatlands.

The Rarest Plant — In the meadow just outside the garden wall, a field of wild tulips *(Tulipa sylvestris)* blooms in mid-April. These rarely seen, sweetly scented, lemon yellow tulips have naturalized here and carpet the ground year after year.

The Oldest Tree — The English oak *(Quercus robur)* that sits at the eastern end of the Boxwood Parterres has grown here for centuries. No one knows exactly how long. But it probably dates to George Carter's years at Oatlands, in the early 1800s. This venerable oak, widely used in Europe, with its classic lobed rounded leaves and shiny long acorns, leafs out to a lustrous dark blue-green in summer and spreads its branches as wide as it is tall.

Season's Greetings — Look for the peonies in spring, the spider lilies in summer, and the crocuslike *Sternbergia* in fall. They are some of the most spectacular seasonal bloomers at Oatlands.

Greenhouse — Built by George Carter in 1810, the greenhouse is the second oldest standing greenhouse of its kind in the United States. Since greenhouses were extremely unusual in the nineteeth century and clearly a mark of status and wealth, Carter placed his just inside the original garden gate so that it was the first building visitors saw as they entered. He grew exotic fruits and vegetables here, including strawberries and asparagus. During the early 1900s, Mrs. Eustis updated the greenhouse by installing a state-of-the-art heating system. She propagated boxwood and many other plants here. She also planted the two Japanese maples that still flank the greenhouse doorway.

Size: 4.5 acres
Hours: Open daily April through December, except
Thanksgiving, Christmas Eve, and Christmas Day, Monday
through Saturday, 10 A.M. until 5 P.M., Sunday, 1 P.M. until 5 P.M.
Admission: $7, gardens and grounds only
Distance from Capitol: Forty-four miles
Telephone: 703-777-3174
Address: 20850 Oatlands Plantation Lane, Leesburg, VA
Web site: www.oatlands.org

DIRECTIONS

BY CAR: Oatlands is located six miles south of Leesburg on Route
15, approximately forty minutes from Washington, D.C.
From D.C./Arlington, take Interstate 66 West to exit 67 (Dulles
Airport) to 267 West (toll road) to Leesburg. Take exit 1A, then the
second right (15 South Warrenton). Oatlands' front gates are five
miles on the left. From Fairfax, take Route 50 to Route 15 North at
Gilbert's Corner. Turn right (north). Oatlands' front gates are six
miles on the right. From Baltimore/Frederick, take Interstate 70 West
to Frederick. Then follow Route 15 South to Leesburg Route 15
bypass to 15 South Warrenton. Oatlands' front gates are five miles
on the left.

River Farm

From George Washington to the American Horticultural Society

River Farm has something for just about everyone. For history buffs, it is the connection to George Washington, one of America's first horticulturists. For horticulturists, it is the excellent information and services offered by the American Horticultural Society, headquartered here. For birders and wildlife lovers, there are populations of blue-

Two-hundred-year-old Osage orange, above the Long Border

birds and ospreys and hawks and eagles, as well as red foxes, rabbits, and more. For youngsters, the Children's Garden is a dig-in-the-dirt treat. For shoppers, the annual spring plant sale is one of the best in the area. And for the rest of us plant lovers, twenty-five acres of trees, shrubs, bulbs, annuals, and perennials advance the mission of the American Horticultural Society to "make America a nation of gardeners, a land of gardens."

HISTORY

The question most often asked about River Farm, owned by George Washington from 1760 until his death in 1799, is, "Did he live here?" The answer is no, but he did work the land. River Farm was the northernmost of Washington's five farms (located about four miles from Mount Vernon). Here Washington planted wheat, rye, and corn—and perhaps the walnut trees growing in the meadow down by the Potomac. Washington, however, was not the first owner of the farm.

The first English owners of River Farm were the Brent family, relatives of Lord Baltimore, the English king's proprietor in Maryland. Their story goes back to the 1690s. Mary Brent was a Piscataway Indian princess who had been given a grant of eighteen hundred acres, called Piscataway Neck, that included what is now River Farm. It passed through several generations of the Brent family and then became the site of a busy and well-known ferry business, known as Clifton's Ferry, which connected to the main thoroughfare between Georgia and New York. The land was put up for sale by William Clifton, who owned the ferry, in 1755. George Washington acquired the eighteen hundred acres for 1,210 pounds sterling in 1760.

In 1773 Washington leased the farm to Tobias Lear, his personal secretary. Lear lived there with his wife, Fanny Basset, who was a niece of Martha Washington. Later, Washington willed Lear the use of the farm, rent free, for his lifetime. After Lear's death the farm was occupied by two generations of the Washington family. In 1859 a nephew of George Washington sold about a third of it to three Quaker brothers, named Snowden, from New Jersey. That third was divided and resold again several times until the present twenty-five acres was purchased in 1919 by Malcolm Matheson, who turned it into an elegant country home. Through a generous gift from philanthropist and garden lover Enid Haupt, the American Horticultural Society was able to purchase the twenty-five acres in 1973 and make River Farm its national headquarters.

TOUR

Begin your tour at the front door of the house. Around the front door, the **Entry Court** holds many native shrubs, trees, and groundcovers. The most notable of these are three shrubs that are among the best and most dignified natives for area gardens: Virginia sweetspire (*Itea virginica* 'Henry's Garnet') with racemes of white flowers in summer and purple-red autumn leaves; another large shrub known as fringetree *(Chionanthus virginicus)* with fragrant white flowers borne on panicles; and dwarf fothergilla *(Fothergilla gardenii)*, also known as bottlebrush, bearing white flowers—that look exactly like bristly brushes—in early spring. Additional shrubs such as Oregon grape holly *(Mahonia rotundifolia)* with yellow flowers and blue berries, and nonnative English boxwood *(Buxus sempervirens* 'Suffruticosa') make this bed next to the house a model for anyone contemplating candidates for a shrub garden.

Another extraordinary view here close to the house is of the tulip poplar tree *(Liriodendron tulipifera)*—so named because of its tulip-shaped leaves—towering above the house near the front door. A popular tree in Washington's time, tulip trees, our tallest native hardwood, once grew thickly from Massachusetts to Florida and Mississippi. These giants can grow to 190 feet and have been cultivated since 1663. This one is about eighty years old.

South of the house lies the George Harding Memorial **Azalea Garden.** Planted and maintained by the Azalea Society of America, this garden presents some seven hundred (all labeled) of the best and most colorful azaleas and more than four hundred different cultivars. Volunteers who work regularly in the garden point out that outstanding cultivars include 'Acrobat,' 'Quakeress,' 'Kazan,' 'Copperman,' and 'Betty Ann Voss.' (Home gardeners, take note!) Perhaps the most hybridized and experimented-on shrub in the world, azaleas present a pleasantly daunting task to anyone trying to decide which to cultivate in a home garden. This garden plot helps to sort through the possibilities.

Early-blooming azalea
(Rhododendron roseum)

Planted among the azaleas are a number of interesting specimen trees, including snow bell *(Styrax japonica),* bass wood *(Styrax obassia),* and river birch *(Betula nigra* 'Heritage') with salmon-brown and cream-colored peeling bark. This particular cultivar, 'Heritage,' has

earned superstar status as one of the very best, with glossier leaves, better color, cold hardiness, and a number of other virtues. Patented by its breeder, 'Heritage' is considered a superior plant and vaulable addition to landscape gardening. Another extraordinary tree found here among the azaleas is the rare dove tree *(Davidia involucrata)*. This native of China is described by enthusiasts as "the most handsome of flowering trees." Also known as the handkerchief tree, its white blossoms seem to flutter down from their stems in mid-May like handkerchiefs (or some say doves). Arborists note, however, that it has the bad habit of not flowering every year and being slow to flower. Some trees may not flower for ten years. But both of the dove trees at River Farm were in full bloom in 2003.

Head east toward the river and you will come to the **Ha-ha Wall and Meadow.** The ha-ha, or sunken fence, found here was a popular garden feature in the eighteenth century. (There is also one at Mount Vernon.) Ha-has were designed for both aesthetic and practical purposes. Aesthetically, they preserved the flowing lines and sweeping vistas that landscapers of the period desired. And since wildlife and livestock were not welcome in manor gardens, the sunken fence served the practical purpose of keeping out the animals without sacrificing the view. Ha-has were supposedly named for the cry of surprise let out when strollers discovered they had come to a hidden fence. This ha-ha, to the east of the house, preserves the stunning view to the Potomac and borders the meadow below.

The **Meadow** is planted with native grasses and flowering perennials, and 40,000 native meadow plants are currently being added. It is mowed once a year in early winter to keep down woody plants. Otherwise, it is left untended and uncultivated. It attracts and provides

88

habitat for wildlife, which abounds here at River Farm partly because of the emphasis placed on integrated pest management and organic practices. Sightings of red foxes and their kits, along with resident ospreys, bald eagles, and bluebirds make this a popular overlook. At the far edge of the meadow are two large black walnut trees *(Juglans nigra)* thought to date to the late eighteenth century when George Washington owned the farm. Other trees bordering the meadow include oaks and sycamores.

Behind the house, just outside the ballroom, lies the **Ballroom Terrace** and **Long Border**. As you would expect of a centuries-old country estate, the terrace is bordered by English boxwood (*Buxus sempervirens* 'Suffruticosa'), still considered the gold-standard, "true" edging boxwood. There are specimens here more than a hundred years old. The boxwood edges the terrace on the river side in a long, tall drift of billowy hedge. A hedge as tall as this one (about three feet) can take up to 150 years to grow. Near the hedge is a Kentucky coffee tree *(Gymnocladus dioica)*, one of George Washington's favorites. He introduced the species to Virginia after one of his surveying trips to the Ohio River Valley and successfully germinated seeds he collected there. The seeds were roasted by Native Americans and ground up as a coffee substitute by early European settlers.

On the opposite side of the terrace, the **Long Border** features shade-tolerant shrubs and perennials such as Lenten roses *(Helleborus spp.)*, an exquisitely fragrant daphne *(Daphne odora)*, and epimediums, along with native oakleaf hydrangeas *(Hydrangea querquifolia)*, sweet pepperbush *(Clethra alnifolia)*, tree peonies *(Paeonia suffruticosa)*, and phlox *(Phlox divaricata)*. Spring bulbs include tulips and daffodils. Along the brick wall a number of ivy cultivars are espaliered.

At the back end of the Terrace and Long Border is the
Annual Border, which is planted with more than fifteen
hundred tulips in spring. The gardeners at River Farm
change the border seasonally. During the summer it is
planted with tropicals and annuals. Directly across the
lawn from the Annual Border is the **Fragrance Garden**,
which includes roses, rosemary, lavender, thyme, sage,
catnip, and clove-scented dianthus. Another interesting
inhabitant of the Fragrance Garden is a quince tree
(Pseudocydonia sinensis), with beautiful bark and large
egg-shaped citron yellow fruit. In earlier times aromatic
quinces were placed in bowls to perfume a room.
Quince fruit can also be used to make jams and jellies.

Continue north along the rose trellis walk and you will
come to the **Children's Garden** with wonders that would
entice Alice. First stop: the Maze. And it is a real maze.
Kids enjoy finding their way through the daffodils in
spring and sunflowers in summer. In spring, more than
a thousand daffodil bulbs, representing nine cultivars
('Fortissimo', 'Spring Pride', 'Accent', 'Spellbinder',
'Delibe', 'Holland Sensation', 'Bridal Crown', 'Mary
Bohanon', and 'Ice Follies') are planted here, with the
help of volunteers.

Children's Garden

Next stop: Beau Beau's Garden. The garden pays tribute to Dr. H. Marc Cathey, president emeritus of AHS, and his example of passing on a love for plants to younger generations. Beau Beau is his granddaughters' nickname for him. The animal topiaries and colored flags represent his granddaughters' favorite colors and animals. Designed on a pint-size scale, the garden welcomes little people in a range of ages and sizes.

On the way to the Alphabet Garden, kids might want to stop off at the Butterfly Bed. A combination of trees and perennials attractive to butterflies grow here: an elm tree (*Ulmus americana* 'Princeton'), a birch tree *(Betula jacquemontii)*, and other plants nurture caterpillars and the emerging butterflies.

The Alphabet Garden, where big plastic alphabet letters are "growing" among the plants, is a long border on the western side of the Children's Garden. In addition to emphasizing the importance of learning the alphabet, its special feature is the plot where kids can dig up worms and learn how they help to aerate the soil and keep plants healthy. Children are encouraged to put the worms back in the dirt after they have held them. They also like to touch the weeping pussy willow for good luck, and notice that the alphabet is not in proper order.

The Boat Garden—designed around a skiff like the ones that once could be seen from River Farm sailing on the Potomac—and the Bat Cave are additional garden displays that give kids a chance to interact with and think about the environment. Like the rest of River Farm, they help kids begin to see and appreciate the links between plants and people.

Fruit of the Osage orange
(Maclura pomifera)

Head back toward the house and you will come to the area called **Garden Calm,** dominated by a huge Osage orange tree *(Maclura pomifera).* This tough, durable native tree in its tranquil setting here does indeed induce a feeling of calm and serenity. Thought to be about 200 years old, the tree is the second largest Osage orange tree in the United States. (The oldest and largest is at colonial patriot Patrick Henry's home in Brookneal, Virginia.) The tree is believed to have been a gift from Thomas Jefferson to the Washington family. Jefferson is known to have received seedlings of the Osage orange (named for the Osage Indians of Missouri) from the Lewis and Clark Expedition of 1804–1806.

Along with this magnificent specimen, the trees in this shade garden are among our most distinct and beautiful deciduous trees. Another example is the ginkgo *(Ginkgo biloba),* one of the oldest known trees (growing on Earth for some 150 million years), which exhibits magnificent fall color and adapts to almost any soil and situation. Another great native tree found here is the sourwood *(Oxydendrum arboreum).* Truly an all-

season ornamental, it has white flowers in June and July and spectacular fall foliage that turns pinkish-red, yellow, and purple, often all at the same time. But this garden doesn't stop with trees. It includes shrubs, such as the oakleaf hydrangea, also lovely in spring and fall, and a bevy of early spring bulbs: hundreds of daffodils, crocus, and fritillaria *(Fritillaria meleagris)* with bell-shaped flowers in a checkered pattern! Garden Calm is a fine place to sit and consider the riches of River Farm.

OFF THE BEATEN PATH

Down the hill toward the river, in the northeastern corner of the garden, is the **Franklin Tree Grove.** Though it is easy to miss, it is perhaps the most extraordinary garden at River Farm. Three Franklin trees *(Franklinia alatamaha)* grow here. Extinct in the wild, these small trees (they grow to about twenty feet) have handsome fall foliage and perfect, five-petaled, white flowers in late summer. This aristocratic tree was discovered in 1765 by John Bartram, considered the Father of American Botany. Bartram, who established America's first botanical garden in Kingessing, Pennsylvania, found the tree along the Altamaha River in Georgia and collected a few for his garden. By 1800 it had disappeared from the wild. Supposedly all plants in commerce today are derived from Bartram's original collection. Bartram named the tree for his friend Benjamin Franklin, who published several pieces by Bartram in his almanac and with whom he exchanged seeds and information. Franklin trees are valued for their showy flowers and fall color, but they don't establish well. Look long at the beautiful specimens here, for you are likely to find *Franklinias* only in arboretums or through special circumstances. They are the white tigers of the plant world.

BIRD'S EYE VIEW

From the front room of the house or from just above the ha-ha, the view of the Potomac is the best on the planet. Even better than the view of the Potomac from Mount Vernon—which is saying a lot—this prospect of the shining river is worth the trip to River Farm. The meadow, too, is a lovely sight. It is alive with activity: bluebirds, sparrows, and Eastern kingbirds busily hunt insects for their young, and hundreds of butterflies search out nectar from the native meadow flowers. Keep looking up and you may see the bald eagles soaring—or just sitting in the sycamore tree.

GARDEN NOTES

Pawpaw Tree — In addition to its distinctive name, the pawpaw *(Asimina triloba)* is also unique in being the sole food source for the zebra swallowtail butterfly. Animals, such as raccoons, also seem to relish its fruits, which are fragrant and have the texture of a banana. Look for it just outside the Gift Shop.

Bulb Central — In spring the bulb display is one of the most extensive in the area. It starts in March, with scilla *(Scilla siberica)*, crocus, and *Chionodoxa*, also called glory-of-the-snow for its early bloom. Those small beauties are followed by tens of thousands of tulips and daffodils. The variety and quality is notable.

Annual Plant Sale — The River Farm plant sale is held each spring during Virginia Garden Week. The plant sale continues to grow and expand each year. Among other offerings, you can get hard-to-find perennials, native plants, trees, shrubs, and annuals along with expert advice from the AHS staff and numerous vendors from around the region. It is also a good

time to acquaint yourself with interesting combinations of perennials, shrubs, and trees in the garden. River Farm is a horticultural showcase for environmentally responsible gardening.

Size: Twenty-five acres
Hours: Open daily April through September, Monday through Friday, 8:30 A.M. until 5 P.M., Saturdays, 9 A.M. until 1 P.M.
Admission: Free
Distance from Capitol: Eleven miles
Telephone: 703-768-5700; Toll free 1-800-777-7931
Address: 7931 East Boulevard Drive, Alexandria, VA
(off the George Washington Parkway about halfway between Alexandria and Mount Vernon)
Web site: www.ahs.org

DIRECTIONS

BY CAR: From the Outer Loop Beltway traveling east, exit Route 1 North to the first traffic light; go right on Franklin Street. Go three blocks and take a right on Washington Street, which becomes the George Washington Memorial Parkway at the south end of Alexandria. Drive four miles, pass under a stone bridge, and take the next left, following signs for East Boulevard Drive. Follow signs to River Farm. From the Inner Loop Beltway traveling west, take the Old Town/Mount Vernon exit and follow signs to Mount Vernon, the very first exit after the Woodrow Wilson Bridge. Follow the exit to the traffic light, and make a right onto Washington Street, which becomes the George Washington Memorial Parkway at the south end of Alexandria. Drive four miles, pass under a stone bridge, and take the next left, following signs for East Boulevard Drive. Follow signs to River Farm.

Tudor Place

Where Six Generations of the Peter Family Flowered

T udor Place sits high on the crest of a hill in Georgetown overlooking the Potomac River. Opened to the public in 1988, the house and gardens maintain the structure given them during the Federal period. Yet Tudor Place is not a period garden—nor is it meant to be. It is a very personal garden created by a family who did most of the work themselves. And it is a special kind of living museum—a landscape

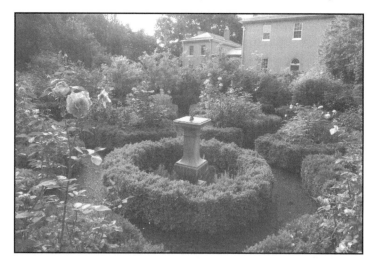

The Flower Knot

built in layers over two centuries. The property of the Peter family since 1805, the estate's 5.5 acres offer an exception to the here-today-and-gone-tomorrow tradition of American demographics. Until 1983 Tudor Place had been in the hands of the Peter family for six generations. Here you can feel the presence of that family, with its distinct personalities and tastes, developing through the generations. Thanks to Armistead Peter III, who established the Tudor Place Foundation, the grand old place lives on.

HISTORY

Tudor Place's last occupant, Armistead Peter III, could in just a few leaps trace his lineage back to George Washington. Born in 1896, Peter spent his childhood at the knee of his great-grandmother, Britannia Wellington Peter Kennon. For Britannia Kennon, it was an easy step back in time to the Great Man himself—her mother was one of George Washington's four step-grandchildren and the first mistress of Tudor Place. (Born at Tudor Place in 1815, Britannia inherited the home in 1854 and remained its mistress until her death in 1911.) Though various members of the family contributed to the garden over the years, it was shaped mainly by the efforts of Britannia and Armistead. In 1969 Armistead Peter endowed the estate and gave a scenic easement on the property to the Department of the Interior. His preservationist motives were clearly expressed in his memoirs. There he quoted Ann Pamela Cunningham, the woman who led the battle in the 1850s to preserve Washington's Mount Vernon home: "Though we slay our forest, remove our dead, pull down our churches . . . let no irreverent hand, no vandal hand desecrate [this place] with a finger of progress."

The **South Lawn** is a good place to start a tour of Tudor Place. Across the football-field expanse, an enormous white oak *(Quercus alba)*—which sprouted in the stump of a locust tree around 1875 according to family journals—and a majestic tulip poplar *(Liriodendron tulipifera)* dominate the eastern edge of the property. The tulip tree, probably planted when the Peters first laid out the garden, may be the most remarkable tulip poplar in the entire country; it has sinuous branches like an oak and an unusual rounded (instead of the more typical upright) crown. More than 100 feet tall and 20 feet in circumference, it is has been designated a landmark tree for the District of Columbia. Also on the South Lawn, near the western end of the house, a pecan tree planted by Britannia Kennon around 1875 spreads its branches.

These large specimen trees help give Tudor Place the ambience of a southern landscape garden and its feeling of oldness. Particularly in winter, you can appreciate the mature garden that doesn't depend on flowers. Around the South Lawn's boundaries stand hollies, magnolias, and various evergreens. The family began adding this screen in the 1920s. Today it is a living wall, shielding the house so effectively from city traffic and noise that it's hard to believe you're in Georgetown.

Another interesting feature of the South Lawn is its shrubberies. Island beds such as these punctuating an open expanse are characteristic of a naturalistic style first popularized in England by Capability Brown in the eighteenth century. The beds, planted with a variety of old-fashioned flowering shrubs, add to the feeling of a rural southern landscape. The shrubs include quince *(Chaenomeles)*, mock orange *(Philadelphus)*, Carolina

allspice *(Calycanthus)*, and lilac *(Syringa)*. In one bed a cloud of pink puffs— the flowers of several large smoke trees *(Cotinus coggygria)*— catch the sun. One is growing in a slightly horizontal fashion. According to family records, it was toppled by a storm in 1947. Today its low-growing branches add their footnote to history.

Sprig from the smoke tree *(Cotinus coggygria)*

Yet another hallmark of Tudor Place is its old roses, which are found in nearly every section of the property. Among those on the south side of the house is 'Old Blush,' a medium pink china rose *(Rosa chinensis)* that has bloomed here for nearly two hundred years. It was planted by Martha Peter in 1815. This South Lawn view of Tudor Place with lush old roses on either side of its domed neoclassical portico offers a glimpse of the Federal period when Tudor Place was built.

Extending that glimpse of another era is the graceful **Conservatory,** next to the portico, with three large floor-to-ceiling windows. For almost two centuries, pots of southern hothouse favorites, such as gardenias, hibiscuses, and oleanders, were overwintered here and then brought outside in May to soak up the sun. One longtime conservatory resident, a sago palm *(Cycas revoluta)*, is displayed in a huge wooden tub in spring and summer on the eastern side of the house. It is the third-generation descendant of a plant purchased in Philadelphia in 1813 by Tudor Place's first owners, Martha and Thomas Peter.

As you continue around to the north side of the house, a gravel drive and the **North Garden** come into view. At the end of the vista that sweeps up from the entrance gate is a circle of luxuriant mounded boxwoods (*Buxus sempervirens* 'Suffruticosa'). **Box Circle**—dating back to about 1805—emphasizes the balance and order so typical of Federal-period tastes. Hidden inside the boxwood is a locust stump, once used for tethering the horses that brought visitors and carriages up the drive. From Box Circle the North Garden fans out east and west and is divided into several sections: the Flower Knot, the Circle Garden, the Orchard, the East Garden, and the Bowling Green.

Set inside a French parterre of clipped boxwood, the **Flower Knot** borrows from garden design traditions that date back to the Renaissance. The quadrants of the Flower Knot are crisscrossed by paths that divide it into sixteen small beds. (Like two big X's in a large rectangle, which is further subdivided into squares and rectangles.) The Flower Knot's sixteen smaller interior beds, which are bordered with boxwood, are planted with old-fashioned perennials. Growing alongside the perennials are many fine roses—including moss, shrub, hybrid tea, and old musk roses as well as a floribunda rose (*Rosa* 'Gruss an Aachen') that was a favorite of Armistead Peter's wife.

The **Circle Garden**, a rectangular plot north of the Flower Knot, was a vegetable garden in the early 1900s. Armistead Peter redesigned the garden and laid the brick himself. The moss-covered brick encircles a central dogwood tree *(Cornus florida)*. The outer beds contain many of the shrubs the family planted over the years, including summersweet and rose of sharon.

The **Orchard**, a rectangular plot east of the Circle Garden, was devoted to apple and pear trees during the Federal period. Today apple trees are espaliered along the north side of the garden. The history of this area is the most undocumented in the garden. A historical study is underway to determine the period of significance in the garden and what was put in after the family lived here.

Part of the shaded **East Garden**, at the eastern edge of the property, was once a lawn tennis court. Much has been changed here since the era of Britannia Kennon. Originally a peach orchard, the area was leveled and turned into a tennis court about 1885. President Grover Cleveland used to pause and watch the games on his way from the White House to his summer home in what is now the District of Columbia's Cleveland Park residential section. The tennis court was removed in the early twentieth century, and the sweeping lawn was created with a screen of white pine, American holly, and magnolias, including a spectacularly large saucer magnolia *(Magnolia x soulangiana)*. Here magnificent crape myrtles and hydrangeas add seasonal displays of color. The last owner, Armistead Peter III, purchased the garden's four limestone pedestals in Venice. Today they hold colorful pots of summer annuals.

East Garden

Along the pea gravel paths to the west lies the former **Bowling Green,** where the family once bowled down an open lane of green. Now it is primarily a green-and-white garden that includes a lily pond. White-edged hostas and liriope, variegated dogwoods, and potted white impatiens are twentieth-century additions. And boxwood that Britannia Kennon removed from the original Flower Knot still prospers here along the Lower Walk bordering the Bowling Green.

If you wind your way along the **Lower Walk,** on your way back to Box Circle you will come face-to-face with one of the problems that the horticulturists who oversee Tudor Place have to ponder in maintaining this living museum. Behind a fountain featuring a large sculpture of a lion, an old European horse chestnut was dying a few years ago. The gardeners decided not to replace it. Today in its place is a yellow buckeye *(Aesculus octandra)* that now stands more than twenty feet tall. (It is an American cousin of the European horse chestnut.) As a stricter view of garden restoration has come into favor, the horticulturists at Tudor Place must decide whether to keep the buckeye or plant something more in keeping with the garden's history, something planted when the family was in residence here.

OFF THE BEATEN PATH

In this garden of delights, the **Summer House** is a spot that might easily be overlooked. Among the many plots and paths, this special niche offers a wonderful thinking post. Situated at the northern end of the garden above the Bowling Green, the view from the Summer House is framed by two graceful stone whippets guarding the Green. Presumably, the Peter family and their guests of an earlier era enjoyed spirited games here on many a pleasant afternoon. The lush lily pond at the opposite

end of the Green had its handsome sculpture added in the early twentieth century. A bit formal, like the Peters themselves, and reminiscent of many ages in the life of this quintessentially American family, the view from the Summer House shows many sides of a garden that is as elegant and beautifully alive today as it ever was. It was Armistead Peter's favorite section of the garden, and it may be yours as well.

Stone whippet in the Bowling Green

BIRD'S EYE VIEW

A good place to admire the entire North Garden is from inside the house—from the center window of the upper hall. From there the formal paths of the garden stand out. The north-south axial path that divides the garden into quadrants aligns perfectly with the circle of boxwoods and the front entrance of the house. Perhaps the most interesting part of the view from the second-story window is the Flower Knot. Originally the knot lay across the garden path in the southeast corner, but during the Civil War trespassers plundered the boxwood when the family was away. Indignant at this invasion, Britannia Kennon moved most of the remaining boxwood several hundred feet west to the Lower Walk. Then the plan for the Flower Knot was lost. But in the 1920s, Armistead Peter discovered that another member of the family had copied the design at her Virginia estate. Hence the Peters were able to reconstruct the garden, albeit in a new location. The center of the original design featured a laburnum tree with chains of golden flowers. The latter-day Peters chose to fill the spot with an old sundial from

Crossbasket Castle, the family's ancestral home in Scotland. Today lavender flourishes at the base of the sundial pedestal, successfully mixing the past and present in the ongoing story of Tudor Place.

GARDEN NOTES

Looking Back — Neat rows of petals layer the crinkled pink flowers of the Brazilian plume plant *(Justicia carnea)* displayed in a big pot on the arbor terrace adjacent to the South Lawn. Given to Britannia Kennon by an admirer, it is an example of a nineteenth-century plant that is rarely seen today.

The Oldest Pot Plant — The sago palm *(Cycas revoluta)* that sits in a tub on the eastern or southern side of the house in spring and summer is the descendant of a sago palm that was planted in a tub here at Tudor Place nearly two hundred years ago. A receipt for the purchase of the sago palm in Philadelphia is part of the family's garden records.

The Oldest Tree — The tulip poplar *(Liriodendron tulipifera)*, also called tulip tree and tulip magnolia, on the south side of the house has surpassed all expectations for this species. Taller, older, and stronger than most tulip poplars, it has survived many storms and many generations who have lived beneath its branches. Nor has it exhibited the problem of being weak-wooded as many tulip poplars are. Once common in the forests of the southern Appalachians, this gentle giant is probably close to two hundred years old.

Local Lore — Thomas Peter, who married George Washington's step-granddaughter Martha Custis, was the son of the first mayor of Georgetown. When Martha and Thomas Peter lived here, they could look out their south-facing windows to the ships sailing up the Potomac into the harbor of Georgetown.

Size: 5.5 acres
Hours: Open daily, Monday through Saturday, 10 A.M. until 4 P.M., Sunday 12 noon until 4 P.M. Closed the month of January.
Admission: $2, for self-guided garden tour
Distance from Capitol: Four miles
Telephone: 202-965-0400
Address: 1644 31st St., NW, Washington, DC
Web site: www.tudorplace.org

DIRECTIONS

BY CAR: From Northern Maryland, take Interstate 270 South toward Washington. Exit left at Route 355 (Wisconsin Avenue). Stay on Wisconsin Avenue for six or seven miles (fifteen to twenty minutes) and go past the National Cathedral. Make a left turn onto Q Street. Go two blocks. Make a left onto 31st Street. Tudor Place is located at 1644 31st Street, NW. Look for the large gate and tour entrance on left. From Northern Virginia, cross Key Bridge (stay in the right lane). Turn right onto M Street and continue through three traffic lights, crossing Wisconsin Avenue. At the third light, turn left on 31st Street and continue for six blocks. Tudor Place is located at 1644 31st Street, NW. Look for the large gate and tour entrance on the left.

Brookside Gardens
Hot Plants, Cool Combos

Brookside is for inspiration. Stroll this rolling wooded landscape—and gardening ideas will come as rapidly as photosynthesis in spring. The many collections of Brookside showcase ingenious ways of combining plants in designs scaled to home gardens. Beds display hardy species tested for the Mid-Atlantic region and offer practical solutions for area gardeners. Brookside isn't just glorious collections of trees, shrubs, azaleas, grasses, and bulbs—it's also about how you can capture some of that glory in your garden.

Azalea Garden

HISTORY

As part of a forward-thinking green space strategy,
Brookside Gardens was established to combat sprawl in
Maryland's fast-growing Montgomery County after
World War II. In the early 1960s the county purchased
some 28,000 acres and turned 500 acres into Wheaton
Regional Park. About 50 interior acres were set aside
for the formal and informal public display gardens that
are today Brookside Gardens. As early as 1965, discus-
sions began at the Maryland-National Capital Park and
Planning Commission for an arboretum or display gar-
den for this booming suburb. Long before opening day
on July 13, 1969, scores of designers worked to create a
green oasis for Montgomery County, a burgeoning bed-
room community outside the nation's capital.

In 1972 Brookside began a second growth spurt. A
Fragrance Garden—first designed with Braille signs,
textured walkways, and fountains that shot up when
touched—was added. The Aquatic Garden, Rose
Garden, and Gude Garden with its Japanese-style
teahouse also date from this period of growth and
activity. The gardens have matured and plant collections
have grown and changed considerably over the decades.
But Brookside is still the hub for home gardeners that its
designers envisioned.

TOUR

If it is winter, or raining, make a beeline for the
Conservatories. Winter, spring, summer, or fall, the
Conservatories at Brookside are like stepping into a
rainbow. But if the weather is fine, or even bracing,
start your tour from the Visitor Center. Volunteers
will answer questions and tell you what not to miss in
the collection. And the free maps and brochures will
enlighten your visit.

Stop first at the newly expanded **Children's Garden**. Here, curious young gardeners can see the plant world that awaits them and how to grow home favorites like sweet peas, herbs, cutting flowers, and veggies. The theme here changes every two years, and there are periodic special exhibits. One recent display, the Fairy Folkgarden, featured Phil and Rhoda Dendron in a series of magical and mystical plant experiences. The differences between lichens, fern fronds, shamrocks, mushrooms, and tree bark were elvishly explained. Trees in the garden that draw children of all ages include the ghost bramble *(Rubus cockburnianus)*—with startling chalk-white stems and shiny green leaves that are feltlike underneath—and the paperbark maple *(Acer griseum)*, a 2003 county champion due to its size and health.

Continue to the **Winter Garden** at the end of the Children's Garden. The path highlights early bloomers and plants with attention-grabbing bark, winter fruits, or berries. Clusters of winter hazel shrubs *(Corylopsis sp.)*, with their graceful wands of pale yellow flowers in March, and yellow-tasseled witch hazel trees (*Hamamelis x intermedia* 'Arnold's Promise') thrive here. Another favorite, the popular Lenten rose *(Helleborus sp.)*, which blooms from early February until June, is a main attraction. The garden also includes a varietyof early-flowering harbingers of spring, such as snowdrops *(Galanthus sp.)* and winter aconite *(Eranthis hyemalis)*, that give gardeners a turbocharge for making it through the late-winter blahs and into spring.

Witch hazel
(Hamamelis x intermedia)

Next, head for the **Gude Garden** and its Japanese tea-house. Follow the curving path to the right out of the Winter Garden. Walk toward the rolling hills and the Asian-inspired teahouse pavilion. In 1972 landscape gardener Hans Hanses transformed what was nine acres of swampy, flat woodlands into the award-winning necklace of ponds and rolling open hillocks it is today. The garden honors prominent local nurseryman Adolph Gude, Sr., whose family donated many of the fine specimens including the beeches, blue atlas cedars, Southern magnolias, and most of the conifers sheltering the teahouse. The kousa dogwoods were added in 1991.

From this pavilion lookout you can take in the weeping cherries strategically placed on the open hills across the ponds and the Japanese maple growing through the deck. Colorful Japanese koi, or carp, scoot through the water; so do snapping turtles, eastern painted turtles, wood ducks, green-banded mallards, and Canada geese.

Around the teahouse are assorted Japanese maples, spirea, and small variegated hollies. Particularly note-worthy is the 'Full Moon' maple *(Acer japonicum)* with its cascade of lacy, fine-cut leaves that go from soft green to buttery yellow to crimson in fall. Head toward the Foster's hollies *(Ilex x attentuata* 'Fosteri'*)* off the back deck of the teahouse. Beyond the hollies, all along the bank, are ground-hugging shrubs *(Stranvaesia davidiana* 'Prostrata'*)* with tiny red berries, planted with graceful ornamental grasses, azaleas, creeping deutzia, and a silky white willow *(Salix alba).* An instant tonic, these plants help to jumpstart ideas for some of those spaces in your garden that resist redesign.

Circle back along the main loop that hugs the creek and winds toward the Conservatories. On the right side, away from the ponds, look for a dozen or more bushes of purple beautyberry (*Callicarpa dichotoma* 'Issai') with their signature lavender berries in autumn. Collected during plant excursions to Asia, specimens of these eight-foot beautyberry bushes were tested at Brookside Gardens and are now commercially available. Also on the edge of the woods are several large deciduous shrubs *(Meliosma cuneifolia)*, which sport white flower plumes in summer and red berries by fall. Don't miss the three Korean prickly ash trees *(Zanthoxylum koreanum)*, with their strange bark of assorted lumps, knobs, and bumps. This ash tolerates poor soil and in autumn brightens the season with aromatic red berries.

Next, head for the pentagon-shaped **Fragrance Garden** and inhale deeply. The garden's raised central beds display plants from different geographic regions each year to highlight a scent theme. A recent display of spectacularly fragrant plants illustrating South American culinary herbs was so popular that several became part of the permanent fragrance collection; other displays

Tulips in the Fragrance Garden

here have focused on French Provençal herbs and on plants from Asia or the Mediterranean region. No pesticides are used, and visitors are encouraged to touch, tweak, smell, and taste. You might also look for the award-winning champion sweet bay magnolia *(Magnolia virginiana)*. Named a winner in 2003 for its size, health, and fragrance by Montgomery County officials, the sweet bay is known for its creamy-white, gobletlike flowers, maroon interiors, and scarlet seeds. This beauty, planted in 1969, is one of the oldest trees in the Fragrance Garden. In June don't miss the blooms and perfumes of the 'City of York' climbing rose—just opposite the sweet bay.

Permanent plants bank outer beds and hillocks: purple sage and early bloomers (in January and February) such as the Japanese apricot *(Prunus mume)* with delicate pale rose blossoms. Each year the tulip and seasonal displays change. One spring the five beds bloom with pink hyacinths, apricot-peach 'Parrot' tulips, or lavender cotton *(Santolina chamaecyparissus),* and the next spring new bulbs and edgings emerge. Many of the plants here are bat- or moth-pollinated—and so they release their scent in the evening, making a twilight stroll a special treat.

In late spring, eyes turn toward the *Magnolia sieboldii,* with its unusual downturned blooms and red stamens. Other favorite plants to look for and smell include licorice mint, catnip, assorted thymes and oreganos, clove-scented sweet williams *(Dianthus),* and Italian yellow jasmine.

Now head for the three **Formal Gardens** (next to the Rose Garden, tucked just off to the left). Linked by flagstone paths and enclosed by low stone walls or clipped yew hedges, these three gardens feature showy

year-round perennials, spring bulbs, summer annuals, flowering weed-squelching groundcovers, and chrysanthemums in autumn. Succession plantings is a big idea at Brookside. Note how early-blooming bulbs, such as snowdrops and yellow winter aconite, are used in the first of these three rooms, the Maple Terrace (formally known as the Round Garden). When early flowerers die back, they are quickly followed by a reliable, fast-growing groundcover, blue plumbago, or leadwort *(Ceratostigma plumbaginoides)*, which springs to life in the Maple Terrace just as daffodils, aconite, and tulips go limp. In the Yew Garden—second in this triptych of gardens and named for its clipped yew border—miniature white grape hyacinths edge an impressive white rose of York *(Rosa alba* 'Felicite Parmentier'). The third room, or Perennial Garden, is marked by purple stone walls. Here you can find new varieties of hardy plants and shrubs with long blooming seasons. It is home to popular fountain grasses such as the billowy 'Karley Rose' pennisetum, the woody 'Blue Mist' caryopteris, and 'Husker Red' penstemons *(Penstemon digitalis)*. Nearby, mauve coneflowers mix with allium (*A. christophi* 'Star of Persia'), and clusters of Asiatic lilies and lambs' ears (*Stachys* 'Helen von Stein') bloom amid bright Japanese anemones.

Rose lovers might want to backtrack here to the path between the Yew and Perennial Gardens and find the shaded pergola. These arcades offer the best views of more than a thousand rose bushes in Brookside's **Rose Garden** collection. Created by landscape architect Dale Armstrong as a display garden for All-American Rose selections, the garden features the newest award-winning roses. Meticulously planned on about 10,000 square feet, the Rose Garden features 17 white specimens among its 102 cultivars. Included in the many

prize-winning hybrids are David Austin English roses and rugosa rose hybrids. Perennials and ornamental grasses add color and interest to this garden even when the roses are not flowering. Rectangular yew hedges on one side join forces with Japanese holly on the other wall to frame the garden and to shelter the plants from the worst of area windstorms. In a typical year, early to mid-June is the best time to enjoy the roses, as first blooms are the

Rugosa rose *(R. rugosa)*

most vivid and fragrant. A magenta English shrub rose—'The Prince'—takes up an entire bed here. A hardy orange (*Poncirus trifoliata* 'Flying Dragon') in the center of the garden offers year-round interest with white blossoms in spring, silver dollar-sized velvety orange fruit in fall, and interestingly contorted thorny stems in winter.

Before leaving the Rose Garden, look for the weeping Japanese katsura tree (*Cercidiphyllum japonicum* 'Pendula') nearby with its red bark, cascading branches, and oval and heart-shaped leaves. A spectacular landscape tree, in fall the katsura's colors range from yellow to apricot. In late spring and summer, when the katsura is all leafed out, it's like being under a Tiffany lamp.

Follow the covered arbors and trellises out of the Rose Garden to the **Trial Garden.** Here curators at Brookside plant unusual new plant varieties, try out imaginative design plans, and display shrubs and flowers that add color and interest all summer. As you enter, look for the gigantic Norway spruce. Its shaggy bogeyman shape is hard to miss. As you head toward the covered

113

Conservatories (down the stone path), note the almost fluorescent chartreuse groundcover (*Lysimachia numullaria* 'Aurea'). A hard-to-kill perennial, it lights up any path or patch. Sometimes favorite plants of the horticulturalists find a spot here, too. In 2003 several varieties of the Lenten rose *(Helleborus spp.)* in pale yellows, creams, soft mauves, and purple pinks stood out, along with striking specimens of the golden-twig dogwood *(Cornus sericea)*. If plants succeed in the trial bed, they may secure a place in a permanent collection. As you leave the Trial Garden, you'll find an arching grove of river birches (*Betula nigra* 'Heritage'). Known for their strikingly smooth, creamy, curling bark, these trees are good alternatives to the white paper birch, which gets borers in the Washington area.

Follow the path by the Rock Garden and turn up the sloped hill to your left for a walk through Brookside's **Azalea Garden**. This seven-acre woodland garden is home to some four hundred varieties of azaleas and rhododendrons. Depending on the weather and the species, peak bloom falls between mid-April and the end of June. Although Glenn Dales account for the largest grouping in the two thousand-plant collection, gardeners will see both Asiatic and deciduous azalea varieties and all major hybrid groups: evergreen Kurumes, Satsukis, Gables, and Pericats, as well as the deciduous Knap Hills and Ghents. Meandering paths allow for close-up inspection of the massed bushes. A broad assortment of shade-tolerant plants round out the garden: witch hazels, Japanese andromeda, sweetbox, skimmia, and bulbs. A gazebo at the crest of the hill gives visitors a chance to take a breather and gaze back through the colorful woods and over to the ponds of the Aquatic Garden.

Somewhat removed from the rest of the garden, the
Aquatic Garden is well worth the excursion. Water-
loving plants are arranged along the banks of two
separate ponds joined by a path. Head across the bridge
to Anderson Island in the Upper Pond. The Anderson
Pavilion celebrates the lives of Greta Jean and Greta
Karling Anderson, a mother-daughter pair of gardeners
and Brookside benefactors. Just before you cross onto
the bridge, note the triangular collection of fragrant
summersweet shrubs *(Clethra alnifolia)*. Lovers of
conifers will find several to admire here, including the
blue-tipped Serbian spruce, *(Picea omorika)*, Norway
spruces, and three bald or swamp cypresses *(Taxodium
distichum)*, whose slender pyramidal shapes can reach
seventy feet. (They are called *bald* cypresses because
they lose their leaves in winter, unlike most cypresses,
which are evergreen.)

Each spring the pavilion hosts
several tea parties for children.
It's the perfect spot to dress up,
slow down, and munch tot-
sized treats. In summer this
spot seems as charmed as
the bower in *A Midsummer
Night's Dream*. The pergolas
are hung with trumpet honey-
suckle (*Lonicera sempervirens*
'Cedar Lane'); a splayed,
weeping, wide-spreading cedar
(*Cedrus atlantica*, 'Glauca
Pendula'); and climbing rose
'Darlow's Enigma.'

Trumpet honeysuckle
(Lonicera sempervirens)

BIRD'S EYE VIEW

Gazebos (from the verb "to gaze") first became fashionable along European rivers in the 1500s. The gazebo overlooking the Aquatic Garden sits smack in the middle of thousands of flowering azaleas in springtime. From mid-April to early June, enjoy a stunning view of both the azaleas and the thousands of daffodils that bloom along the creek below the gazebo.

GARDEN NOTES

Living Library — As part of its teaching mission, Brookside labels all woody plants with tags that include the age of the specimen, its botanical name, and the garden or nursery from which the plant first came. For horticultural students, the library keeps printed guides that list the significant plants in many of the individual gardens. See the librarian for these lists.

Wings of Fancy — Perhaps the most anticipated event in the conservatories is the annual butterfly exhibit, which runs from mid-May until the third week in September. It's the definition of delight. In 2003, tropical butterflies from Central and South America took center stage,

Swallowtail butterfly

thrilling visitors with their graceful loops and flutters. Kids can learn to identify these lovely winged creatures and see the life cycle of a caterpillar from withered ugly duckling to beautiful airborne plant navigator. Among the tropical favorites: blue morpho, striped zebra longwing, tiger swallowtail, giant owl, yellow cracker, and, of course, the monarch, master of the marathon journey to Mexico and back. Here, children (and parents) find out which plants act as butterfly magnets. If you stand still, a butterfly may land on you. A number of butterfly bushes *(Buddleia davidii)*, sometimes called summer lilac, are here, along with butterfly milkweed *(Asclepias tuberosa)*, a perennial wildflower with showy, long-lasting orange flower clusters and beaked pods that look nice in flower collections. Permanent butterfly plant magnets in the South Conservatory collection include bleeding heart vine *(Clerodendron thomsoniae)*, golden trumpet vine *(Allamanda cathartica)*, pagoda vine, and star jasmine.

Winter's Toll — Both the viburnum and the camellia collections have changed significantly in recent years—due mostly to devastating winters. Forty percent of the viburnums had to be removed recently because of winter damage. Plans call for replacing these scented perennials. In the Camellia Garden a series of severe winters in the late 1970s decimated the collection. Only with the 2001–2002 introduction of new, hardy, fall-blooming camellias did this garden get a new lease on life. Donated by National Arboretum horticulturist William Ackerman, who developed these hardy hybrids, the new camellias will do much to rejuvenate Brookside's collection. Additional plantings are planned. Similarly, in the Winter Garden, plans call for increasing the display of plants known for colorful or unusual winter fruit, bark, or foliage. Stay tuned.

Mark Your Calendars — With about a hundred courses each year and an average of fifteen large plant society shows, Brookside Gardens continues it original educational mission. Other yearly events include Wildflower Day, programs for school children, and the winter Garden of Light show for nighttime visitors. Plant clinics run by master gardeners also are held. (To find out more, call 301-962-1400 or consult Brookside's Web site.)

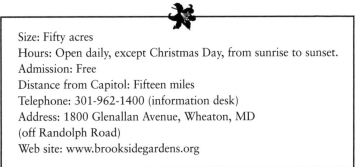

Size: Fifty acres
Hours: Open daily, except Christmas Day, from sunrise to sunset.
Admission: Free
Distance from Capitol: Fifteen miles
Telephone: 301-962-1400 (information desk)
Address: 1800 Glenallan Avenue, Wheaton, MD
(off Randolph Road)
Web site: www.brooksidegardens.org

DIRECTIONS

BY CAR: From Interstate 270 and points west, take exit 4A, Montrose Road east, which turns into Randolph Road. Go approximately seven miles and turn right onto Glenallan Avenue. From Interstate 495, the Capital Beltway, take exit 31A (north on Georgia Avenue/Route 97) toward Wheaton. Drive three miles north on Georgia Avenue to Randolph Road and turn right. At the second traffic light turn right onto Glenallan Avenue.

Meadowlark Botanical Gardens

Protecting the Potomac Valley

Meadowlark Botanical Gardens is as bright and beautiful as the lark for which it is named. The garden's ninety-five acres spread across rolling, tree-covered hills. Its forests and lakes provide a haven for wildlife—and for visitors who flock to the garden in

Lake Caroline in winter

greater numbers each year. But it offers more than sanctu-
ary in the middle of suburbia. As its trails, bridges, and
plant collections have taken shape over the past two
decades, so has its focus on conservation. As wild habi-
tats around the world shrink year by year, Meadowlark is
focusing on the wild places in our region. Meadowlark's
conservation initiatives home in on the Potomac River
Valley and its watershed—and the increasingly important
role that plant diversity plays in the relationships between
plants and people.

HISTORY

Social historian Caroline Ware and economist Gardiner
Means were environmentalists before that term made it
into the language. They were also Harvard-trained aca-
demics who worked to bring the New Deal to fruition
during President Franklin Roosevelt's administration.
Transplanted New Englanders, they bought their
seventy-four-acre farm outside Washington, D.C., in
1935 and grew to love the Virginia countryside as much
as they treasured their New England roots. For forty-
five years they farmed and planted gardens and raised
sheepdogs here. But by the 1970s the suburbs were
encroaching on their rural retreat. In the summer of
1980 they donated their land to the Northern Virginia
Regional Park Authority to "preserve the bounty of the
Virginia countryside."

Meadowlark Botanical Gardens opened to the public in
April 1987. By then, trails, three lakes, and several col-
lections—of hostas, daylilies, and cherry trees—had
been added. An azalea garden, a lilac collection,
Siberian irises, and a native tree trail, along with three
gazebos, made the area into a fully functioning public
garden. In 1992 the Meadowlark Visitor Center opened,

and in 1998 the Atrium began hosting weddings and parties and other public events. But as the garden evolved, it also remained true to the conservation ethic of Ware and Means. As they had, Meadowlark looked to the future and in 1999 initiated a regional native plant conservation program. Today one of the most active conservation programs for native plants in the nation is in full swing at Meadowlark. The educating and teaching tradition that was integral to the lives of its benefactors lives on here as well. Classes and tours, a Biodiversity Series education program, wildflower and birding hikes, and cooperative programs with local colleges, garden clubs, Smithsonian Associates, public schools, and others extend the bounty that Caroline Ware and Gardiner Means envisioned.

TOUR

Start your tour at the **Visitor Center**. With a map you can wind your way through the 3.5 miles of paved trails in an hour or two. There is also a mulched trail of less than a mile, and a one-mile perimeter trail. Whatever your time frame or your interests, Meadowlark can fill an hour, a day, or a week—and get you involved in conservation for the rest of your life.

The gardens are organized into ornamental plant collections, which contain natives and nonnatives, and into native conservation collections. Within the Ornamental Collections there are theme gardens and plant libraries.

Additionally, you can look on the Web site and check out the blooms *du jour*—daffodils and bulbs, flowering cherry trees, Lenten roses in March and April; the peony collection in May; the hostas and the prize daylily winners in June and July; the salvia and herb gardens in September; the grasses and asters and mums in October;

the conifers, hollies, and nandinas through the winter. If you begin with the ornamentals, and if it's spring in Washington, what more likely destination than the **Cherry Trees**? Lining Lake Caroline, the cherry trees (number 11 on the map) offer a miniversion of the Cherry Blossom Festival. They are Yoshinos *(Prunus x yedoensis)* like the majority of those around the Jefferson Memorial—and in early April they are the highlight of the garden.

If it's July, try the **Bold Garden** near the Atrium (number 5 on the map). Outrageous is the rule here, and for starters, the empress tree *(Paulownia tomentosa)*—pruned to resemble a shrub with leaves as big as umbrellas—proves it. (It's a pruning trick, called stooling, that gardeners use to force a tree to put its energy into growing bigger leaves instead of more of them at greater heights.) Other gigantic-leaved attractions include members of the *Alocasia,* the *Colocasia* (commonly known as elephant ears), and the *Xanthosoma* genera. Many of the plants in the Bold Garden are tropical, and the area's hot, humid summers encourage them to grow and bloom riotously. Case in point: The cannas, which grow to heights of ten feet and brandish blooms of fluorescent orange, red, and yellow. Not to be outdone, the burgundy leaves of the ten-foot castor bean plants *(Ricinus communis)* and the clusters of their red or pink spiky fruit will make you think you're on the set of a jungle adventure movie.

In August or September make the **Salvia Collection** (number 11 on the map), directly downhill from the Visitor Center, your first stop. For variety of species, you can't do better. Though some salvias bloom as early as May, most get going as the sun gets hotter. A genus of some nine hundred species, the adaptable and often aromatic salvia grows in dry meadows, in scrubby or

122

rocky sites, in grasslands, woodlands, deserts, and on mountains—on every continent except Australia and Antarctica. You'll find more than fifty species here, ranging from the sky-blue blooms of *Salvia guaranitica* to the variegated foliage of *Salvia officinalis* 'Tricolor' to the almost transparent petals on three-foot stems of *Salvia sclarea*—and every hue in between. Besides their infinite variety and hardy nature, they are relatively pest-free, long-blooming, drought-tolerant, and they even attract hummingbirds. When the rest of the garden is winding down, they are revving up. Stroll the collection, take time to smell the salvia, rub their leaves, and decide which ones you'd like for your garden. In fact, you could have a garden with nothing but salvia and you wouldn't be sorry—at least from June to October.

If you want to try another plant library, the **Daylily Collection** is not far away (number 11 on your map). Browsing this collection is like looking at a shelf filled with books by a favorite—and very prolific— author. They're all similar in style, but each has its own appeal. Knowledge of the *Hemerocallis* (from the Greek meaning "beautiful for a day") genus as a medicinal herb and garden perennial goes back not just centuries but millennia. From these patriarchs (some

Stout Medal-winning daylilies

fifteen species) have come more than thirty thousand cultivars. One of the most hybridized plants in the world of horticulture, daylilies' popularity results from their wide range of colors (from white to yellow, orange, purple, and deepest red-black), their rugged

123

constitutions, and their repeat blooming through the heat of the summer. Though most blooms last for only a day, the pleasure of growing daylilies lasts through the summer. And at Meadowlark you can also have the pleasure of seeing all the Stout Medal winners since 1950. Awarded each year for the most aesthetically pleasing new hybrid, the Stout Medal honors Dr. Arlow B. Stout, who is considered the Father of the Modern Daylily. From madder red-black to creamy white, double or single-flowered, solid or multicolored, short or tall, the daylilies are a tribe worth knowing— and visiting at Meadowlark.

Whatever the season, make time for the **Potomac Valley Native Plant Collection** (number 17 on the map). It is the largest of Meadowlark's native plant conservation initiatives. Started in 1999, the collection focuses on building a diverse array of plants native to the Potomac watershed. The objective is to encourage conservation of native plants and their habitats through education and display. And, in fact, much of the initial development of the collection has been accomplished through volunteer effort, primarily through Eagle Scout projects and through sharing information with other conservation agencies, native plant societies, colleges and universities. Follow the trail to number 17 on the map and you'll arrive at the Monadnock Rock Garden, which is the lower entrance to the Potomac Valley Collection. This area was created to mimic rocky habitats found in the high mountains of the Potomac Valley. The rock garden has a rich assortment of native wildflowers, such as Virginia bluebells, trilliums, jack-in-the-pulpits, pink and yellow lady's-slipper orchids, and native columbines. Some are uncommon, such as the scarlet red catchfly *(Silene virginica),* named for its sticky calyx, which traps flies and other insects. It is a plant referred to in colonial

literature but not usually seen today. All the plants in this garden are beautiful, but none are as surprising as the yucca (*Yucca filamentosa* 'Adam's Needle') and the cactus *(Opuntia humifusa)* here at the entrance to the garden. Did *you* know that cactus and yucca were native to the Washington area?

The selection of shrubs here is fairly robust. (This is true even though the deer population, for a number of years, has kept the native plant population closely cropped. Today there is a ten-foot deer fence that keeps them out.) The flame azalea *(Rhododendron calendulaceum)*, near the Monadnock Rock Garden, with its two-inch salmon-pinkish-orange blooms in May and June is one of the showiest of American azaleas—and particularly beautiful in this natural setting of dappled light and forest shadows. Another native azalea, *Rhododendron viscosum*, is remarkable for its fragrance, uncommon in azaleas, and its delicate white flowers. The leatherwood *(Dirca palustris)*, which flourishes in moist, shady areas, is distinctive for its rich foliage that turns yellow in fall. Cliff green *(Paxistima canbyi)*, a versatile shrub that in rock gardens can be groundcover, is found in the more mountainous sections of the Potomac Valley. It bears greenish-white clusters of small flowers in summer. Here, too, are highbush and lowbush blueberries *(Vaccinium corymbosum* and V. *angustifolium)* loaded with edible berries in summer, bearberry and button bush, and an old-fashioned favorite of southern summer gardens, the Virginia sweetspire *(Clethra alnifolia)*. The elegant symmetry of ferns spreading through the woods and fiddleheads unfurling here and there make this area a hiker's delight. One of the tall stands of cinnamon fern *(Osmunda cinnamomea)* is more than fifty years old. Silky-fine fronds of maidenhair fern proliferate in the rich soil of a rotting log. There are

New York ferns, Christmas ferns, log ferns, grape ferns, and ebony spleenworts, an evergreen fern on dark purplish stalks. Nearby, club moss sprouts on the moist, shady forest floor. Fern and club moss are primitive plants, which do not flower, and reproduce by spores, not seeds. They date to the time of the dinosaurs, when the plant world was a world without flowers.

But there are flowering perennials here, too: foamflower *(Tiarella cordifolia)* and tall, white plumes of cimicifuga *(Cimicifuga racemosa)*, also known as black cohosh, used medicinally as a sedative. Its graceful spires can grow to three or four feet, and it blooms in summer. Like the ferns, these perennials flourish in the moist leafy soils of the woods. For those familiar with Gerard Manley Hopkins's nature poetry, this forest of "dappled things" (where "worlds of wanwood leafmeal lie") will bring to mind his tongue-tripping rhythms.

Cimicifuga *(C. racemosa)*

The native trees here make up the most mature forest at Meadowlark: hickories, hornbeams, blackgums, red and white oaks, tulip poplars. (With their straight tall trunks and soft wood, it is easy to see why the poplars were the Native Americans' tree of choice for making canoes.) Meadowlark's largest sycamore, along with abundant stands of American holly *(Ilex opaca)* flourish here as well. In the understory, redbuds light up the woods in spring, and the small yellow-flowering cucumber magnolia *(Magnolia cordata)* is a rare treat for magnolia-philes. Also in the understory are

fringetrees, bladdernuts, and the sweet bay magnolia. As you would expect, wildlife in this area of the garden is abundant. Chipmunks and even a coyote find refuge here. Birdwatchers will find bluebirds, flickers, pileated woodpeckers, nesting orioles, and even indigo buntings—the "poster" bird on the cover of many a bird book.

The Potomac Valley Native Plant Collection features often overlooked plants that form the ecological and aesthetic foundation of our local forests. None are selections—that is, no plants growing here have been manipulated by plant breeding and hybridizing. All are native plants and "rescued" plants that have been brought to the garden when construction and development in the area would have led to their destruction. The plant collection being assembled here makes it possible for visitors to discover and explore the diversity of regional plant communities and understand the need to conserve them as part of our own unique natural heritage.

OFF THE BEATEN PATH

For a glimpse of what life in colonial Virginia almost 250 years ago might have been, go to the **Historic Log Cabin** (number 25 on the map). The one-room cabin dates to the mid-1700s and has been restored to that period. The cabin was once surrounded by the farmhouse that was home to Ware and Means. That house was removed, and then the cabin was completely dismantled. Restorers carefully numbered each timber for later replacement to its original location in the cabin. When logs were too rotten to be saved, a timber specialist used replacement timbers from other eighteenth- and nineteenth-century log structures. A new cedar-shake roof—not original to the cabin—and stonework finished the job.

Soon the cabin will sit in a garden typical of the farms and homesteads in the Virginia Piedmont of the eighteenth century. Unlike George Washington's Mount Vernon, which offers a look at a wealthy landowner's world, the cabin and environs at Meadowlark's site reflect the life and garden of a typical colonial family. At that time, the colonials here would have traveled by foot or horse to the ports of Alexandria and Georgetown for supplies. Falls Church would have been an overnight stop for travelers making that trip. At the same time, forests of the region, which were abundant, were being cleared for farming and cut for timber. Native American cultures of the area were starting to experience rapid changes as the European presence in North America expanded. This site at Meadowlark offers a look back in time to the environment of the Virginia Piedmont even before it became part of the new nation.

BIRD'S EYE VIEW

The highest point of the garden is the **Hillside Gazebo** (number 23 on the map.) From here you can see the rolling hills and the gardens nestled among them. And you can get a great view of the **Native Tree Collection**. Trees planted here are some of the best choices for use in home gardens: fringetrees, with white flowers in spring and olivelike blue berries in fall; pawpaws, the host plant for zebra swallowtail butterflies; river birch and hop hornbeam with their delicate, shaggy bark; and sweet bay magnolia, a smallish tree with creamy white, fragrant flowers.

GARDEN NOTES

Garden Chemistry — Opened in 1998, the Cancer Treatment Garden showcases plants that contain powerful toxins to fight various cancers. Some of the plants

are known sources of effective chemicals used in chemotherapy and some produce promising chemicals under investigation. The garden is situated close to the Visitor Center for ease of access to cancer patients, who may not want to take long walks. Plants growing here include the happy tree *(Camptotheca acuminata)*, which is used to treat lung cancer, leukemia, and testicular cancers; the Pacific yew *(Taxus brevifolia)* from which tamoxifen is synthesized to fight breast cancer; the May apple *(Podophyllum peltatum)* with chemical compounds enlisted to do battle against leukemia, ovarian, and testicular cancers; and the rosy periwinkle *(Catharanthus roseus)*, which contains toxins that fight leukemia, Hodgkin's disease, and prostate cancer. Plant researchers explore many different ecosystems to find plants that might prove suitable in cancer treatment and research.

Wetland Wonders — If you like ponds and all that goes with them, head for Lake Lena, one of three lakes in the garden. Various native aquatic species have been added to the lake: pickerelweed, fragrant water lilies, arrowhead, and sweet flag. In the marshy shore areas, you'll

Lake Gardiner

find red and blue cardinal flowers *(Lobelia cardinalis and L. siphilitica)* and blue flag iris. Several native wetland species are also naturalizing around the lake, such as cattail, willow, water purslane, and several sedges. A floating log, provided expressly for the turtles, has become a spa for the native turtles living in the lake. There are often three or four sun-basking at one time. A haven for species displaced by development, Meadowlark also has a special program to accept local box turtles and native aquatic turtles. Even wading birds, such as the great blue heron, little green heron, and black-crowned night heron, frequent this pond. These long-legged hunters fly in, low and graceful, with heads down and legs trailing behind. They wade or stand motionless, and then suddenly—with deadly precision—stab a minnow or bluegill at water's edge.

Size: Ninety-five acres
Hours: Open daily except Thanksgiving, Christmas, and New Year's Day. Hours vary with seasons.
Admission: $4 for ages eighteen to fifty-nine, $2 for ages seven to seventeen and sixty and older; $20, annual pass. Admission free December, January, and February.
Distance from Capitol: Twenty-one miles
Telephone: 703-255-3631
Address: 9750 Meadowlark Gardens Court, Vienna, VA
Web site: www.meadowlarkgardens.org or www.nvrpa.org

DIRECTIONS

BY CAR: The gardens are located off Beulah Road, between Route 7 and Route 123, south of the Dulles Access Road. To reach Meadowlark Botanical Gardens from the Beltway, take Route 7 toward Tysons Corner. Drive three miles west on Route 7, turn left onto Beulah Road, and drive two miles to the garden entrance on the right.

United States Botanic Garden

The Other Domed Hothouse on Capitol Hill

A pleasure dome of sights and smells, the United States Botanic Garden is one of the nation's oldest. Step into this huge glasshouse conservatory and explore a dozen galleries featuring Earth's landscapes and ecosystems. From desert to jungle to garden primeval, the U.S. Botanic Garden is ecology at

Bartholdi Fountain

its best. Presidents Washington, Jefferson, and Madison envisioned a botanic garden that showed the interrelatedness of plants and man. Today the mission is much the same: to demonstrate the diversity of plants worldwideby highlighting their cultural, economic, aesthetic, therapeutic, and ecological significance. The collection showcases more than thirty-five hundred plants.

HISTORY

Congress created the U.S. Botanic Garden in 1820, but it took until 1842 to construct a greenhouse to nurture seedlings and rare plants. At that time a four-year expedition to the South Seas headed by Admiral Charles Wilkes returned from a government-sponsored odyssey. Wilkes brought back 10,000 plant specimens, hundreds of seeds, and 250 live plants gathered from the far-flung corners of the world. The arrival of this botanic treasure trove expanded exponentially the original vision—from a public garden for plants native to the new American nation to one displaying plants from around the world. Wilkes's plant collection, miraculously kept alive for months on the high seas, was stored initially in a hastily erected greenhouse behind the Old Patent Office Building. In 1850 the plants moved into a new structure on the Mall. After nearly a century at this site, in 1933 the U.S. Botanic Garden moved to its present location at First Street and Maryland Avenue, SW, a new Victorian-style conservatory inspired by London's Crystal Palace.

Several original specimens from the Wilkes collection survived various uprootings and more than 150 years to become prized specimens. Today, after a major renovation, the Botanic Garden is more educational than acquisitive. But it is still the repository of those

survivors and many more grand plant collections. In April, when many of them are in bloom, an annual month-long exhibit featuring them is in full swing.

Along with the conservatory and its two surrounding acres, the U.S. Botanic Garden also includes a triangular wedge across Independence Avenue, the Frederic Auguste Bartholdi Park. Named for the Gilded Age sculptor who created the historic fountain at its center, Bartholdi Park is about as ingeniously designed and centrally located as a public garden in Washington can be. Created as a series of domestic landscape gardens, the park features botanical theme plots with innovative plant combos suitable for small urban and suburban home gardens.

TOUR

In good weather start your tour on the **Terraces** outside the U.S. Botanic Garden's front facade, modeled after the Orangery of Louis XIV's palace at Versailles. Each year, from May to October, the terraces on either side of the main entrance are transformed into special theme gardens that are just as dream-worthy as Louis's were. In 2003, heirloom vegetables, flowers, and plants were center stage. Amid the wooden trellises and fluted umbrella tables and chairs (for thinking green thoughts in the shade) sprouted rare forms of tomatoes and beans, plump pumpkins, long, squat hot peppers, squash, and watermelons. All of them were heirloom varieties at least fifty years old.

Inside the conservatory, enter the **Garden Court,** where the sounds of water splashing in blue-tiled pools inspire cool thoughts in steamy seasons. The collection here showcases plants essential for everyday life—plants that

produce fiber, wood, food, flavor, and more. Despite the utilitarian emphasis, however, this entry court is exotic as a toucan. Catering to seasonal visitors who want a jolt of color and instant gratification, the Garden Court offers a constantly changing show: the glow of poinsettias in winter; spotted foxgloves and lush olive trees in summer; fuchsias, fragrant gardenias, and orange-red bromeliads with gaudy topknots in spring. Sharing the spotlight are spiral West African ginger plants *(Costus afer)*, camphor trees *(Cinnamomum camphora)*, a Panama hat plant *(Carludovica palmata)*, and the ylang-ylang tree *(Cananga odorata)* from which perfume makers derive the essence of Chanel No. 5. Other dramatic and delicious plants here include the chocolate tree, the avocado tree, and the Indian almond on the south side.

From the Garden Court you can go east or west to explore the perimeter gardens. Save the central Jungle with its ninety-three-foot dome for a dramatic finale. Continue in either direction, and you will eventually pass through all the exhibit rooms. (Or, consult the map in the Visitor Guide if you want a particular area.) The interpretive messages of the conservatory are clearly marked. The west side is devoted to plants and their relationships to humans. Exhibits on the east side focus on plants and the environment.

In the Jungle

In the **Plant Adaptations** area on the east, or left, side of the Garden Court, the focus is on the adaptive tricks plants use to survive in diverse environments. Plants with significant symbiotic relationships are presented. For example, nitrogen-fixing bacteria feed legumes and help them survive, even in impoverished soils. Although this "magic" takes place underground in the root system, the lesson of nitrogen-fixing bacteria is not lost on farmers or home vegetable growers. Symbiotic relationships allow plants to live and thrive when they might not otherwise survive. (In spring, look for the Wilkes Expedition plant, a native yellow hibiscus [*Hibiscus brackenridgei*] in this room.

Beyond is the **Garden Primeval.** This room re-creates what a mid-Jurassic period primeval forest might have been like some 150 million years ago when ferns and cycads covered the planet. It was a time when a series of changes in the lush jungles of the Jurassic era created the first seed-producing plants, and when ferns built trunks to become tree ferns. It was a world without flowers, but not without drama. It was the time of the dinosaurs when the single large continent of Pangaea was splitting up to separate Europe from North America and Africa, and carrying plants and animals into new climates. (To see something similar in the natural world today, you would have to go to the mountain forests of New Zealand.) Here visitors experience a dense, green, flowerless environment: *Dioon spinulosum* with its huge elongated cones, and horsetails, and tasseled ferns. A compact, palmlike cycad *(Cycas revoluta)* cradles a seed-bearing cone bigger than a football. A younger female cycad is crowned with a nest of bright gold, velvety-looking new leaves and orange seeds—though the mature foliage feels more like leather than velvet. More exotic species, such as the six-foot Australian tree fern

135

(Sphaeropteris cooperi) and the Tasmanian tree fern *(Dicksonia antarctica)* bring to mind that ancient jungle, a warm, humid, endlessly green landscape below lightning-filled skies alive with gliding pterosaurs.

Next comes the **Oasis.** This area borrows most noticeably from the Middle East, where the desert periodically sprouts garden refuges with tree canopies of date palms and papyrus and spring-fed pools. The focus is on the unique adaptations plants have made in parched desert environments. Both Old World (Middle Eastern) and New World oases plants are displayed. The Washington palm *(Washingtonia filifera)* growing here—named after George Washington—is the only palm native to the western United States. It is typical of palm oases in the Sonoran and Mojave Deserts of the Southwest.

The **Desert** is the next garden on the east side of the conservatory. Dramatic rockwork suggests a landscape typical of southern Arizona's and northern Mexico's Sonora Desert. Visitors can explore water conservation issues and note how cacti develop individual hues,and even hair, in response to the particular light and climate in which they grow. Some cacti adapt to arid climates by developing tiny creases, or rivulets, to catch scarce rainfall and efficiently deliver itto the plant's interior.The shape of the agave cactus, with its broad base and rosette top, works well for storing water efficiently.

Agave *(A. victoriae-reginae)*

Interesting shapes abound in this desert garden—from the squat round 'Old Woman' cactus to the octopus agave with its long, tentacle-like tendrils. Look for the ferocious blue cycad *(Encephalartos horridus)* named for its extremely sharp leaves. (It's another descendant of a plant from Wilkes's expedition.) And there's more than cacti. Several types of heat-tolerant euphorbia thrive here: the African milkbush *(Euphorbia tirucalli)*, with bright green candelabra-like branches that can reach more than twenty feet, as well as euphorbias abloom in fluorescent yellows and reds. Look for the blue-hued plants, too, such as the succulent known as blue chalksticks *(Senecio serpens)* with fleshy, blue-frosted stems and yellow flowers.

On the west side of the conservatory, the focus is on plant exploration and the uses of plants from a human perspective. Scores of plants known for their palliative effects find hospitable ground in the Medicinal Plant area. (Placards note common curative uses.) The black bean tree *(Castanospermum australe)* is being tested in U.S. labs to treat HIV/AIDS. Leaves of the Madagascar periwinkle *(Catharanthus roseus)* are ground up and used to make chemotherapeutic drugs to treat Hodgkins disease, adult and childhood leukemia, and prostate cancer. Look for this exotic periwinkle, with its pink-centered white flowers, in the edging beds. Ephedra, a dietary supplement now banned by the FDA, is here, too. Sumerians made medicine from its various parts more than five thousand years ago, as did the East Indians and Chinese. And then there's the graceful betel nut palm tree *(Areca catechu)*. Native to Malaysia and Polynesia, its fruits are chewed as breath mints or stimulants by Malaysian and Polynesians.

The **Orchid** exhibit shelters representatives of a family of more than twenty thousand species, the largest family of flowering plants in the botanical world and one of the oldest. Scientists think orchids emerged more than 90 million years ago—and researchers are now discovering that orchids are related to onions, iris, even asparagus. Some horticulturalists think the number of individual orchid species may be as high as thirty-five thousand. (Only Antarctica is without representatives of this plant family.) About 140 orchid species grow in the United States. The U.S. Botanic Garden's collection, numbering about six thousand different plants, draws visitors from around the globe. At any given time, at least two hundred of the bizarre and beautiful members of this family are in bloom here. People flock to the big, blowsy cattleyas (the most popular corsage orchid), the phalaenopsis orchids (like moths on a stem), and of course, the big garlands of the Hawaiian lei orchids, or dendrobiums. Perhaps the biggest collection is the lady's-slipper orchids *(Paphiopedilum)*, which are represented by several glorious varieties that look like they were hand-painted. Night-pollinating orchids are here, too, sprinkled among the lady's slippers that form a hillock of delicate blooms.

The **Plant Exploration** room contains rare and endangered plants obtained through the Convention on International Trade and Endangered Species (CITES) program. Rare and endangered plants here include the kona palm *(Pritchardia affiis)* and the karoo cycad *(Encephalartos lehmanii)*. This collection also showcases new types of plants and new uses—and highlights recent advances in plant science. Exhibits change frequently. A recent display highlighted industrial plant cleaners developed with the U.S. Department of Agriculture. Plants

recently featured here, such as sweet alyssum *(Alyssum maritimum)*—with a variety of monikers including healdo, madwort, and sweet Alice—can clean up fields contaminated by heavy metals. And they are being used to do just that. The Plant Exploration room also features several plants collected on the 1842 Wilkes Expedition. Look for the powderpuff plant *(Mimosa strigillosa)*, the crane flower or bird of paradise *(Strelitzia reginae)*; and the amaryllis-like crinum lily *(Crinum augustum)*. The newest addition to the U.S. Botanic Garden, the **Southern Exposures** garden, pays tribute to unusual plants from two distinct regions: the southwestern United States and northern Mexico, and the coastal seaboard of the South. Enter here and you will find a sheltered, sun-lit sanctuary filled with captivating botanical characters. Framed on all sides by the glassed conservatories and the towering walls of the domed Jungle, this courtyard will eventually hold more endangered species and CITES plants than any other area in the Botanic Garden. The garden celebrates sun-loving plants in dry and wet habitats. Curators hope to expose visitors not only to this sunny site but also to unusual native plants they can experiment with at home.

Divided by a wide slate walkway, this sheltered courtyard features, on one side, southwestern plants growing in a gritty native soil high in sand and clay and buffered with lime. There is the Texas skeleton plant, a relative of the aster family, and the blue beargrass *(Nolina nelsoni)*. Its graceful, upright habit (like a narrow-leaved yucca with small white flowers) makes you want to touch it. But beware of its ridged, sharply serrated leaves. A signature plant, the Texas mountain laurel *(Sophora secundiflora)* is a small evergreen tree from the legume family with purple, wisteria-like flowers—that smell like Kool-Aid—and large fuzzy seed pods. It is both beauti-

ful and good for drought-resistant landscaping. Look also for the handsome Arizona rosewood *(Vauquelinia californica)* and the desert willow *(Chilopsis linearis)*, found in desert washes and creeks from southern California to southwest Texas and northern Mexico. It blooms from April to August with large, fragrant, orchid-like flowers. Sprinkled throughout these more unusual southwestern natives are mints, autumn sages *(Salvia greggii)*, as well as colorful flowering annuals tumbling from pots.

The other side of the walk, a larger area with a pond, accommodates plants native to the coastal U.S. along the Gulf Coast and lower reaches of the Coastal Plain. Framed by a low bentwood railing, the beds contain an acidic, sandy soil mix. One of the most striking plants here is the loblolly bay *(Gordonia lasianthus)*, an evergreen tree native to the southern seaboard with big, camellia-like flowers. Shrubs, such as the Florida anise *(Illicium floridanum)* and the Texas star hibiscus *(Hibiscus coccineus)*, along with the yellow-flowering water lily *(Nymphaea mexicana)*, make this area as lush as a Charleston garden party. This side of the garden also showcases endangered species such as the fleecy-blossomed pygmy fringetree *(Chionanthus pygmaeus)* from south Florida, the fragrant swamp privet *(Forestiera acuminata)*, and clusters of a small magnolia *(M. ashei)*, also native to Florida.

Texas star hibiscus
(Hibiscus coccineus)

When you leave this sun-drenched patio, you're on the threshold of an entirely different world—the dramatic ninety-three-foot central domed **Jungle**. (A giant sago palm, or cycad, another descendant of a Wilkes expedition survivor, occupies a special place of honor here. Look for it inside the sliding glass entrance doors on the Garden Court side.) Deliberately planted to resemble an abandoned, overgrown tropical plantation in an equatorial climate, this area features vines and towering palms twisting over broken stone steps. The Jungle is a living metaphor for the global clash between nature and humans—and the overdevelopment humans often herald. There are four layers of plantings in the Jungle, each illustrating an ecological niche and role typical of plants in rain forests around the globe. Soaring palm trees *(Roystonea regia)* make up the top layer; next come lush canopy plants that block the sun and hold the moisture in the rain forest. Smaller trees live under this canopy, along with jungle-floor vegetation and roots. Scattered throughout the Jungle are epiphytes, such as Spanish moss, growing on tree branches.

In this setting, horticulturists explain to schoolchildren and other groups how the Spanish moss bearding the trees can live without a root system, or how crocodiles and frogs, pocketed in bromeliads, depend on each other in a Florida swamp. Ponds, minifountains, bridges, and staircases, one with a missing banister, peek through the foliage. All this rampant growth evokes the inexorable march, and eventual triumph, of nature over human constructions. It is a rain forest swallowing a tropical ruin. You could be exploring Mayan temples or uncovering long-buried civilizations in the Amazon rain forest.

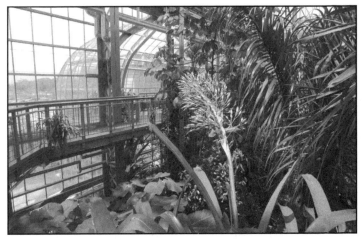

View from the Jungle canopy walkway

BIRD'S EYE VIEW

Don't leave the Jungle without ascending the heights—
the bridge and walkway that ring the entire conserv-
atory dome. From here you can survey the Erector set-
like innards of the conservatory and peer down on even
the tallest palms.

OFF THE BEATEN PATH

Cross Independence Avenue and head for the main
Bartholdi Park entrance at Independence Avenue and
First Street. This triangular wedge is an idea park—and,
like the fountain at its center, a work of art. Its forty-
one beds, created by curator Rob Pritchard and his
staff, comprise seven theme gardens crafted with the
home gardener in mind. The idea is to feature small
model gardens incorporating new sustainable plants and
hot horticultural trends that can be easily duplicated in
the nation's backyards. As a certified wildlife habitat,
Bartholdi Park also highlights the role of water in
botanic settings to attract birds and wildlife year round.

No theme bed is larger than 70 x 30 feet, and the curvilinear paths—using a variety of crushed rock, river stones and fieldstone, wood chips, and multicolored bricks to showcase the options—lead to within sniffing range of most plants. In Bartholdi the aim is not to unify the area, as in other garden settings. Rather it is to show home gardeners various ways of creating walkways for up-close plant access, so they can pick and choose elements that work for them.

Consult the map in the central garden to the right of the fountain before starting the self-guided tour. The layout includes a number of plots: seasonal displays along Independence Avenue; a semiformal American Parterre area with a spectacular view of the Capitol Dome; a much-copied and much-photographed low-maintenance Patio Garden for Capitol Hill townhouses and other small garden spaces; a walled Rock Garden; a Palette Garden snuggled next to a subtle Romantic Garden with an arbor and fragrant blooms in many hues; and generous Heritage (featuring native plants) and Shade Gardens. Whimsical plant lovers will delight in the **Palette Garden** (aka the White Garden). The artistry here relies on a monochromatic theme. Right now, it's white—with a variegated hydrangea and white Japanese anemones that stand out in evening light. And for pure drama, in spring, there's St. Mary's thistle *(Silybum marianum)*: the Sarah Bernhardt of the White Garden with

leaves that are a mosaic of green-and-white mottles and stripes. In summer St. Mary's thistle disappears and the white 'Casa Blanca' lilies take center stage. Tall and stately, they are the essence of regal—and fragrant as well.

'Casa Blanca' *lilies in the White Garden*

143

Some late spring highlights at Bartholdi include huge blooming hedges of rosemary (*Rosmarinus officinalis* 'Salem') and profusely flowering Virginia bluebells in the **American Parterre** set amid the low, decorative walls of stacked Pennsylvania and Maryland fieldstone of the Rock Garden. There are also massive clumps of thirty-year-old yuccas, and lovely river birches (*Betula nigra* 'Heritage') with their trademark peeling brown-and-white bark. Sprinkled throughout Bartholdi are strategically placed benches and arbors, many with memorable views of the conservatory's crystal dome, or the U.S. Capitol cupola. The arbor in the **Romantic Garden** is draped with the 'Moonlight' climbing rose, a gift of the late and beloved garden writer Henry Mitchell. The **Rock Garden**'s euphorbia *(Euphorbia myrsinites)*, with its glorious chartreuse bracts, is particularly suitable in rock gardens. It demands attention, as do scores of native North American columbine *(Aquilegia canadensis)* with their red-and-cream, bell-shaped blooms. Shades of blue also claim their fair share of gazes: the fragrant lavender-blue Dalmatian iris *(Iris pallida)*, with its silvery blades in spring in the American Parterre, and the sky-blue flower clusters of plumbago *(P. auriculata)* in the border gardens along Independence Avenue in summer. Another drama queen is the statuesque cardoon *(Cynara cardunculus)* with its blue thistle flower. On a breezy day, it is poetry in motion with rippling three-foot stalks topped with royal blue blooms—and especially well-placed front and center in the impressive American Parterre. This garden, which is *formally* laid out in circles and allées, is *informally* planted. The result: a structured elegant garden perfectly suited to relaxed lifestyles.

Curators at Bartholdi favor native trees and grasses for their beauty in all seasons and urge gardeners to try grasses such as switchgrass *(Panicum virgatum)*

or finestem tussock grass *(Nassella tenuissima)*. Found from Texas to South America, this hardy grass literally dances with the wind and looks spectacular with a dusting of snow. In autumn it turns a tawny gold-brown. Another innovation here is the use of hardy hollies, particularly the small-leafed 'Shamrock' *(Ilex glabra)*, which greets you at the First Street entrance or the small-leafed 'Nana' *(Ilex vomitoria)* near the Second Street entrance. These elegant

Cardoon *(Cynara cardunculus)*

mounds achieve the same border-defining effects as boxwood—and they are much more fast-growing. In the American Parterre Garden, ten Japanese 'SkyPencil' hollies *(Ilex crenata)* create an allée to frame both the fountain and the hilltop Capitol. Like the rest of the plants in the garden, the grasses and the hollies have been carefully selected and optimally placed to give visitors spectacular reasons for gardening in all seasons.

GARDEN NOTES

Bartholdi Fountain — Frederic Auguste Bartholdi (1834–1904), designer of the Statue of Liberty, created the fountain for the 1876 International Centennial Exhibition in Philadelphia. It was purchased for $6,000 and moved to Washington, D.C., soon afterward and placed at the foot of the Capitol before becoming the centerpiece of Bartholdi Park in 1932. Layered like a wedding cake, the thirty-foot-high Bartholdi Fountain is rich in swirls and shells and scallops. Water shoots and

spouts from fishes and turtles and sea nymphs. Frolicking fish rise to a middle layer of sea nymphs holding up a top tier of lights and seashells and spilling water. The lavish nineteenth-century artistry of the fountain provides an interesting contrast to the intricately crafted twenty-first-century botanical artistry in the minigardens around it.

Orchids and Butterflies — Each year, from January through May, the Botanic Garden partners with the Smithsonian's Department of Horticultural Services to display both institutions' renowned orchid collections. The annual exhibit is a tropical sensation of butterflies and orchids. The site of the exhibit alternates venues. In 2003 it was at the Smithsonian's Arts and Industries Building, a few blocks west. In 2004 the exhibit—Orchids: Beauty and Beyond—was held at the USBG.

From the Terrace — Typical of the in-depth information and ecological lessons offered in Terrace shows, a recent exhibit on heirloom vegetables offered this wealth of information: An *heirloom* is something of value handed down from generation to generation. Many people cherish roses grown from cuttings from a great-grand-mother for their fragrance and longevity. Heirloom fruits and vegetables are no different. There are cultural, genetic, historical, and sentimental reasons for saving seeds. Once a seed line is lost, the species is extinct. The commercially grown replica simply does not have the same genetic traits. The heirloom varieties displayed in this recent terrace exhibit survived because they are tougher, more disease-resistant, or more adaptable to severe climactic variations, all qualities that make them extremely valuable to the human family. Some of the heirloom varieties in recent exhibits include the 'Moon and Stars' watermelon *(Citrullus lanatus)*, a sweet dark

green orb dotted with yellow star splotches. Thomas Jefferson grew this plump, pretty fruit at Monticello. A very special bean seed on display, known as the Cherokee Trail of Tears bean *(Phaseolus vulgaris)*, retains a pure seed line today because Native Americans brought it with them on the tragic march from Tennessee's Great Smoky Mountains to Oklahoma in 1838–1839. Dr. John Wyche inherited the bean seeds from his Cherokee ancestors who survived the forced march, and he guarded them for decades before passing the seeds on for safekeeping.

Size: About three acres
Hours: Open daily, including weekends and holidays, from 9 A.M. until 5 P.M.
Admission: Free
Distance from Capitol: Directly in front of Capitol
Telephone: 202-225-8333; Plant hotline: 202-226-4785
Address: Maryland Avenue and First Street SW, Washington, DC
Web site: www.usbg.gov or www.architectofthecapitol.gov

DIRECTIONS

BY CAR: From Virginia, take Interstate 395 to the 14th Street Bridge and continue to Independence Avenue. Go east on Independence to First Street and the USBG. From Maryland, take Route 50 to Bladensburg Road. Go south on Bladensburg to Maryland Avenue, then west on Maryland Avenue to USBG.

BY BUS: The 30S Metrobus stops at First Street and Independence Avenue.

BY SUBWAY: From the Federal Center Southwest stop (red line), go three blocks north to Independence Avenue. The USBG is located two blocks south of Independence at First Street. Walk around to the Maryland Avenue entrance.

United States National Arboretum

A Local Garden With a Global Reach

T he U.S. National Arboretum sits in the nation's horticultural "catbird seat." It is the nation's premier horticultural education and research facility and, at 446 acres, one of the largest gardens in the world. It may also be Washington's

The Capitol Columns

biggest and best-kept secret. While throngs of tourists line the Mall to see the cherry blossoms, equally impressive collections of dogwoods and azaleas bloom here, far from the crowds. The Arboretum also boasts stellar collections of hollies, boxwoods, dwarf and slow-growing conifers, herbs, a prairie and wildflower meadow, extensive fern and native plant displays, and the country's finest bonsai from China, Japan, and North America. Charged with researching and developing trees and shrubs that will thrive in various U.S. climates, the Arboretum has produced many of the best new woody plants in America. The National Arboretum is a national treasure—and a treasury of genetic resources for the future.

HISTORY

The story of the Arboretum is the saga of a dedicated group of men and women who overcame a mountain of bureaucratic inertia to create this botanical mecca. Part of the impetus for the National Arboretum came from England's Kew Gardens, considered by American horticulturists to be a model botanical retreat and research facility. The first formal attempt to make this dream a reality came in 1901 when the McMillan Commission drew up a plan for a combined Botanic Garden and Arboretum near the nation's Capitol.

It took twenty-five years to secure the funds to buy the land for such a grand project. But before that could happen, the country's abrupt entry into World War I stalled discussions. In the late 1920s a bill seeking $300,000 for the initial land purchase was finally drawn up and presented to President Calvin Coolidge. The Bureau of the Budget denied the bill.

Then Mrs. Frank B. Noyes, chairwoman of the Garden Club of America, made a National Arboretum her own personal mission. An amateur gardener and lover of all things green, Mrs. Noyes was also a leading light on the city's social and political scene. And her husband was the publisher of *The Washington Star*. "I will not take 'no' for an answer!" was her frequent refrain. For a forty-five-day period in 1926, features supporting the Arboretum appeared every three days in *The Star*. And, as separate bills authorizing its creation came before the House and the Senate in March 1927, four favorable editorials appeared.

By the end of 1929 the first 190 acres, encircling Mount Hamilton in northeast Washington, were purchased. The land included marshlands, plowed fields, woodlands, farms, and sharply pitched slopes—and it needed a great deal of work. Groves of mature oak, maple, and beech stretched over the slopes of Mount Hamilton. Topographic maps were commissioned along with a site plan. However, plans for the Arboretum had to be shelved again with the onset of the Great Depression.

The Civilian Conservation Corps worked on the site and provided major improvements between 1934 and 1941, when America entered World War II. But by then a temporary nursery was up and running. In 1949 the Arboretum and its azalea collection opened to the public for the first time for just eight days.

TOUR

Start with the **National Bonsai and Penjing Museum.** The bonsai collection began in 1976 with a bicentennial gift of fifty-three specimens from Japan. Many specimens are more than 120 years old, and there is a Sargent juniper *(Juniperus sargentii)* that is 280 years

old. The oldest bonsai in the collection is the 380-year-old Japanese white pine *(Pinus parviflora)*. This ancient bonsai survived the 1945 Hiroshima bombing and was cared for by the same family for six generations.

As you enter the collections along a blue-slate walk, wildflowers carpet the path beneath a small forest of Japanese cedars. Solomon's seal, epimediums, and more—all native

Japanese black pine
(Pinus thunbergiana)

to Asia—help re-create an Asian-inspired walk through a miniature forest. The garden is designed to separate worldly concerns from a spiritual quest. The message— Forget Your Earthly Cares—echoes throughout the peaceful paths of the Arboretum.

Begin with the International Pavilion where displays quickly dispel some enduring misconceptions. Although bonsai is commonly believed to have originated in Japan, China was the first to cultivate bonsai. *Penjing*, meaning "landscape planted in a tray," was an established botanical art form and gardening skill in China more than a thousand years ago. The Japanese imported the art several centuries later.

In all the bonsai pavilions, meditative, light-infused, airy courtyards display the trees in a dignified procession. Benches invite visitors to contemplate the age and grace of the bonsai in each collection. The Japanese also gave the Arboretum six *suiseki*, or viewing stones, which formed the core of a growing collection of stones. These evocative stones are prized both for their geologic and magical qualities. Some look like dragons or fountains; others like clouds or waterfalls or treacherous precipices

sculpted to scale. See if the the Chrysanthemum Stone called Moon Night is on display. The stone looks half plant, half gray onyx. Covered with gray-green, flower-like imprints, it conjures up a magical place with spiritual forces at work. In fact, the feathery "chrysanthemum" blossoms are the result of mineral deposits.

The tropical bonsai room houses plants that need a controlled greenhouse environment to thrive. These include exotic, warm-weather bonsai: Fukien tea, banyan, willow leaf fig, and flowering bougainvillea.

Exit the Bonsai Museum and walk up the road to the entrance of the **National Herb Garden**. Inspired and funded in part by the Herb Society of America, this 2.5-acre garden contains 800 varieties of herbs. The centerpiece of the Herb Garden is the formal Knot Garden, patterned after those prized by Europeans in the sixteenth century. A visitor favorite, the Knot Garden is set in the middle of a gray bluestone courtyard and framed by eighteen-foot arbors entwined with vines. The arbors offer a shady spot from which to contemplate the Knot Garden's geometrically patterned beds, borders, and walkways.

A cottage-style Rose Garden of antique and heritage roses lies next to the Knot Garden. Rose lovers and collectors flock here, as the varieties are all from classes of roses popular in gardens before 1867, when the introduction of hybrid tea roses changed the rose family forever. If roses are your passion, visit the Herb Garden in late May, when these antique specimens are likely to peak. Unlike post-1867 rose generations, most of these older plants bloom just once a year. Two are of special note: *Rosa gallica officinalis*, the Apothecary Rose, the oldest known cultivated rose, made famous in the thirteenth century when apothecaries used it for their

The National Herb Garden

herbal concoctions; and 'American Beauty' (circa 1875). Stands of many varieties of lavender and several varieties of blooming rosemary plants surround the roses. On a warm day the floral bouquet is glorious.

Herbal diversity is the idea in the Theme Gardens. Visitors learn about cultural, pharmaceutical, culinary, and industrial uses of the vast herb family throughout history. The Industrial Garden illustrates how essential herbs were to many discoveries—from paints, plastics, and fibers to machine lubricants. For example, the common castor bean is key to many highly refined lubricants, while soybean seeds are the source of an oil used in the production of paints and varnishes.

The Antibiotics Theme Bed is a popular stop and includes such widely marketed flowers as the coneflower *(Echinacea)* along with St. John's wort, chamomile, and the Oregon grape, prized for its flavonoids. Mints flour-ish in the Medicinal Garden, along with several poppy

varieties, shepherd's purse, and the Pacific yew used to make the cancer-fighting drug tamoxifen. Early American history buffs will find sage, orris, yarrow, and dandelion in the Colonial Garden and learn that the first white Americans used the powdered root of arugula to remove freckles and black-and-blue spots. The small Dioscordides Garden is named for the Greek physician whose book, written in 60 A.D., includes lists of therapeutic plants compiled and saved two thousand years ago.

Next, head for the **Conifer Collection**, which includes the Gotelli Collection of Dwarf and Slow-Growing Conifers. Nestled within a larger twenty-acre collection of full-sized conifers and Japanese maples just below the Dogwood and Asian Valley areas, this seven-acre garden will quickly disabuse you of the notion that all conifers look alike. You can see the subtle variations in shapes, textures, and colors, even the different needle lengths. Yellow and blue conifers stand side by side, with some specimens sprouting brightly colored cones. The unique atlas cedar (*Cedrus atlantica* var. *glauca* 'Pendula'), with branches extending thirty feet, has no upright habit at all. Seek out the dawn redwood (*Metasequoia glyptostroboides*), which can live for a thousand years, and moss cypress

Dawn redwoods (*Metasequoia glyptostroboides*)

(*Chamaecyparis pisifera*), among the other juniper, fir, cypress, arborvitae, hemlock, yew, pine, and spruce on display. These trees are especially beautiful after a light snowfall.

The renowned Gotelli Collection holds more than fifteen hundred dwarf conifers and ranks among the world's most outstanding conifer collections. Interestingly, trees "dwarf" because of climate change, viral disease, insects, bud mutations, or a chance seedling variation. Arborist and collector William T. Gotelli donated the dwarf conifers in 1962 in hopes that further attention to research—and propagations to other arboretums—would resolve complex nomenclature problems that had plagued dwarf conifer enthusiasts for years.

Perhaps it is now time to take on Mount Hamilton and the Azalea Collection, unless, of course, a picnic seems a better idea. If a meal is on the agenda, tables can be found near the thirty-acre **National Grove of State Trees** on the far side of the Capitol Columns. The National Grove nurtures specimen trees sent by every state in the union for display and preservation. California has its redwood, Vermont its sugar maple, Ohio a buckeye, and so on. Planted by volunteers since 1990, the site boasts an attractive semicircular stone teaching wall with botanical drawings and a map to pinpoint each tree.

From the Grove of Trees, head for the **Capitol Columns,** water stairs, and reflecting pool. These 1826 sandstone Corinthian columns, the work of Italian and British masters, were saved when the central east portico of the U.S. Capitol was extended in 1958. After overseeing inaugurations from Jackson to Eisenhower, these dramatic sentinels were warehoused for decades, until they were given a new life here in the late 1980s. They are

illuminated for evening programs, and make a stately backdrop to the tall native grasses, butter-colored rosinweeds, and hyssop-leafed thoroughworts that flourish in the Prairie and Meadow displays in late summer and fall. From your perch among the columns, take in the big-picture view of Mount Hamilton, where thousands of azaleas spread into the woods.

A walk in the woods is the best way to see the **Azalea Collection.** (In fact, you can make the length of your trip through the azaleas long, medium, or short. What follows is the long version. If you want the medium version, just take the Henry Mitchell Walkway, noted below. And if you want the short version, drive along Azalea Road. At the R Street Gate, bear right on Azalea Road. Follow this route past the Boxwood Collection to view the azaleas.) A network of rustic woodland trails follows the contours of Mount Hamilton and allows close-up inspection of the blossoms. If time permits, follow the trail up to the top of Mount Hamilton (elevation, 240 feet) where, on a clear day, you can enjoy a tree-framed view of the Capitol.

The trails through Mount Hamilton wind through one of the most extensive evergreen and deciduous azalea collections in the world. All of the azaleas on the Glenn Dale Hillside are the breeding work of Benjamin Y. Morrison, the first Arboretum director. He envisioned the modern hybrid azalea and successfully married the large blossoms and exciting colors of the tender Indica group with the hardiness of more northerly species. Morrison hybridized the Glenn Dales using plants brought to the Plant Introduction Station in Glenn Dale, Maryland, from Japan. He often used Japanese hybrids dating back hundreds of years. Morrison crossed these to create hardy plants more suited to North American

climates. In 1939 the final Glenn Dale crosses were made with late-blooming Satsukis. Today, the Glenn Dales comprise about 70 percent of the Arboretum's azaleas. To see masses of Morrison's hybrids, start at Glenn Dale Hillside along Azalea Road, where the flowers cover the steep slopes. Nearby, look for the 1952 Morrison Garden, which showcases many of his named selections.

For anyone who wants to learn more, the story of six major azalea hybrid groups is told along the Henry Mitchell Walkway, named for the beloved *Washington Post* columnist whose entertaining garden columns appeared twice a week for many years. (The curator of the collection suggests that you bring a cutting of your favorite azalea and try to find it here.) These hybrids all do well in the Mid-Atlantic area. They include the Glenn Dales, four hundred of which are near and in the Morrison Garden; the Robin Hills (about sixty plants); the tiny-flowered, early-blooming Kurumes, first brought to the United States for the California World's Fair in 1910; the late-blooming, creeping, mounding North Tisburys; the slow-growing, drought-tolerant *Rhododendron kiusianum*, whose tiny flowers make it a great choice for rock gardens (about twenty plants); and the late-blooming Satsukis, a group of azaleas hybridized over hundreds of years that blooms in late May and June. The favorite of many, the Satsuki can display a variety of blooms, colors, stripes, and sectors on the same plant branch. Some Satsuki flowers are four inches in diameter, others a half-inch.

Along the east slopes of Mount Hamilton, late-blooming azaleas near the Frederic P. Lee Garden and Pond extend the season into late May and early June. Lee Garden is diverse, including all sizes of the late-blooming Satsukis:

some ground hugging with large blooms and diminutive leaves, others five feet or taller. Cheek-to-jowl with the Satsukis are the bold yellows and oranges of upright native azaleas. The Lee Garden and Pond can be entered from the Henry Mitchell Walkway.

Prairie dock *(Silphium terebinthinaceum)*

East of the Azalaea Garden and technically a part of the Fern Valley Native Plant Collection are the demonstration Meadow and half-acre Midwestern Prairie. In summer the grasses undulate in the breeze while the prairie flowers lend color and variety. Butterfly weed *(Asclepias tuberosa)*, a perennial milkweed with attractive beaked pods, sprouts everywhere amid the tall summer grasses.

OFF THE BEATEN PATH

The **Fern Valley Native Plant Collection** pays homage to a special, one of-a-kind collection of wildflowers, hundred-year-old trees, ferns, and shrubs indigenous to the eastern United States. The Fern Valley Trail is divided into three sections: a wooded upper trail, with plants typical of the northeastern United States—hemlocks,

white pines, and a collection of ferns and wildflowers; a middle area containing deciduous plants from the Piedmont's woodland area—chestnut, American beech, and carpets of May apples; and a lower portion, featuring plants found in the southeastern U.S.—long-leaf pines, azaleas, magnolias, and rhododendrons.

Fern Valley's glorious canopy of mature tulip poplars, white oaks, and American beech lines a spring-fed stream. One small tree, the Franklin tree *(Franklinia alatamaha)* deserves special mention because of its history. Believed to be extinct in the wild today, this tree was discovered in Georgia in 1765 by botanist John Bartram, who named it after Benjamin Franklin and nurtured it for years.

Started in 1959 by the National Capital Area Federation of Garden Clubs, Fern Valley is home to a prized collection of ferns. The first one up in the spring is fragile fern *(Cystopteris fragilis)*, followed by the aptly named cinnamon fern *(Osmunda cinnamomea)*, which looks as if it had been dipped in the powdery spice. Many fern fanatics visit in June when spores are arrayed in splendiferous detail on the underside of the fronds. Others prefer spring, when ephemeral wildflowers bloom with the unfurling ferns. Small trout lilies *(Erythronium spp.)*, with yellow flowers and leaves speckled like the side of a trout, and Virginia bluebells *(Mertensia virginica)* carpet Fern Valley in early spring. But hurry. They go dormant by June. And don't miss the rare Oconee bells *(Shortia galacifolia)*, tiny mountain flowers that grow in

Cinnamon fern
(Osmunda cinnamomea)

North Carolina and Georgia. The plant was lost to
science for years, only to be repropagated here after its
rediscovery. The dark shiny evergreen leaves and short-
lived fringed white and pale pink bell-shaped flower of
the Oconee bell is a great find in the woods. But its
fleeting bloom lasts for only a few weeks in early April.

BIRD'S EYE VIEWS

If you are hiking or biking, stop at the Beech Spring
Pond or Heart Pond to watch the ducks, geese, and
swans. If you want a serene spot, there is a solitary
bench under a weeping tree just below the hillock
crowned by the Capitol Columns. But the very best view
is from the top of Mount Hamilton. Those who hike to
the top (by following the trail that begins across from
the entrance to the boxwoods) will get a spectacular
view of the Capitol and Washington Monument, espe-
cially in winter when the trees are bare.

GARDEN NOTES

The Oldest Tree — Don't leave the Arboretum without
making a special trip to see the two-hundred-year-old
willow oak *(Quercus phellos)*. This very special tree—
about a hundred feet tall with a one-hundred-foot
spread—was already a century old when the present site
was acquired. It has long, narrow leaves reminiscent of
the willow and is located within the research field at the
center of the Arboretum.

Pine Tree Extraordinaire — South of the walled
Morrison Garden you'll find a lacebark pine *(Pinus
bungeana)* with gray-white peeling bark. This fifty-year-
old beauty is one of the largest in the United States and
one of the most beautiful of the introduced pine trees.
Its foliage is a dark green and, unlike most pines, its
needles last up to five years.

Information Central — The Herbarium was one of the first endeavors of the Arboretum, but it is not about the fragrant plants you chop or crumble into your soups. The Herbarium is a collection of six hundred thousand dried plant specimens, with a focus on cultivated plants. It is invaluable to scientists the world over.

For Daphne-ophiles — If you visit the Gotelli or Asian collections in late March or early April, look for the uncommon lilac daphne *(Daphne genkwa)*. Deciduous and a spring bloomer, this shrub literally showers itself with flowers of the purest shade of lavender. It is more cold-tolerant than its evergreen relatives and more sun-tolerant as well.

Lilac daphne
(Daphne genkwa)

Azalea Watch — Since 1990 the earliest reported peak azalea bloom has been April 15, the latest May 4. Some late bloomers last well into June. To better plan your visit, call the Arboretum or consult the Web site's Azalea Blossom Watch (www.usna.usda.gov). If you plan to visit during peak bloom, come early on weekdays or arrive by 9 A.M. on weekends.

R & D — The Arboretum is famous for its research program and germplasm collections, which preserve plants for their valuable genetic material. Single-genus groupings include hollies, crabapples, azaleas, daffodils, magnolias, boxwoods, daylilies, peonies, dogwoods, and maples. Besides doing wide-ranging developmental research on the hardiest, most disease-resistant trees, shrubs, and floral plants, researchers also work with the floral and the nursery industries to develop new

technologies and to evaluate superior plants. For the home gardener, the Arboretum promotes new methods for disease detection and control, including environmentally sensitive models.

Hot Horts — To learn more before your visit, and to see what Arboretum curators rank as this week's blooming pick, visit the Arboretum's Web site.

Horticultural Mecca — The Arboretum's library, collections, and sprawling grounds are open daily to horticulturists, plant geneticists, and everyday plant lovers. Professional and amateur botanists come here to identify hard-to-locate specimens by using the Herbarium, with its six hundred thousand dried plant specimens. To use the ten-thousand-volume reference library, call the librarian for an appointment (202-245-4538).

Size: 446 acres
Hours: Open daily, except Christmas Day, 9 A.M. until 5 P.M.
Admission: Free
Distance from the Capitol: Three miles
Telephone 202-245-2726
Address: 3501 New York Avenue, NE, at 24th and R Streets, NE, Washington, DC
Web site: www.usna.usda.gov

DIRECTIONS

BY CAR: From northwest Washington, follow New York Avenue east to the intersection of Bladensburg Road. Turn right (south) onto Bladensburg Road and go four blocks to R Street. Make a left on R Street and continue two blocks to the Arboretum gates. From the Maryland suburbs, take the Capital Beltway (Interstate 495/Interstate 95) to exit 22B (Baltimore-Washington Parkway) toward Washington. Follow the Baltimore-Washington Parkway approximately seven miles to Route 50 West (New York Avenue). Once on Route 50 get in the left lane. You will approach the intersection of Bladensburg Road, where only the two left lanes turn onto Bladensburg Road. Make the left onto Bladensburg Road and go four blocks to R Street. Make a left on R Street and continue two blocks to the Arboretum gates. From Virginia, follow Interstate 395 north over the 14th Street Bridge. Take the U.S. Capitol exit and follow New York Avenue signs. Follow signs until the freeway ends at New York Avenue. Turn right onto New York Avenue and follow New York Avenue east to the intersection of Bladensburg Road. Turn right onto Bladensburg Road and go four blocks to R Street. Make a left on R Street and then continue two blocks to the Arboretum gates.

BY SUBWAY: On weekends and holidays, except December 25, enjoy direct shuttle service from Union Station by hopping on the X6 Metrobus. The bus operates every forty minutes. On weekdays, the closest Metrorail subway stop is Stadium Armory Station on the blue and orange lines. Transfer to Metrobus B2; disembark from the bus on Bladensburg Road and walk north two blocks to R Street. Make a right on R Street and continue two blocks to the Arboretum gates.

The Bishop's Garden

Close Encounters of the Medieval Kind

The Bishop's Garden has never looked new. Nestled close beneath the National Cathedral, this contemplation garden was intended to complement the Gothic cathedral and serve as a private garden for the bishop. The garden was planted with mature boxwood—including donations from the homes of Presidents Washington, Jefferson, and Madison; atlas cedars brought from the Holy Land in 1901; and majestic yews. The idea in creating the Bishop's Garden

The National Cathedral

was that plantings should be appropriate to cathedrals of the fourteenth century—primarily evergreens and ivy, with no bold displays. From the day it opened in 1928, it has provided a sense of permanence and of tranquility.

HISTORY

The idea of a national cathedral began almost when the nation did—in 1791, when George Washington and Pierre L'Enfant, the architect who planned the capital, envisioned "a great church for national purposes and a house of prayer for all people." It took another century to get funds and a congressional charter. In 1898 the first bishop of Washington, Henry Yates Satterlee, began acquiring land for the cathedral. When landscape architect Frederick Law Olmsted, Jr., began to lay out the close, or cathedral grounds, in 1907, the site was still country and the hillside home to wild dogs. Neither Wisconsin nor Massachusetts Avenue extended outside the city.

Comprising a little more than three acres of the fifty-seven-acre close, the enclosed Bishop's Garden sits just below the cathedral on its sunny south side. Protected from the wind, the garden nestles on this warm slope of Mount St. Alban almost like a sunken garden—with a growing season that can extend into November and December. Towering above the garden and visible from every point, the cathedral emphasizes the intimate human scale of the garden.

Florence Bratenahl, wife of the cathedral's first dean, joined forces with Satterlee and Olmsted to design and create the garden. She founded All Hallows Guild in 1916 with the mission of raising funds for the upkeep of the close landscape. Their work began when the site

held only piles and piles of dirt dumped from the hole dug for the cathedral's foundation. She solicited boxwood from mature gardens throughout Maryland and Virginia; secured stone (dating to George Washington's time) from Old Town Alexandria when the city installed new curbs; and designed the broad flight of fifty-one steps (built of sandstone from George Washington's Aquia Creek quarry) leading from the eastern end of the garden up to the south transept of the cathedral. But she didn't stop there. Through people like sculptor and collector George Grey Barnard, she acquired much of the garden's Gothic sculpture, including its prized Carolin-gian baptismal font.

TOUR

There are several entrances—but most visitors enter from South Road through the dramatic **Norman Arch**. The Norman Court entrance is built of local stone to set off the two twelfth-century arches dismantled in France and reassembled here. As you make your way through a shaded, winding corridor leading from the Norman Arch, you pass under the outstretched arms of native American hollies and silvery-blue atlas cedars (*Cedrus atlantica* 'Glauca'). Continue down the steps walled with plush, seven-foot English boxwood and edged with hosta, silver lamium *(Lamium maculatum)*, and many ferns, including silver-splashed Japanese painted fern (*Athyrium nipponicum* 'Pictum'), filigree fern, Vidal's fern, lady fern, cinnamon fern, and tassel fern.

At the bottom of a flight of steps, peace descends. You can hear the gentle music of falling water splashing over old stone into **St. Catherine's Pool** in the garden below. The pool is in the shape of a primitive cross. Expressing what many feel, one visitor stopping at the bottom of

the stone steps put it simply: "Ah! This is Heaven on Earth." The Bishop's Garden is one of the few gardens in the United States where an Old World granite bas-relief saint kneeling in prayer is entirely authentic. In the wall above the pool, St. Catherine (on the far left of a fifteenth-century sculpture) holds her traditional wheel, and a saint (on the far right) holds a palm—symbols that identify them as martyrs. Also acquired from the collection of George G. Barnard, the bas-relief carving was donated to the garden in 1937. Sweet-scented mid-summer blooms of *Hosta* 'Frances Williams' catch late afternoon light above St. Catherine's Pool along with irises and *Juncus*, an aquatic grass. And occasionally a heron swoops down to drink from the pool and catch an unwary goldfish.

Directly below the pool is a **Foliage Garden** filled with evergreens and plants of interesting textures and quiet blooms. In the center stands the weeping styrax (*Styrax japonica* 'Carillon'), a small graceful tree that blooms in spring. Statuesque *Fothergilla* and other specimen shrubs such as evergreen rosemaries, *Daphne* 'Carol Mackie,' and the rosette-shaped leaves of *Euphorbia robbiae* make this an impressive winter garden.

Continue east along the **Upper Perennial Border.** What draws many to the Bishop's Garden is its Old World feel. Not only two-hundred-year-old boxwood or ancient stone or yews—but timelessness. The Celtic Cross, near St. Catherine's Pool, dates from the early Christian pilgrimages of the Middle Ages. Inscribed on the cross are the letters IHS—the sacred monogram of Christ (in Greek it is *Ihsous*, meaning "Jesus"). On the eastern end of the border there are rare old plants such as the medlar tree, which was a staple of the monastic garden. The medlar bears small, brown-skinned quince-

Upper Perennial Border

like fruit. Though some, including Geoffrey Chaucer, have called the medlar a "homely tree," this one *(Mespilus germanica)* in the Upper Perennial Border stands its venerable ground. As do the Michaelmas daisies in fall and other plants that would have been as familiar to the monk in his cloister as they are to us walking the garden today. Though there are splashes of color here from tulips in spring to asters in fall, white blooms are especially effective in the Upper Perennial Border, where they unfurl season by season. Along the walk, white butterflies ripple the *Heuchera sanguinea* 'June Bride' or shasta daisies or 'Snow Lady' mums or white sneezewort or *Phlox* 'David' or Japanese anemones *(Primula japonica* 'Honorine Joubert'). And above the stone wall at the eastern end of the Perennial Border, a Japanese pagoda tree *(Sophora japonica)* with creamy white panicles of flowers makes a spectacular show in midsummer. The pure-white blossoms seem made for the biblical and Christian themes so thoughtfully executed here.

The granite statue of the Prodigal Son at the eastern end of the **Rose Garden** presents a more modern view. This contemporary sculpture, donated to the garden in 1961, sits among soft mounds of curly boxwood (*Buxus microphylla* 'Curly Locks'). The mounded forms of the boxwood complement the circle of father and son and reinforce the serenity of the garden. The statue of the Prodigal Son, based on the biblical story of the forgiving father and the returning son, occupies a niche near a Chinese winter hazel *(Corylopsis sinensis)* that blooms in March. The warm, picture-postcard view of the winter hazel lighting up the statue is part of the plan. Garden designers and horticulturists at the garden try not only for seasonal but also for monthly interest in an informal setting where nothing is too formally pruned or symmetrically displayed. From Mother's Day through the fall, you can smell the roses—mostly floribundas and hybrid teas—that occupy the center of the garden. The inclusion of a rose garden in this medieval garden is thought to have been Olmsted's and Bratenahl's effort to provide a fragrant experience for the blind or those with failing sight. The coral-pink *Rosa* 'Perfume Delight' is one of the most pungent.

A standard element in a monastic garden was the kitchen garden. The Bishop's Garden modern equivalent is the **Sundial Garden**. An eighteenth-century English bronze sundial sits atop a thirteenth-century Gothic capital of limestone from a ruined monastery near Rheims Cathedral in France. It also was acquired in 1928 from the collection of George G. Barnard. Here salvias, sages, artichokes, ginger mints, lavenders, fennel, garlic chives, rosemary, bee balm, germander, southernwood, along with sunflowers and moon vines on teepees, are all conveniently labeled. At the eastern end, a giant pyramidal boxwood *(Buxus sempervirens)* provides a striking example of this shrub grown tall.

Continue around the Sundial and Rose Gardens and down the steps just south of the enclosed garden, to the **Huidekoper Border**—where a range of blue blooms last well into the fall. Cranesbill geraniums and bluish-purple pansies in spring give way in weekly waves to sage, false indigo, centaurea, purple thistle, and campanula. A tree peony (*Paeonia* 'Tamafuyo') with double blooms—as big as tissue-paper corsages—is a dependable favorite for spring visitors.

Tree peony *(Paeonia suffruticosa)*

OFF THE BEATEN PATH

The **Hortulus**, meaning "little garden," is one of the smallest spaces in the Bishop's Garden and the only true period garden on the cathedral grounds. The Hortulus features geometric raised beds encircling a baptismal font reputedly carved in the time of Charlemagne, Emperor of the Holy Roman Empire. Herbs planted here were used in ninth-century monastery kitchens or infirmaries. One of the sources used in planning the Hortulus was the St. Gall (Switzerland, 830 A.D.) physic garden plan, a record of an ideal, if not actual, monastery garden. The plan listed sixteen herbs and flowers—ten of which appear in the Hortulus. The main difference is that at St. Gall, herbs would have been chosen for their medicinal properties and space allotted accordingly. Other sources for plant materials here come from Charlemagne's plant list (812 A.D.), a map of a Benedictine monastery (820 A.D.), and a poem titled "Hortulus." Written by the Abbot Walahfrid Strabo in 849 A.D., the poem includes this simple dictum: "Though a life of retreat offers various joys / None, I think, will compare with the time one employs / In the

study of herbs, or in striving to gain / Some practical knowledge of nature's domain. / Get a garden! What kind you get matters not."

Sit on a cool stone in the Hortulus, and you will yearn for an herb garden. You have to look no farther than the robust sage *(Salvia officinalis)* to imagine all those medieval pots of beans made edible, even tasty, by this common plant. (To say nothing of the sage ales and sage teas to soothe nerves, or sage as a chewing herb to whiten rotting teeth.) On a quiet morning in the Hortulus, it is easy to conjure up the monastic or cottage plot where herbs bloomed. In May the purple blooms of the sage in combination with the feathery *Artemisia* and the *Iris germanica* 'Florentina' make a charming display next to the *Rosa gallica officinalis*, or Apothecary Rose. The oldest known rose, the gallica's flowers framed by boxwood surrounding the font present a timeless signature. Used in everything from rose windows to rose water, the *Rosa gallica* with its upright blooms was the best variety for medieval rosaries, though medieval gallicas were probably wilder and more treelike than their modern forms.

The clary sage *(Salvia sclarea)*, a medieval favorite rarely seen today, is another spectacular inhabitant of the Hortulus. Its translucent, lavender-and-orchid blooms on a stalk, which can grow to several feet, adorn big, sweet-scented, sandpapery leaves. Called clary, or clear-eye, the plant's leaves infused with water were used as an eye-wash. Other June bloomers complement the coarse-leaved clary: daisylike buds of feverfew; tall, celery-scented stems of lovage topped with airy yellow blooms; lacy white caps topping stalks of coriander; along with tansy, dill, rue, and parsley. No wonder one medieval tavern keeper's wife in a Chaucerian tale boasted of her herb garden: "For comers to the house, right a sportful sight."

171

No matter what the season, a visit to the Bishop's Garden should include a few moments in the **Shadow House** at the lower end of the garden. The octagonal Shadow House gazebo, built from stones from President Grover Cleveland's summer house, once located near here, provides eight "windows of opportunity." The gazebo's Gothic windows frame some of the garden's largest, most dramatic vistas: a silhouette of the dawn redwood *(Metasequoia glyptostroboides)* said to live for a thousand years—effectively set off against the massive cathedral; snow-dusted hollies and yews, their branches aglow with bright red cardinals in slanting sun; the blue drifts along the lower walk below a perfectly pyramidal copper beech; the May-blooming golden chain tree (*Laburnum watereri* 'Vossii') brushing the southwest window of the Shadow House; the ornamental Sundial Garden with goldfinches feasting on seeds; a blaze of autumn woodland at the bottom of Pilgrim Road shielding the close from the noisy city below.

Perhaps the best view of the Bishop's Garden and one of the best in the city is from the seventh-floor observatory in the cathedral tower. (Access is from the West Front of the Cathedral and then up to the seventh floor on the elevator.) There you can see why L'Enfant and Satterlee and others wanted this particular hill for the site of the National Cathedral. You can also see the Capitol and the Potomac River and Maryland and Virginia. And from there, you can look down on a garden for the ages. "For who knows," Florence Bratenahl reflected in a speech delivered on Easter 1932, "but what the days beyond our own may have . . . a craving for stillness . . . more poignant than the urgency of this hour?"

The Oldest Rose *(Rosa gallica officinalis)* — The petals of the Apothecary Rose, the oldest known rose, were used by apothecaries in the Middle Ages to make tonics, astringents, purgatives, and eyewashes. Records of the gallica date back to 1200 B.C. when the Persians used a gallica as a religious emblem. The gallica was also adopted by Henry IV as the model for the Red Rose, the emblem of the House of Lancaster.

The Tallest Tree *(Metasequoia glyptostroboides)* — Known as the dawn redwood, this spectacular tree towers over the garden as the cathedral does. Growing to more than a hundred feet, the dawn redwoods, native to China, were only rediscovered in the middle of the twentieth century.

A Sacred Plant *(Taxus baccata)* — Several huge yews dominate the Bishop's Garden. Look for them at the eastern end of the Perennial Border. Yews are among the oldest sacred plants. Yews were regarded by the Druids, the priests and learned class among the Celts, as connected with birth and death. From yew wood, the Celts made spears and shields. And their sacred rites were often held in groves of yew. Legend has it that even Robin Hood's bows were made from yew wood.

Olmsted Walk — When you leave the garden, exit through the gate at the eastern end, through the yews, and then head down the Pilgrim Steps to Pilgrim Road. You will be facing a statue of George Washington on horseback—and the Olmsted Woods. When Frederick Law Olmsted, Jr., laid out the Cathedral close in 1907, these woods were part of his design. At that time, Massachusetts Avenue did not extend to this point, and

he intended these five acres southeast of the Cathedral to be part of the approach to the cathedral. The woods were a chance, as he put it, to "brush off the hurly-burly of the city" and enter a more contemplative realm. It took almost a century to realize that vision. But today, the woods are being preserved. Water runoff problems are being solved, soil issues addressed, and invasive exotics removed. The woods are being restored to their native state as primarily an oak, beech, and mixed hardwood forest. Wildflower Walks are conducted in March and April, and a Nature Trail will soon be in place. Take the winding stone path through the woods and enjoy the wildflowers and flowering shrubs. Or sit in Contemplation Circle and observe the cathedral of trees, how the tulip poplar and chestnut oak and tupelo live and grow. If you are a follower of Thoreau, you will be reminded of his words: "In wildness is the preservation of the world."

Medieval Artifacts — The massive Carolingian baptismal font, sitting in the middle of the Hortulus, was acquired for the garden from George G. Barnard in 1928. The oldest garden sculpture in the city, if not the nation, it is thought to have been carved in the time of Middle Ages ruler Charles the Great (742–814), or Charlemagne, who conquered and united much of western Europe. Fonts such as this one were found in cathedrals in the Middle Ages. Another medieval artifact, acquired from the collection of George Barnard in 1928, is the Bird Font, or Birdbath, in the Upper Perennial Garden. It is a thirteenth-century capital of limestone from the Cluny monastery in Provence, France. The French philosopher Abelard, who lived from 1070 to 1141, and was the partner of Heloise in one of the most famous romances in history, died at the monastery in Cluny. He and Heloise were later buried together in the Pere-Lachaise cemetery in Paris.

Cathedral Greenhouse — Herbs and other plants for modern gardens—and many that can be seen blooming in the Bishop's Garden—can be obtained at the Cathedral Greenhouse. Look for Katherine of Tarragon (named for Catherine of Aragon, Henry VIII's first wife) the greenhouse cat, who suns herself among the herbs.

Size: Three acres
Hours: Open daily, 9 A.M. until 5 P.M.
Admission: Free
Distance from Capitol: Four miles
Telephone: 202-537-5596
Address: Wisconsin and Massachusetts Avenue, NW, Washington, DC
Web site: www.nationalcathedral.org

DIRECTIONS

BY CAR: From Virginia, take the Beltway into Maryland to the Wisconsin Avenue/Bethesda exit. The cathedral is about six miles south on Wisconsin Avenue. From Maryland, take the Beltway west and exit south on Wisconsin Avenue. Continue for about six miles to the cathedral. From the District of Columbia, take Wisconsin Avenue north, or take Massachusetts to its intersection with Wisconsin Avenue.

BY SUBWAY: The Tenleytown/AU station (red line) is closest to the cathedral. Then take a 30S Metrobus about a mile and a half south on Wisconsin and get off at Massachusetts Avenue.

BY BUS: Take the 30S Metrobus along Wisconsin, or the N buses along Massachusetts, or the 90 and 92 buses along Woodley Avenue.

Enid A. Haupt Garden

Paradise Revisited

A t first glance, it looks like a plush colorful carpet, rolled out in front of the Smithsonian Castle. But this welcome mat, known as the Victorian Parterre, is only the threshold. So step across and enjoy Enid's Eden. The garden sits atop the underground complex that houses the museums of Asian and African art. Stretching between the Castle, the Arts and Industries Building, the Freer Gallery of Art,

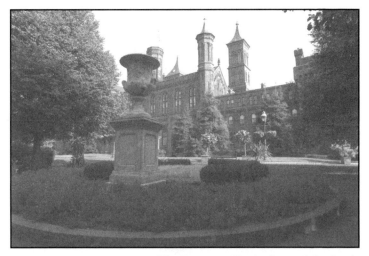

The Downing Urn in front of the Castle

176

and Independence Avenue, this garden is not only rooftop but also front yard. Envisioned several decades ago by S. Dillon Ripley, the eighth secretary of the Smithsonian, the garden also offers its own round-the-world spin. Ripley imagined the garden as a reflection of the history of landscape architecture, as he put it, "from Marrakech to Mindanao." By that he meant that as one of the last open spaces on Independence Avenue near the Mall, it should become not only a pleasure ground but also an icon of the latter-day Smithsonian Institution showcasing cultures from around the world. In particular, the garden had to introduce people to the new museums dedicated to African and Asian art—and serve as an appropriate setting for the Castle, the Smithsonian's original building (completed in 1855). It was a grand vision, and it took almost two decades to accomplish. It is a design in three parts: the Victorian Parterre in front of the Castle recalls the Smithsonian's past; the Moongate Garden, located in front of the underground Sackler Museum of Asian Art, represents the Asian influence; and the Fountain Garden, located in front of the underground Museum of African Art, suggests the African influence. The living garden is a haven for contemplation and a meeting ground for people of every culture.

HISTORY

What is today the Enid Haupt Garden was for about 140 years the South Yard. Originally intended as a pleasant garden for the Smithsonian staff in the mid-1800s and later used as a site for solar research by an early secretary of the Smithsonian, it has changed character many times. From 1880 to 1895 bison were penned here as part of research and conservation meas-

ures undertaken by Smithsonian scientists. The bison were moved to the National Zoo when it was established in 1890. During World War I the U.S. Army Signal Corps erected quonset huts here, which housed air and space exhibits. In the 1930s solar observations were carried out in a carriage house in the South Yard. In the *Sputnik* years of the late 1950s and 1960s, rockets and other artifacts were displayed here. Eventually they were moved to the Air and Space Museum when it was completed in 1976. This prime real estate was even used as a parking lot. Then a Victorian garden was installed to celebrate the U.S. bicentennial in 1976.

The Enid Haupt garden has been designed with many connections to the past. The Arts and Industries building, which opened in 1881, was built to house the forty-five boxcar loads of objects left over from the 1876 Centennial Exposition in Philadelphia. It was that exposition's Victorian parterre—a sunken ornamental garden with patterned flower beds in the best nineteenth-century fashion—that inspired the one in the Haupt Garden today. The parterre's beds still change with the seasons. And antique cast-iron furniture and replicas of gaslight lampposts remain as emblems of the Victorian era. Horticulture and history are linked to the era when the Smithsonian was created, long before the Haupt Garden was built.

Fern settee

178

But Dillon Ripley was looking toward the twenty-first century when he envisioned this space. By the 1980s Ripley had not only engaged architects and planners but also started raising money for his pet project. At that time, he approached Enid Annenberg Haupt, a friend and well-known philanthropist interested in horticultural projects. As the story goes, he asked—and she said yes. Her only condition was that it should be a mature garden. "Can you guarantee that the plants will be . . . so large that when I walk into the garden on opening day it will feel like a mature garden? . . . Since, you know, Dillon, I am getting on." Ripley told her that would require "three million dollars." And the deal was done. In the following years Enid Haupt consulted with the horticulturists and landscape architects Jean Paul Carlhian and Lester Collins and others on plant materials and plans. The garden opened in May 1987.

TOUR

Enter through the **Renwick Gate** on Independence Avenue. As you walk through the gate, originally intended for carriages, notice that it is on axis with the south door of the Castle. Designed from an 1849 sketch by James Renwick, Jr., architect of the Castle, the gates were not produced in Renwick's lifetime. Beside the gate, four stone pillars, made from red Seneca sandstone also used in construction of the Castle, were intended as an entrance for visitors on foot. Two littleleaf lindens *(Tilia cordata)* flank the gate.

Proceed along the **Victorian Parterre**. This centerpiece garden looks old, but it is reborn every few months and completely redesigned every few years. This rectangular lawn is planted with violas and pansies in spring (up to three thousand of them in some years); colorfully

179

patterned variegated plants such as coleus or Joseph's coat in summer; and ornamental cabbages and kales in the fall. The pansies, which bloom through mild winters, are almost always part of the plan. (No doubt their velvety petals and delicate exterior gave the word "pansy" its negative connotation—but these tough little troopers are anything but!) And other plants such as heather (another interesting hardy plant with weatherproof color) and spring-flowering bulbs such as hyacinths and tulips are added in with the pansies to make interesting patterns in spring. In summer, succulents such as echeveria, bright bloomers such as bougainvillea, and others are added to the mix.

The swirls or garlands or diamonds of plants in the parterre are edged with little wickets of black cast-iron, shaped like bent twigs and cut boughs. (These must be removed by the garden staff every time they mow the grass.) Accenting the Victorian motif, baskets filled with blooms hang from the lampposts. Framing the parterre and blocking the view of the busy street are ten saucer magnolias *(Magnolia x soulangiana)*, five on each side. Delicate-looking but hardy, these are the "mature" trees that Enid Haupt requested. With roots that spread outward more than downward, they were carefully chosen for a rooftop garden. When they bloom in early April— one of the first signs of spring—they seem worth all the dollars and devotion it took to plant full-grown trees in soil deep enough to anchor and nourish them on the rooftops of underground museums. And the soil itself was no small issue. When the garden opened in 1987, the soil's pH was 8 or 9—too alkaline for many plants. The ideal for most plants is 6 or 7. The staff still works to achieve that with everything from worms, which aerate the soil, to amending the soil with sulfur, top dressing, and other aeration techniques.

From the Victorian parterre, continue west to the
Moongate or Granite Garden. Sitting opposite the
Sackler Gallery of Asian Art, the garden is modeled
on the Temple of Heaven in Beijing. In China the circle
isa symbol of Heaven. Large granite circles are used here
as both gates and seating. The idea of a contemplation
garden reaches its most dramatic expression inside the
moongates. Stark and severe, it is a marked contrast to
the other parts of the garden. Yet, if you gaze through
its moongates on opposite corners of the garden, as if
you were gazing through keyholes, you'll see that they
frame other parts of Smithsonian's past, the Freer
Gallery of Art to the west and the Arts and Industries
Building to the east.

At the center of the garden an island sits in a shallow
square pool with four bridges reaching over it. The
black granite at the bottom of the pool adds to the
illusion of an island surrounded by water—and to the
garden's mood of solitude and contemplation. The
theme of squares and circles finds expression in the two
nine-foot moongates, accented by a weeping Japanese

Moongate Garden

181

cherry tree *(Prunus subhirtella* 'Pendula'*)*. There are echoes of the past here as well. Look up to the diamond-shaped picture window in the pavilion of the Sackler Museum of Asian Art. That shape was inspired by the pyramidal roof of the Victorian-era Arts and Industries Building east of the Haupt Garden. Along the wall of the pavilion, katsura trees *(Cercidiphyllum japonica)*, especially lovely in their fall coloration, often the stone wall. To the west is a magnificent weeping beech (*Fagus sylvatica* 'Pendula'). Beyond the beech, form and function enjoy a perfect union. Abundant ropes and loops of wisteria *(Wisteria sinensis)* camouflage the museum's loading dock in a mass of purple blossoms in spring. If you visit the garden early in the morning or late in the evening, you are likely to find people doing tai chi or sitting cross-legged in the lotus position gazing into the middle distance.

To the east, beyond the Victorian parterre, lies the **Fountain Garden**. As you enter this garden, the sweep of Ripley's goal of reflecting the history of landscape architecture "from Marrakech to Mindanao" comes full circle. Outside the African art pavilion, this garden of paved walks and fountains displays its Moorish influence— its echoes of Marrakech. It is a summer garden and hence a water garden. Atop its benches, its Moorish origins are also preserved in rivulets or troughs that recall the four rivers of paradise.

Wisteria *(Wisteria sinensis)*

182

The centerpiece of the garden is an eight-foot jet of water that spurts up and spills down right in the middle of this courtyard. It is made for Washington's hot summers. Here young and old shed their shoes in a flat garden, which provides no curbs or barriers to stub toes or twist ankles. Some dart through the spray and others sit and draw inspiration from the soothing rhythms of splashing water.

At the north end a veil of water covers a stone wall. Called the *chadar*, or waterfall, it was inspired by the Shalimar gardens of India. Surrounding the garden, the bubblers in the benches channel water back to the waterfall. Suggesting many views of happiness—whether Persian, Moorish, or American—this is primarily a place to get cool. Around the Fountain Garden, four dense hedges of ligustrum *(Ligustrum japonica)* reinforce the idea of a walled garden. (In ancient Persia, the word for paradise, *pairidaeza,* translates as an "enclosure, or walled garden.")

The garden's paving and fountains are also reminiscent of the Alhambra gardens in Spain. The diamond shape of the garden recalls the picture window of the Sackler. Look up to the picture window of the African art museum and you will see a circle. It is designed to echo the Moongate Garden as well as the round arches of the Freer Gallery and to provide another example of the cross-fertilization that various cultures have exerted on the design of these buildings—and on the global village we live in.

Continue to the east and then back toward the Castle and you will come to the **Downing Urn.** Though he died in a tragic steamboat accident at the age of thirty-seven, Andrew Jackson Downing was considered America's first

important landscape designer. In his midtwenties he was already attempting to develop an American aesthetic of landscape gardening. He encouraged circular carriage drives and gravel walks in an attempt to achieve rural retreats and parklike settings in a nation growing more industrial and urban. After touring the Mall at the invitation of President Fillmore in 1850, Downing presented his recommendations to the Smithsonian regents in 1851. His main goal was to establish a public park and groves of trees (all scientifically labeled) in the middle of the capital city—features he had observed in Paris and London. Though it is hard to believe today, there were no public parks in the largest cities in the United States in the mid-1800s.

A year later, Downing died. Shortly after his death, the American Pomological Society (dedicated to the horticulture of fruit trees), which he founded, created a subscription for a memorial to Downing. In a Victorian age, a memorial urn was decided on and designed by Calvert Vaux, another noted landscape designer. Erected on the site of Downing's proposed national park, the urn has been on the Smithsonian grounds since 1856. After more than a century in the open air, the urn is badly deteriorated. Though the handles and various elements have been repaired, conservators have recommended that the urn be moved inside. Currently at home here in the Haupt Garden, it is a tribute to Downing's enduring and far-reaching influence.

OFF THE BEATEN PATH

On the opposite side of the garden, next to the Freer Gallery, lies the **Perennial Walk**. The only real flower walk in the garden, the perennial bed features ornamentals, shrubs, and vines that are summer standouts. Start

at the corner where the Darlington oak (*Quercus hemisphaerica* 'Darlington') shades the walk and proceed down the brick-and-granite path. In summer the Perennial Walk features choice and hardy perennials. One eye-catcher is the cloverlike oxalis *(Oxalis regnellii)* with its three leaflets that close at night and look like purple butterflies on a stem. Other bold ornamentals include cranesbill geraniums (*Geranium* 'Brookside'), a magenta clematis (*Clematis* 'Gravetye Beauty'), and the African blue lily *(Agapanthus africanus)*. The spiky blue-green leaves of the upright euphorbia *(Euphorbia characias)* are a dramatic counterpoint to the arching habit of the ornamental grasses, such as *Miscanthus* 'Morning Light', and the bright gold panicles of the golden rain trees across the path. The long-lasting true-blue blooms of the salvia *(Salvia guaranitica)* are another great addition to this roster of tough and beautiful plants. At the end of the perennial walk, you'll see an aged stone lantern. A centuries-old ornament for an Asian garden, the lantern is a reminder of the international character of the garden and of the world-class Freer Gallery of Asian Art next door.

If you're interested in seeking out a niche garden far enough off the beaten path to be downright hidden, then cross back to the other side of the garden to the west terrace of the Arts and Industries Building. Duck into the little grassy area and around the wall, where you'll probably enjoy solitary splendor even in the middle of the summer tourist season. In this protected courtyard, the plants are typical of more southern climes. The crape myrtles (*Lagerstroemia indica* 'Muskogee') and the eucalyptus *(Eucalyptus cinerea)* and the viburnums *(Viburnum cinnamomifolium)*, with their lacy white flower clusters and blue-black berries, thrive in the heat and survive the cold better in this

enclosed space. Added to the gray-greens of the eucalyptus and the mottled bark of the crape myrtles are the variegated pinks, greens, and golds of the coleus plants along the south wall. And if you want to gaze all the way to Asia, look through the glass window and the stairwell of the African art museum to the Asian art museum on the opposite side of this little world.

BIRD'S EYE VIEW

Since the Haupt Garden is a rooftop garden, built atop the Asian and African art museums, it is not easy to find a place to look down on it. What it lacks in overlooks, however, it makes up for in axial lines and geometric paths. Go to the easternmost point of the garden, next to the Arts and Industries terrace, and face west. There you will get the telescopic view: Ahead, the diamond shape of the Fountain Garden merges with the lush patterns of the Victorian parterre and lines up perfectly with the granite keyhole of the Moongate Garden. In one long sweeping gaze, you can see it all.

Looking toward the Fountain Garden

Settees and Urns — Cast-iron furniture had become an important part of the garden scene by the mid-1850s. Displayed in private gardens, conservatories, and in cemeteries, Victorian garden furniture was manufactured for mass consumption in a limited number of designs. One of these designs was the fern settee, or bench. Four fern benches can be found on the eastern side of the garden, on the north terrace of the Arts and Industries Building. Other replicas of these designs include a squirrel settee and a swan settee, displayed along the walk in front of the Castle. A morning glory chair and grape chairs can be found near the Downing urn.

The Linden Tree — The Haupt Garden and the underground museum complexes were constructed around a venerable old European linden tree that grew between the Castle and the Arts and Industries Building. It was planted at the time the Castle was built in the 1850s. A major element in the design of the Haupt Garden, it was a testimonial to the importance of our history, of what had come before. The picture window of the African pavilion was centered on the tree. The linden was pruned and fed during the construction period from 1983 to 1987 and protected by a fence. Despite valiant efforts during the construction, this old glory fell on January 3, 1989, a year and a half after the opening of the garden. The Downing urn now stands where the linden grew.

The Tallest Trees — A pair of ginkgoes *(Ginkgo biloba)* flank the south entrance to the Castle. Ginkgoes, which can grow up to eighty feet, are also long-lived. Some species live more than a hundred years, and most get better with age. The ginkgo is one of the oldest trees; it has been growing on Earth for 150 million years ago and its fossil links go back almost 250 million years.

A Tree for All Seasons — At the northeastern corner of the garden, where the Castle walk meets the walk bordering the Perennial Garden, a compact Darlington oak (*Quercus hemisphaerica* 'Darlington') shades the walk. Unlike most oaks, it is evergreen in warmer climates such as Washington. Smaller than most oaks, it is also faster-growing and happy in most soils. With all of these virtues, it is a great choice for almost any garden.

A Perennial Garden — Though it's not actually part of the Haupt Garden, the Mary Livingston Ripley Garden lies just beyond in a courtyard of the Arts and Industries Building. Mary Ripley, wife of Dillon Ripley, the eighth secretary of the Smithsonian, created this garden as a haven for the disabled and a sensory delight for all visitors. Meticulously labeled, it is also a learning center. A virtual horticultural library, the thousands of plants here were selected for their color, fragrance, texture, and year-round interest. The nineteenth-century cast-iron three-tiered fountain and urn in the center of the garden echo the Victorian era—but this popular spot (with packed tours every Tuesday) is definitely a crowd pleaser for the twenty-first century.

Butterfly Boulevard — Located on a narrow strip of green along the east side of the National Museum of American History, this is the first of the Smithsonian's habitat exhibits. And habitats abound: meadow, woodland, urban, and wetland homes for butterflies stretch along the stone walk. More than two hundred woody plants and twenty-five hundred herbaceous plants lure tiger swallowtails, silver-smooth skippers, and more.

Size: Four acres

Hours: Open daily, except Christmas Day, from 6:30 A.M. until 5:45 P.M.

Admission: Free

Distance from Capitol: About half a mile

Telephone: 202-357-1300

Address: 1000 Independence Avenue, SW, Washington, DC

Web site: www.si.edu/gardens

DIRECTIONS

BY CAR: From Virginia, take Interstate 395 to the 14th Street Bridge and continue to Independence Avenue. Go east on Independence to the gates of the Haupt Garden at 1000 Independence Avenue. From Maryland, take Route 50 to Bladensburg Road. Go south on Bladensburg to Maryland Avenue, then west on Maryland Avenue to Seventh Street and left on Seventh Street to Independence. Continue to the gates of the Haupt Garden at 1000 Independence Avenue.

BY BUS: The 30S Metrobus stops at First Street and Independence Avenue. Continue to Seventh Street and Independence and walk to the gates of the Haupt Garden at 1000 Independence Avenue.

BY SUBWAY: The Haupt Garden is located near the Mall, directly across from the Smithsonian Metrorail stop on the blue and orange lines. Its front entrance is on Independence Avenue just west of Seventh Street.

Federal Reserve Board Garden
The Bank's Backyard

The folks who mold national banking policies are mysterious enough. But who would have guessed that hidden behind the formal facade of the Federal Reserve Board building is an engaging garden with eye-catching geometry, whimsical sculptures, swaying ornamental grasses, and whooshing fountains? The rear garden of the Federal Reserve's

The garden's signature grasses

Martin Building offers a bold example of landscape design used as a counterpoint to severe architectural lines and classical style. The garden's interest stems from the irregular lines, shifting elevations, and relaxed plantings that soften this austere financial institution and make it not just approachable but actually inviting. The garden's unveiling in 1977 changed the face of public gardens and thrust landscape architects Wolfgang Oehme and James van Sweden onto the national stage. Three decades later the New American Garden—the name now given to the style of landscape design they created—endures in many gardens around Washington and across the United States.

HISTORY

In 1913 President Woodrow Wilson created the Federal Reserve System to regulate the banking industry and stabilize financial markets. Prior to this, banks used a patchwork of policies that often triggered monetary crises. In 1935 the Federal Reserve Board chose to consolidate its growing staff in a new building on Constitution Avenue and launched a juried competition for a design. It was the height of the Great Depression, but officials overseeing the selection wanted to replace the monumental scale, classical references, and symbolic ornamentation of Washington's public buildings with a more aesthetically appealing style.

Adolph Miller, then chairman of the Federal Reserve's building committee, urged architects to favor simplicity over decoration. The winning design by Philadelphia architect Paul Philippe Cret was an interpretation of the Beaux-Arts style—with its foundations in Greek and Roman architectural traditions. The result: the Eccles Building facing the National Mall on Constitution

Avenue between 20th and 21st Streets. The impressive four-story building with a glowing white marble exterior possessed the grandeur befitting a powerful agency but with Miller's mandate for simplicity.

In the 1970s a second building was designed for the Federal Reserve Board. Called the Martin Building, it sits directly behind (or north) of the Eccles Building. It was with the landscape design of the Martin Building that the team of Wolfgang Oehme and James van Sweden first made their mark. When the harsh winter of 1977 devastated the garden's yews and magnolias, Oehme and van Sweden were invited to submit a design for the Reserve Board's rear garden.

The formally landscaped public space behind the Board's Martin Building was exactly the opportunity the landscape architects wanted. At a time when American public and private gardens were dominated by tired formulas of foundation plantings and clipped lawns, van Sweden and Oehme pioneered new ways of looking at outside space. Their designs infused gardens with new energy and signaled the death of what van Sweden called the "the cemetery look"—a tight, limited palette of predictable plants.

Nowhere was this new garden concept more energetically at play than in the design presented to the Federal Reserve Board in 1977 for its backyard. Oehme and van Sweden stressed low-maintenance plants and a relaxed style. Along with a line of willow oaks that enclosed the garden, the plan featured lavish clumps of swaying ornamental grasses, bold sweeps of black-eyed Susans and other perennials, and open lawns with jagged edges and tucked-away seating nooks. The team's slide show of their proposed garden stunned the bank board into

silence. One commissioner suggested the design was too informal for gardens at the Martin Building. However, the day for relaxed styles had come. In the debate that followed, informality won out. Within the week Oehme and van Sweden were cast in the role of free-spirited architects for the public gardens of the Federal Reserve.

TOUR

Begin your tour of Oehme and Van Sweden's signature garden at corner of 21st Street and Virginia Avenue, on the northwestern side of the Federal Reserve Board complex near the Martin Building.

As you walk east on Virginia Avenue, willow oaks *(Quercus phellos)* block out the sky and focus your attention to your right. Follow the iron railing to the entrance of **Edward J. Kelly Park**. (Kelly was superintendent of the National Capital Parks from 1950 to 1958.) On the right, yuccas (*Yucca filamentosa* 'Adam's Needle') greet you as you enter the park, edging the perennial bed that runs along Virginia Avenue. Crape myrtles *(Lagerstroemia indica)* lean out between park benches that are tucked among the perennials and face the trapezoidal lawn. The focal point here is the statue of a discus thrower atop a Corinthian pillar. The classical sculpture plays off the more modern sculptures in front of the Martin Building—and underscores the contrast in styles between the

Yucca (*Y. filamentosa* 'Adam's Needle')

two Federal Reserve buildings. The gardens of the Martin Building play with norms to showcase divergent styles of art, architecture, and landscape design.

As you circle the statue and enjoy the perennial beds, you may notice that the elevation of the park shifts. The park is filled with these subtle land heaves, creating optical illusions in line and perspective. Walk along the perimeter of Kelly Park and you come to a dramatic drop in elevation, the tennis courts. The most unexpected element of this public space, the tennis courts easily could have dominated the park's panorama and could have become a less-than-natural focal point. But by recessing them below street level, Oehme and van Sweden confined them visually to make the public space a more private one, whether you are grabbing a bite or lobbing the ball.

From the tennis courts, continue to the **Central Green Space**. Walk over to the sculpture of the baseball pitcher and look over his shoulder. Across the lawn, in your line of sight, a batter, catcher, and umpire anticipate the pitch. This sculptural grouping is a sharp departure from the classical lines of the discus thrower—yet somehow the two pieces of art work together. The classical column in Kelly Park gives that triangular niche a serene and contemplative air. The smoothly shaped baseball figures add an element of fun to what might otherwise be a somber park at the foot of a megalithic monetary institution. Vastly different in style and subject, the two sculptures celebrate athleticism. One symbolizes individual strength in its classical form; the other highlights the focus, anticipation, and strategy of America's favorite team sport.

Baseball players in the Central Green Space

The baseball players—positioned in a straight line—parallel the path to the right of the lawn. And this central "lawn" is neither traditional nor predictable. Irregularly shaped, it has edges that turn in sharp angles—which force you to constantly adjust your line of vision. Look over the shoulder of the pitcher and you'll see an Oehme and van Sweden trademark, a big bed of waving ornamental grasses. The grasses and the lawn sculptures soften the building's imposing lines and add a bit of playfulness. Several kousa dogwoods and a stand of large magnolias *(Magnolia virginiana* and *M. grandiflora)* anchor another triangular wedge near the baseball figures.

From the baseball catcher, continue toward the tennis court through the allée of elmlike Japanese zelkovas *(Zelkova serrata)*. Outlining the perennial bed before you, the irregular angles step out sharply. These beds

hold some of Oehme and van Sweden's signature plants: 'Autumn Joy' (*Sedum* 'Herbstfreude') and several of the grasses they like to use *(Carex morrowii, muskingumensis,* and *pendula).* The berm and plantings help to shield the park from the street and mask the intrusion of the tennis court. You'll also find St. John's wort *(Hypericum calycinum)* and colorful summer-blooming black-eyed Susans (*Rudbeckia fulgida* 'Goldsturm') massed under the thornless honey locusts *(Gleditsia triacanthos inermis)* bordering the tennis court. Natives and exotics, the plants are not only informal and relaxed but also durable and hardy in city gardens.

The park benches near the berm exaggerate the diagonal lines along the opposite side of the path. The beds on the embankment near the tennis courts are laid out in triangular wedges, where ivy and liriope alternate, one bed pointing up, the other down. Though geometric, the effect is one of light-hearted fun rather than of strict conformity. Brightly colored tulips crown this raised berm in spring, adding their bold whimsy. Never taking itself too seriously, the Federal Reserve Board garden is restful, playful—and quirky.

BIRD'S EYE VIEW

Return to just south of the tennis courts for the most dramatic and sweeping overlook of the Federal Reserve Board grounds. From here the angularity of the park's borders, the use of horizontal lines, the ways trees soften and shape the vertical space around the lawns, and the mounded berm all come into focus. The discus thrower and the baseball players, visible from here, draw your eye back to the lawns and remind you of the playful spirit of the garden.

Lunch by the fountain or take a timeout in the **Robert Latham Owen Park** on the eastern side of the Martin Building. A circular terrace steps down to the base of the enormous fountain that dominates the plaza. Water rockets skyward, breaks against squares of rock, and flows out and around the circular pool. The sounds of the water's whoosh and fall create a peaceful white noise that blocks out nearby traffic. The lawn to the east of the fountain is encircled with beds decorated with sedum, daffodils, tulips, and a lush grouping of grasses. At center stage is a circular sculpture called "Bloom." Created in 2001 by Wendy Ross, the sculpture is all angles and shiny metal, and yet it bears an amazing resemblance to a black-eyed Susan—one of Oehme and van Sweden's signature plants.

For a bonus fountain experience, make your way to Constitution Avenue to the front of the Eccles Building. In summer follow the path of red and pink astilbe as you exit Robert Owen Park. Continue south to Constitution Avenue and the National Mall and you will be facing the Federal Reserve Board's white marble Eccles Building. Two formal courtyards—complete with fountains and

"Bloom" in Owen Park

plantings—flank either side of this building. This plaza, with its matching sunken fountain gardens, stands in stark contrast to the Oehme and van Sweden garden behind the Martin Building. A large urn fountain draws you into the courtyard to the left of the main entrance. The octagonal shape of the pool mirrors the courtyard's outline. Step down into the recessed courtyard and enjoy the whirls of black and white rock dramatically inlaid on the path surrounding the fountain. With its magnolias, weeping cherries, and holly hedges, this garden is a more formal and sedate space—and one consistent with the classical Beaux Arts design of the Eccles Building.

GARDEN NOTES

Founder's Fountain — Owen Park was named for Robert Latham Owen (1856–1947). A member of the Cherokee Indian nation, he was also a U.S. Senator from Oklahoma from 1907 to 1925. As first chairman of the Senate Banking and Currency Committee, Owen pushed the bill creating the Federal Reserve System. Before that, this remarkable man was a teacher, lawyer, banker, and businessman. The park memorializes Owen's long legacy.

Tree Transitions —The Federal Reserve Board garden took on its current design in 1977, when the yews and magnolia trees here suffered severe winter damage. Oehme and van Sweden redesigned the gardens using more cold-tolerant deciduous trees. The Japanese pagoda tree *(Sophora japonica)*, dogwoods *(Cornus kousa)*, willow oaks *(Quercus phellos)*, sweet bay magnolia *(Magnolia virginiana)*, Southern magnolia *(Magnolia grandiflora)*, and the Amur cork tree *(Phellodendron amurense)* are among those that made the cut.

Grasses R Us—The lavish use of ornamental grasses is an Oehme-van Sweden trademark. Some favorites include feather reed grass *(Calamagrostis x acutiflora* 'Karl Foerster'*)*, Japanese sedge *(Carex morrowii)*, drooping sedge *(Carex pendula)*, and purple blooming Japanese silver grass (*Miscanthus sinensis* 'Gracillimus'). Many of the plants used in the Federal Reserve Board garden, including the feather reed grass, had never before been used in American landscaping. Their debut in the Federal Reserve Board garden has led to widespread cultivation of ornamental grasses in nurseries across the nation.

Size: About two acres
Hours: Open daily from dawn to dusk
Admission: Free
Distance from the Capitol: Two miles
Telephone: For tour information, contact the Board's Office of Visitor Services at 202-736-5507.
Address: The Federal Reserve Board garden is a triangular patch of land that lies between 21st Street and C Street on Virginia Avenue.
Web site: None

DIRECTIONS

BY CAR: From areas north of Washington, D.C., take 16th Street south to K Street. Turn right on K Street and continue to 21st Street. Turn left on 21st and continue to Virginia Avenue. Turn left on Virginia Avenue. The park is on the right.

BY SUBWAY: The nearest subway stop is the Foggy Bottom/GWU Metrorail station, which is a fifteen- to twenty-minute walk. Exit the station and turn right onto 23rd Street. Continue about three blocks to Virginia Avenue. Turn left onto Virginia and go about three blocks to the Federal Reserve Board garden, between 21st and C Streets.

Folger Shakespeare Library's

Elizabethan Garden

Knot of Our Time

W
alk a block east of the Capitol to the
Folger Shakespeare Library and travel
back five centuries—to the renaissance of
British gardening. Sit in the Elizabethan
garden, and you will find a small formal knot garden,
representative of the age of Elizabeth I and William
Shakespeare. As elaborately conceived as the embroidered
costume of a sixteenth-century Elizabethan, this tightly
woven "knot" is all pattern and structure and design.

Armillary sundial in the Knot Garden

The rose was the emblem of the Tudor dynasty, and during the Tudors' rule garden making became an art practiced in gardens great and small. The Tudor dynasty ushered in more peaceful times and an end to the dark warring days of feudalism and civil war known as the War of the Roses. During the reign of Elizabeth's father, Henry VIII, monastery lands, which were confiscated from the Catholic church, were parceled out to nobles. Great gardens were created for the king and for the nobles who had acquired the monastery lands. The scientific study of botany was launched. Herbals and gardening books became more widely available. During Elizabeth's long reign (1558–1603) the initiative for making great gardens passed from the crown to the nobles. It was Britain's Golden Age. And it neatly coincided with the life of Shakespeare (1564–1616).

The outstanding feature of Elizabethan gardens was the square knot garden—and such gardens were common in Shakespeare's time. In his history play *Richard III*, Shakespeare compares England's chaotic past to a garden, "her knots disordered, and her wholesome herbs / Swarming with caterpillars." The knot garden was probably named for its imitation of embroidery patterns common in household arts. Popular "Turkey carpets" (what we call Oriental or Persian rugs) also are thought to have inspired knot garden designs. Though the simple knot pattern existed in medieval gardens, it was Elizabethans who fully expressed its potential for complexity and extravagance.

Knot garden geometry often reflected the designs of the half-timbering on Tudor buildings. Typical country estate gardens imposed formal control by placing a symmetrical knot in each corner of the garden or as the

focus of a central bed. The garden was also ordered with gravel paths and rectangular beds and enclosed with a hedge or wall. In the knot garden—often placed beneath the windows of a main room—boxwood, rosemary, lavender, thyme, chamomile, germander, and other herbs were planted in a pattern and trimmed to keep the interlacing knot neat. A closed knot was planted with herbs or flowers filling in the spaces in the formal knot pattern. An open knot used evergreen herbs for form with colored sand filling the spaces in between.

Landscape designer John Webster designed the knot garden for the Folger Shakespeare Library in 1988. Without the patterns of Tudor architecture to mimic, Webster patterned his designs on the patterns found in the art deco designs on the east wall and the balcony of the Folger facing the garden.

TOUR

As you approach the gate at the north end, you get your first glimpse of the garden through the diamond patterns of the iron fence—a preview of the **Knot Garden's** design. At a glance you can see that the entire garden is enclosed on three sides by hedges of holly (*Ilex meserveae* 'Dragon Lady') and laid out in a carefully proportioned grid. Inside, the garden contains several rectangular beds symmetrically arranged around two squares of lawn with the Knot Garden in the center. Like the confining laces and corsets of Elizabethan dress, an Elizabethan knot garden strictly ordered the chaos of nature. In keeping with the Elizabethan sense of design, the herbs in the Folger's knot and the roses on the trellis are the only plants allowed to break out of their rigid enclosures and draw attention to themselves with a subtle interplay of color, texture, and scent. Bold colors were considered gaudy in Elizabethan gardens.

Cross the lawn to the **Central Bed** and you may catch the scent of rosemary, thyme, or the white rose of York (*Rosa alba* 'Madame Plantier'). Each has meaning. In Shakespeare's *Hamlet*, Ophelia identifies the meaning of rosemary very clearly: In her 'mad speech' she says, "There's rosemary, that's for remembrance; pray, love, remember." The white rose, too, had its own significance. The white rose of York and the red rose of Lancaster— symbols of the warring factions in the War of the Roses—combined to create the symbol of the Tudors, the Tudor Rose.

Rose of York (*Rosa alba* 'Madame Plantier')

Boxwood (*Buxus sempervirens* 'Suffruticosa') forms the big X in the center of the Folger knot. Complementing that is a diamond of germander *(Teucrium chamaedrys)*, another herb useful for its tight, low-growing form. A member of the mint family, germander was popular for knots and edgings. Together, the germander and boxwood provide the main structure of the Knot Garden. Within this pattern, various herbs fill the spaces in a less structured, but still quite ordered, way: Rosemary and lavender are kept neatly clipped. Clove pinks *(Dianthus)* and chamomiles, which give color variety to the patterns, require more pruning and deadheading. According to one household account from Elizabethan times, a fastidious earl of Northumberland was so concerned with keeping his garden in order that he employed a gardener "to attend *hourly* in the garden for . . . clipping of knottes and sweeping the said garden."

Flanking the central bed, the soft simplicity of woolly thyme offsets the more complex pattern in the middle. Introduced to England by the Romans, thyme was used not only for ground cover and "turf benches" (soft seats) in Elizabethan gardens but also as a preventive for sciatica, plague, and warts. It was also used in beer as an antidote to shyness and thought to be a cure for hangovers and nightmares.

The Knot Garden seen from the balcony

Before you move on, sit on the bench and enjoy the scents and shapes. Look toward the wall of the Folger, and you will be reminded by the diamonds on the railing of the balcony (which point downward to the boxwood X) of how assiduously nature was tamed to fit Elizabethan ideals. At the center of the knot, taking the place of a simpler sundial, is an armillary sphere, popular in the seventeenth century. It is set within a diamond at the center of the knot. With rings for the equator, meridians, and tropics, the sphere has an arrow

set parallel to Earth's axis. The arrow casts the shadow to tell the time. And it echoes Shakespeare's coat of arms—a spear on the diagonal—which you can see in the plaster ceiling of the Folger's Great Hall.

OFF THE BEATEN PATH

The pattern was the point in Elizabethan gardens. So it is not surprising that the designer of this garden made much of the patterns on the Folger's east wall facing the garden. The wavy line on the wall beneath the balcony gets worked into the far ends of the garden. There, low serpentine boxwood hedges frame the north and south shaded borders. Wild daffodils native to Wales grow in ivy *(Hedera helix)* behind the hedge. And hellebores *(Helleborus orientalis)*, known as Lenten roses, grow in the recesses of the undulating green line of hedge. A plant associated with mystery since ancient times, the hellebore was used in Elizabethan times to get rid of flies, treat melancholy, kill rats and bedbugs, and by sorcerers to make themselves invisible!

Hellebore *(Helleborus orientalis)*

Shading these beds on either end are pairs of Southern magnolias *(Magnolia grandiflora)*. They were planted by Emily Jordan Folger in the 1930s. These aristocratic evergreens, native to the southern United States, were not known to Britons in Elizabethan times. They made their way across the Atlantic a few decades later in the late seventeeth century. A bit anachronistic they are—but their leathery leaves and huge fragrant flowers seem perfectly appropriate in this formal, stately setting.

Before leaving the garden, take time to view the knot garden from above, as it was meant to be seen. Stately gardens of the times were often positioned beneath windows in main rooms and halls, or approached from a terrace commanding a view of the garden. Broad flights of steps usually led to and from these terraces. In the Folger garden, a miniversion of this plan allows you to look down on the Knot Garden. Climb the steps to the small balcony **Overlook**, and you will see the pattern.

From the balcony you can view the application of Rule Number 1 for knot gardens: Make a layout in accord with the house. The crisscross embroidery of the boxwood and of the diamond of germander, within rectangular raised beds, harmonizes with the balcony's grillwork, just as Elizabethan knots harmonized with the geometries of Tudor architecture.

Rule Number 2 was to plant the beds with a mix of flowers to blend colors and textures. From the balcony you can see the rich purple flower spikes and the gray foliage of the lavender, the pale blue blossoms of the silver-green rosemary, the white flowers of the woolly thyme, the feathery greens of the chamomile, the bright jagged pinks of the dianthus, and more—all mingling in a rich mosaic.

Rule Number 3: Grow a garden for all seasons. Even in winter, visitors can enjoy the pattern in the evergreen and semievergreen plants. Like Elizabethans seeking recreation in their gardens, twenty-first-century gardeners can climb the stairs and find the same pleasures.

Rule Number 4 dictated that a knot garden must indulge the sense of smell as well as sight. From the balcony the pungency of the roses, magnolia blossoms, lavender, thyme, and rosemary make the point. Shakespeare also said it in *A Midsummer Night's Dream*. Describing the bank where Titania sleeps, Oberon says: "I know a bank where the wild thyme blows, / Where oxlips and the nodding violet grows, / Quite over-canopied with luscious woodbine, / With sweet musk-roses and with eglantine. / There sleeps Titania sometime of the night, / Lulled in these flowers with dances and delight." In Elizabethan times, fairies were thought to be especially fond of thyme. But for all Elizabethans, the scents of herbs and of flowers "refreshed the head, stimulated the memory, and were even antidotes for the plague."

GARDEN NOTES

A Rose is a Rose is a Rose — There are more than seventy references to roses in Shakespeare's works, more than to any other flower. But many other plants are mentioned as well, including numerous weeds—one hundred fifty references in all. He also sets twenty-nine scenes in gardens.

Over the Back Fence? — John Gerard, author of the most famous herbal of Shakespeare's time, published in 1597, lived in Monkswell, the London neighborhood where Shakespeare also lived. It is likely that they knew each other—and that Shakespeare visited his renowned specimen garden. Shakespeare would certainly have known Gerard's book on herbs.

Plant Lore — Elizabethans relied on plants for multiple uses: household compounds, cosmetics, medicines, even magic potions. In Elizabethan times plants retained the symbolic meanings that they held in ancient times: rosemary for fidelity (brides wore garlands in their hair), friendship, and remembrance (used in burials then and still planted on graves in England today); fennel for flattery and folly; rue for repentance and regret; daisy for wantonness; violet for faithfulness and purity. Surprisingly, Elizabethans did not use herbs for cooking.

Clove pink
(Dianthus)

Lavenders and Pinks — The word "lavender" comes from the Latin verb *lavare,* meaning "to wash." Until the nineteenth century, English washerwomen were called lavenders. The herb was also used in washing clothes—and bodies. Pinks (also known as clove pinks, gillyflowers, gillyvors, and sops-in-wine in Elizabethan times) were often mentioned in Shakespeare's works and in Chaucer's as well. There were fifty varieties of pinks recorded in the seventeenth century. At first, however, these flowers, now known as *Dianthus,* were not pink. They were called pinks because their jagged edges looked as if they had been trimmed with pinking shears, or "pinct."

Shakespearean Headliners — In the garden you will find four cast-bronze interpretations of speeches by Prospero (in *The Tempest),* Brutus (in *Julius Caesar),* Hamlet, and Lear (in *King Lear).* They are half-size renderings of pieces by American sculptor Greg Wyatt for the garden at New Place, Shakespeare's residence at the time of his death, in Stratford.

Linden Tree — Behind the rose trellis is a linden *(Tilia cordata)*, a favorite tree used for the art of pleaching in Elizabethan times. To create an arbor, the Elizabethans planted trees with flexible branches, such as the linden, down two sides of a path.

Size: Less than an acre
Hours: Open Monday through Saturday, 10 A.M. until 4 P.M., closed on federal holidays.
Admission: Free
Distance from the Capitol: A block
Telephone 202-544-7077 or 202-544-4600
Address: 201 East Capitol St., SE, Washington, DC
Web site: www.folger.edu

DIRECTIONS

BY CAR: From Virginia or the south, take I-395 N across the Potomac River toward Washington. Take the left exit to C Street, SW, and the U.S. Capitol. Continue across South Capitol Street, where it becomes C St., SE. Turn left onto Second Street, SE, and then turn right at East Capitol Street, where the Folger is located. From Maryland or the north, take Connecticut Avenue, 16th Street, or North Capitol Street south. Turn left onto Massachusetts Avenue, go past Union Station, and continue on Massachusetts Avenue, NE. Turn right onto Second Street, NE, then left at East Capitol Street.

BY SUBWAY/BUS: From Union Station, take the 96 Capitol Heights M bus or walk away from the front entrance of the station toward Massachusetts Avenue, NE, turning right at First Street. Go left at East Capitol Street and continue one block to the Folger.

Franciscan Monastery Gardens

A Century-Old Cloister

There are more roses in the churchyard of the Franciscan Monastery of Washington than you are likely to see in one garden ever again. The monastery's Romanesque-Byzantine church, topped with a gold dome, sits in a colonnaded cloister. To the west of the churchyard lies

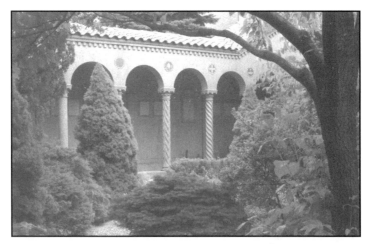

The Rosary Portico

a shady valley garden carved out of the hillside by Franciscan monks at the beginning of the twentieth century. Predating many of the area's oldest gardens, the monastery gardens have been open to the public since 1899. This meditation garden offers a secluded spot, faithfully maintained by the brotherhood, for pilgrims from around the world.

HISTORY

The Order of St. Francis became the official guardians of the holy shrines in Jerusalem more than seven hundred years ago. Today the Franciscans maintain a large presence in the Holy Land, running refugee centers, schools, and caring for the gardens and shrines holy to Jews and Christians alike. The Franciscan Monastery in Washington was established by Father Godfrey Schilling as a training school for monks on their way to the Middle East. In 1897 Reverend Schilling was inspired to create the monastery as he strolled these grounds on what had been a grand estate. His vision also included creating a series of contemplation gardens and buildings that faithfully replicate holy shrines in Rome, Jordan, Israel, Egypt, and Syria. A century ago a pioneer group of friars joined Reverend Schilling, bringing considerable horticulture and gardening knowledge with them.

One of these pioneers was Brother Meinrad Wiget. Coming to the friary in the early part of the twentieth century, he worked for more than sixty years to create a landscape style that combined formal elements with native plants on the rolling forty-four-acre monastery site. Brother Meinrad created the first rose gardens in the early 1900s. During his long tenure as the head gardener, he worked to maintain the greenhouses and to create hillside gardens that replicate those at

Gethsemane and Lourdes. He also built up the collection of exotic and tropical plants, which he wintered in the monastery's nurseries—bringing many from the Middle East. Many of the lovely hemlocks, spruce, and magnolias that tower over the Valley Gardens here today were planted by Brother Meinrad. By the 1940s, visitors by the thousands were making their way to the monastery gardens.

TOUR

Step into the world of the Franciscans and follow the **Rosary Portico** to your left to the Statue of St. Francis in the churchyard. Standing in front of the church, the statue depicts St. Francis encouraging a young boy to release captive turtledoves. This statue, and many other features in the garden, re-create stories and events from Christian history. Next to St. Francis in the churchyard stands a statue of Father Schilling, founder of the monastery. Around them, in every direction, are roses. In spring, bulbs and annuals provide seasonal color along with Siberian squills *(Scilla siberica)*, Spanish bluebells *(Hyacinthoides hispanica)*, and snowdrops *(Galanthus nivalis)*.

Spanish bluebells
(Hyacinthoides hispanica)

Continue around the courtyard to the **Portiuncula Chapel.** Six arching arbors heavy with 'Blaze' climbing roses frame the chapel. To craft this reproduction of a simple chapel in Assisi, Italy, where St. Francis lived with his first followers, acclaimed local sculptor John

Earley used rough, multicolored Potomac River stone. True to the spirit of St. Francis, the garden around the chapel contains junipers and many plants with berries that feed the birds in winter. Though St. Francis admonished his followers to "leave patches of weeds for the butterflies and the birds," there are few weeds here. The beds are immaculate and filled with specimen plants. Hundred of daffodils bloom in March; Oriental lilies follow in June. Ferns and perennials fill outer beds.

Follow the Rosary Portico all the way around to the other side of the church. Sculptor John J. Earley, who invented its concrete mosaic, created this quarter-mile colonnade in 1926 from an aggregate of cement and tiny multicolored pebbles of Potomac River stone. Mosaic panels featured within the fifteen alcoves in the colonnade, also created by Earley, commemorate the fifteen mysteries of the rosary—fifteen events marking sorrowful, joyful, and glorious occasions in Christ's life. Each of the alcoves is separated by colonnades with ten pairs of columns representing the ten Hail Marys in each section of the rosary. Ceramic tiles lining the cloister display the Ave Maria in 150 languages— including Egyptian hieroglyphics, Chinese pictographs, and many African and Native American languages. Lush beds of fragrant lily-of-the-valley *(Convallaria majalis)*, with their perfect tiny bells in spring, line the arched colonnade near the entrance. Along this arcade it is common to see nuns, monks, and other pilgrims meditating in the cloisters. Imagine Jerusalem or Tuscany a thousand years ago.

At the end of the Portico, next to the Friary and the gift shop, is the **Herb Garden**. Though it was planted in May 2000, the herb garden looks like a Mediterranean garden that might have been planted many centuries ago

in the Holy Land, where the Franciscans continue their mission as stewards of sacred places. The selection of plants in the Herb Garden is based on biblical references and features mustard, grape vines, and scented herbs such as hyssop (used medicinally and for purification). In the Old Testament, Moses told the Jews to paint their doors with hyssop or lamb's blood to escape the Angel of Death. Tall stalks of ornamental onions add flowers and color. In midsummer, wheat, symbolizing the body of Christ taken in Communion, grows in the center bed. The location of the Herb Garden, near the Friary, also has historical roots, since medieval monks were known for their homeopathic herbal cures and tonics.

At the foot of the Herb Garden is the entrance to the **Lower Garden.** A small band of monks under the direction of Brother Meinrad hollowed out and landscaped this ravine using a team of horses in 1912. The idea was to faithfully reproduce gardens from the Holy Lands and from the Grotto of Lourdes in southern France. There, Catholics believe, the Virgin Mary

The Grotto of Lourdes in the Lower Garden

appeared to Bernadette Soubirous in 1858. Containing magnificent oaks, towering hemlocks, and flowering shrubs, the Lower Garden creates a peaceful, meditative setting. About halfway down the hillside walk is the Grotto of Gethsemane. It is meant to replicate the Garden of Olives in Jerusalem, where Christ went to pray on the eve of his crucifixion. The Grotto was dedicated in 1916. Woodland perennials surround the Grotto: Lenten roses, Virginia bluebells, and bleeding hearts.

At the center of the Lower Garden is the Grotto of Lourdes. 'New Dawn' roses climb twenty feet up the outside of the cave. Along the walkways red cedars with lichen-covered trunks—like a row of upright pillars—suggest a forest cathedral. Dedicated in 1913, the Grotto is a popular place for sunrise Easter services.

Farther west at the bottom of the valley, beyond the Shrine of St. Anne, open meadows stretch to make up most of the monastery's forty-four acres. In early summer, yellow buttercups and wild mustard grass carpet the sloped hillside. As recently as the 1950s the fields held a vineyard, vegetable garden, orchard, and dairy. While none of these enterprises remain today, this was once a working farm.

Follow the winding path up the hill toward 14th Street, past the Stations of the Cross. The fourteen Stations depict the last day of Christ. European Franciscans imported this tradition of walking the stations of the Cross from Palestine in 1219. A leafy lane of oaks, punctuated by cedars, forms the backdrop. On Good Friday hundreds of pilgrims repeat the centuries-old religious ritual. No one knows the name of the monk who constructed these stations, but they were dedicated in 1916. At the top of the hill is a domed reproduction

of the Chapel of the Ascension. Flanked by double rows of hybrid tea roses and surrounded by hollies, this shrine re-creates the one thirteenth-century crusaders built on Mount Olivet to consecrate the spot where, they believed, Christ ascended into heaven.

OFF THE BEATEN PATH

Retrace your steps to the Portiuncula and look behind it to Mary's Garden. A Japanese cutleaf maple *(Acer palmatum)* cascades over a small waterfall pool. Azaleas surround the garden beneath a canopy of dogwoods.

BIRD'S EYE VIEW

Stand at the entrance of the Lower Gardens in front of the mosaic of Our Lady of Guadalupe and look down on Brother Meinrad's woodland oasis. It was Meinrad's hope that this garden—hollowed out of a hillside— would reflect St. Francis's belief that it is through nature that man most readily experiences the divine. Below, a canopy of hemlocks, tulip poplars, magnolias, and firs tower over the legacy of Brother Meinrad.

GARDEN NOTES

Exotica — From late spring until October the center island surrounding St. Christopher, patron of travelers, showcases tropical and subtropical plants. It was Brother Meinrad's intention to introduce these unfamiliar specimens, native to the Holy Lands, to lend an exotic air to the gardens. So each May, gardeners crate out princess and date palms *(Phoenix dactylifera)*, oleanders, bananas, and lantanas from their winter home in the greenhouse and replant them here next to stands of yucca and scattered elephant's ears *(Colocasia)*. Most dramatic are the angel's trumpets *(Brugmansia sp.)*,

which the brothers introduced to North America from Africa. Carefully cultivated for decades, these shrubs have creamy white trumpets that perfume the evenings and fill the courtyard with scent from summer to fall.

St. Jude and The Topiary Garden — The shiny, dark-green yew can be mounded into gumdrops, sculpted into pyramids, or carved into rectangular wedges and dense hedges. Here the versatile conifer *(Taxus)* is stamped into symbols of faith, including an anchor (for hope), a heart (for charity), and a cross (for faith) to enclose St. Jude, patron saint of impossible causes.

Biblical Lore — Monastery head gardener Joe Arsenault admits to having a soft spot for roses with Biblical or religious names. Sprinkled among the courtyard beds are the floribunda 'Our Lady of Guadalupe'; the hybrid tea 'Ave Maria'; the David Austin rose 'St. Cecilia,' named for the Christian martyr and patron saint of music; and the multihued climber 'Joseph's Coat.'

The Nose Knows — One of the sweetest-smelling roses here is the aptly named, extravagantly variegated, pink and scarlet 'Scentimental,' at the southwest corner of the church.

Rosa 'Scentimental'

Wildlife on the Wing — The U.S. Fish and Wildlife Service says that more than sixty species of migrating birds stop off at the monastery grounds each year. St. Francis would no doubt smile on those statistics. Butterflies and bees also congregate around the Valley Garden's bee balm, butterfly bushes, and Oriental lilies.

217

Garden Guild — Formed to help with the ongoing revitalization of the gardens, the Franciscan Monastery Garden Guild brings new cultivars to the garden annually. The biblical garden, several bluebird and purple martin houses, and a memorial holly hedge are other projects. To volunteer or learn more, call 202-526-6800.

Size: Forty-four acres
Hours: Open Monday through Saturday, 9 A.M. until 4 P.M., Sundays, 1 P.M. until 4 P.M.
Admission: Free, donations welcomed
Distance from Capitol: Four mile
Telephone 202-526-6800
Address: 1400 Quincy St, NE, Washington, DC
Web site: www.pressroom.com/~franciscan

DIRECTIONS

BY CAR: From North Capitol St. and Michigan Avenue, follow Michigan Avenue east past Trinity College, the National Shrine of the Immaculate Conception, and Catholic University to Quincy Street, NE. Turn right and go three blocks to 14th Street.

BY SUBWAY: The closest subway stop is Brookland on the red line. Buses run between the subway and the monastery.

Old Stone House
Washington's Oldest Plot

Y ou could walk past and miss it. It is a modest, unassuming little house. But, as the sign out front tells you, the Old Stone House is the only surviving pre-Revolutionary building in Georgetown. A local legend preserved this simple eighteenth-century structure as "George Washington's Headquarters" long enough for it to survive. Rescued from a used car dealership, the property was purchased by the federal government in 1953. Today this small dwelling, with its garden, is a special sliver of history— a glimpse of a town lot laid out in the mid-1700s.

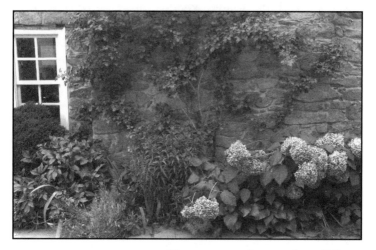

The cottage garden seen from M Street

In 1764 Christopher and Rachel Layman came from Pennsylvania with their two sons and purchased Lot Three, on which the Old Stone House now stands, for one pound, ten shillings. They built a one-room house, on what was then known as Bridge Street (now M Street), out of fieldstone. This simple structure was plain and functional: two- to three-foot-thick walls and packed dirt floors, with a hearth, and a low ceiling to conserve heat. When Christopher died unexpectedly a year later in 1765, he left only some tools, a stove, some furniture, and Bibles. Two years later Rachel remarried and sold the home to another widow and prominent Georgetown landowner, Mrs. Cassandra Chew. Mrs. Chew added the rear kitchen and second floor between 1767 and 1775.

The Old Stone House survived the development of this thriving commercial district mainly because of the myth about George Washington's association with the house. In fact, the only connection was that Washington held meetings with local landowners at Suter's Tavern, two blocks southwest (on what is now 31st Street), while Suter's son rented the front room of the house. Local folklore mixed Washington into the history of the house; legend had it that Washington and Pierre L'Enfant used the site as headquarters for planning the capital city.

In 1807 the Old Stone House passed from Cassandra Chew to one of her daughters, Mary Smith Brumley, who lived there briefly and then continued to rent it out to people and businesses. For some time during the early twentieth century, a sign hung over the front door advertising the house as "George Washington's Headquarters." Although later disproved, the myth

preserved the Old Stone House until the federal govern-
ment bought it in 1953, for $90,000, in response to a
local petition proclaiming its historic significance. At
that time it was owned by Parkway Motor Company,
whose used car lot occupied what is now the garden. In
1960 the National Park Service opened the home and
garden to the public.

TOUR

Stand at the front gate and look into the garden. What
you're looking at is the size and shape of a colonial plot
laid out to support a typical family in the mid-1700s in
the center of George Town. Established in 1751, George
Town was probably named for King George II—or
maybe for early luminaries in the area such as George
Beall or George Gordon who owned land on which the
settlement was established. The village was also referred
to as Sawpit Landing at the time because of the wealth
of timber resources found here. But tobacco was the
lifeblood of the community, and a profitable shipping
trade with European and West Indian markets was
developing in the port. Wharves and mills grew up
along the Potomac waterfront. Up Bridge (now M)
Street—where a bank sits today—there was a spring
where people went for daily water supplies. Even after
the Revolution, in the "metropolis" of Georgetown,
there were only twelve masonry structures. About five
miles away, Old Town Alexandria was a thriving port
and flourishing market town of about twelve hundred
inhabitants by 1762—though George Town was still just
a wide spot in the road.

As you enter the garden, next to the stone terrace you'll
see the twisted trunk of an apple tree (*Malus* 'New
Town Pippin'). Though this tree (which still bears apples
from its one healthy branch) is probably only about

221

forty years old, the New Town 'Pippin' is a variety that has come down to us from colonial times. Look all the way to the back of the lot, and you will see a likely spot for an orchard on a colonial lot of this size. Whether apple, pear, peach, or plum, fruit trees were highly desirable, and eighteenth-century residents who could get the seeds or the cuttings would have planted a few. Early American gardeners also grafted (onto available compatible stock) cuttings raised from seeds of apples or pears or the stones of cherries or other fruit trees. Out back at the far end of the garden, there also might have been a privy or outhouse, a stable for a horse, and maybe a chicken coop or pig pen. Toward the middle of the lot a vegetable garden and maybe a summer kitchen—where colonists would have made candles and soap and washed clothes—might have competed for space. Closer to the house, a kitchen garden could have supplied culinary and medicinal herbs—and maybe even boasted a few bulbs in spring.

What gardens occupied this space from colonial times until the mid-twentieth century is a question that may never be completely answered. Formal research has yet to be undertaken on the history of this narrow plot, so it is not clear what was here before the 1950s. Further, because the garden was terraced and fill dirt was added in the late 1950s, it is unknown whether an archeological survey of the garden would yield much useful information. Though today's garden doesn't look like a colonial garden, there are plants in and around the borders that would have been used in colonial times. Popping up here and there in the border plantings are wild-flowers and herbs such as the

Marsh mallow
(Althaea officinalis)

pink-flowering stalks of the marsh mallow *(Althaea officinalis)*; sweet cicely or chervil *(Osmorhiza claytonii)*, with its anise-scented roots; love-in-a-mist *(Nigella damascena)* with seeds for flavoring breads and cakes; and parsley, with its finely cut leaves rich in iron and vitamins.

Trees in today's garden common in colonial times include the red cedars *(Juniperus virginiana)* on the western side of the garden and the big black walnut *(Juglans nigra)* by the fence on the eastern side of the lot. Walnut trees had several uses. Nuts, which fell like rain in summer and fall, were harvested for their sweet meats; husks were boiled for dyes and sometimes used as abortifacients. Juniper berries were also boiled to give a gamey taste to meat, and juniper sprigs were cooked with fish dishes for the flavor that comes from the resin. The weeping willow *(Salix babylonica)* by the house was found not only in colonial gardens but also was used by Native Americans—and colonials, too—for its medicinal properties. Native Americans chewed willow bark as a pain reliever. Other native plants in the garden, such as the dogwoods *(Cornus florida)* and the fig bush *(Ficus carica)* might have been found in the colonial garden of simple folk like Rachel and Christopher Layman, too. (Colonial gardens in town probably didn't have many trees, though settlers probably gathered nuts and berries wherever they could find them.) The native hawthorn tree *(Crataegus phaenopyrum)*, or Washington hawthorn, which was grown by George Washington at Mount Vernon, could also have been here. Another hawthorn, the American hawthorn *(Crataegus coccinea)*, was highly recommended in a 1804 book on American gardening as the best hawthorn for creating a living fence or hedge. The author, however, lamented the difficulty— for those who want to grow hawthorn hedges—of obtaining seeds.

Now jog forward a few centuries to today's garden and how it came to be. As part of the late 1950s and early 1960s restoration of the only colonial house remaining in Georgetown, this lot was transformed from an asphalt parking lot into a terraced lawn bordered by deciduous trees, woody shrubs, and herbaceous plants. The garden was redesigned in the late 1950s in a Colonial Revival style popular at the time. Colonial Revival gardens, an important chapter in American landscape history, were extremely influential in re-creating the spirit of colonial gardens. However, these period gardens combined a blend of historical evidence and nostalgia in a way that re-created the colonial past from a mid-twentieth-century point of view. And the simple, functional, and downright bare character of colonial gardens was pretty much lost in translation.

Some of the plants in the Old Stone House garden do recall the colonial past: the cedars and the walnuts, the persimmon and the magnolias, the dogwoods and the sweetshrub *(Calycanthus floridus)* are native plants that were part of the colonial plant palette. But most of the plants are more typical of Colonial Revival gardens created for pleasure and leisure rather than function. Neither the working-class Laymans nor the more prosperous Chew family would have had access to the plants established in the garden in the early 1960s. The chaste tree *(Vitex agnus-castus)*, boxwood *(Buxus sempervirens* 'Suffruticosa'), crape myrtle *(Lagerstroemia indica)*, and daylilies are all examples of a Colonial Revival style.

The intent of the 1962 plant plan developed by the National Park Service appears to have been to enhance the restoration of the house and to provide a pleasant garden oasis away from the noise and activity of city streets. Just as Colonial Williamsburg has been a compro-

mise between authenticity and ambience, so no doubt was the Colonial Revival design of this garden. The goal was not to duplicate an early American garden but to adapt to the needs of the times.

In the 1970s another important influence in the person of George Hunsaker strolled into the garden. A National Park Service gardener, Hunsaker came to the Old Stone House in 1976 with a vision. And he proceeded to turn a lawn with a few trees and shrubs into a flower garden with deeply dug borders filled with heritage roses and drifts of colorful and hardy perennials.

The beauty of the Old Stone House garden today is that it is a product not just of Hunsaker's toil and dedication, but of all that has gone before. As it has evolved over the past half-century, natives have been added to the original

Black-eyed Susans *(Rudbeckia hirta)*

plantings: the star magnolia and the Southern magnolia by the front fence, ornamental grasses in the borders. Stroll the garden today and what you see is Hunsaker's vision expanded and evolved over the last few decades. With its loose borders and blowsy blooms, the Old Stone House garden is the city's most famous cottage garden. It feels like a bountiful country garden far from traffic snarls and mall crawls of the twenty-first century. Throughout the seasons, there are shrubs, wildflowers, vines, and fruit trees that hark back to colonial times. Like the American character, the Old Stone House garden is a true mix.

At the front of the main garden, you'll notice a Side Path just beyond the stone terrace. Wander this path—created by use and not by design—and you will find many of the wildflowers and native plants common throughout our garden history. In spring there are Virginia bluebells *(Mertensia virginica)* in a heavenly shade of blue and larkspurs *(Delphinium sp.)* in shades from pale to deep purple. In summer there are common asters; daylilies; Indian strawberries *(Duchesnea india)*, which children like to pick; yarrow (*Achillea* 'Coronation Gold'); marsh mal-lows *(Althaea officinalis)*; bee balm *(Monarda didyma)*; chervil *(Anthriscus cerefolium)* used for salads in colonial times; lemon balm *(Melissa officinalis)* used in teas, soups, and cooking; sweet potato vine (with little yams that can be made into tasty pancakes); and black-eyed Susans *(Rudbeckia hirta)*. In fall, there are golden-rods *(Solidago sp.)*, rose hips, New England asters *(Aster novae-angliae)*, and the bright red and orange fall foliage of the dogwoods.

Bee balm *(Monarda didyma)*

Interestingly, yarrow and the daylily quickly made their way westward across the Atlantic to become naturalized into the early American landscape. Many Old World fruits, such as apples, quince, cherry, plum, pear, and peach, were also quickly introduced into the New World. Though early settlers found a bounty of huckle-

berries, raspberries, blackberries, and wild strawberries, native fruit trees such as the crab apple and the wild cherry produced inferior fruit, and Old World fruits were in demand from early in the eighteenth century. No wonder John Chapman (aka Johnny Appleseed)—who made it his life's work in the early 1800s to plant apple trees from Pennsylvania to Ohio and beyond—was so well-loved. Everybody wanted one, and they weren't that easy to come by.

BIRD'S EYE VIEW

When you come to the end of the side path, you'll be at the far end of the garden. Sit on the bench and admire the garden. Then close your eyes and imagine the long procession of Americans who have inhabited this space.

GARDEN NOTES

Subtle Distinctions — For history buffs, it is interesting to note that the Old Stone House is the oldest pre-Revolutionary structure in Georgetown and the oldest in the city still on its original site. (There is an older pre-Revolutionary house—in the Kalorama section of Northwest—that was moved to its present location from New Hampshire.) The Old Stone House is also unique in that it is constructed of fieldstone—a contrast to the red bricks common in Georgetown.

Vegetable Verities — The first American book on vegetable gardening was written by John Randolph, a resident of Williamsburg, Virginia. Known as "John the Tory" because of his sympathies with the king, Randolph patterned his book on a similar English manual. But his book was written for the American gardener and climate. It was printed in America in 1788.

Naming the Plants — Linnaeus's system of Latin genus and species names was established in 1753. Matching botanical names with the common names given to plants in colonial times has been a task for botanists and horticulturists ever after. Many plants have been added—and removed—based on ongoing research and new information.

Colonial Care Packages — English colonists carried on lively exchanges of seeds and information with those back home, and much of what is known about plants in colonial gardens comes from that correspondence. Further, it is interesting to remember that English gardeners were as anxious for the New World golden-rod *(Solidago sp.)*, black-eyed Susan *(Rudbeckia sp.)*, and Southern magnolia *(Magnolia grandiflora)* as American colonists were for fruit trees and flowering bulbs from the Old World.

A George Town Gardening Manual — *The American Gardener,* by John Gardiner and David Hepburn, was even more pertinent to the inhabitants of George Town than Randolph's book on vegetable gardening. But this how-to volume didn't confine itself to vegetable plots. Kitchen gardens, vineyards, hop yards, fences, flowers, and herbs are all discussed. Hepburn, a "gardener of 40 years experience" had been a gardener for a governor and for John Mason on Mason's Island (now Teddy Roosevelt Island). Gardiner, a self-proclaimed horticul-turist "well skilled in all the branches of gardening" was a practical man who "in the culture of vegetables and fruit trees . . . could not be excelled." As a parting shot, they offer a tempting recipe for tomato ketchup.

Size: About one acre
Hours: Open Wednesday through Sunday, noon to 5 P.M.;
closed on all federal holidays.
Admission: Free
Distance from Capitol: Three miles
Telephone: 202-426-6851
Address: 3051 M Street., NW, Washington, DC
Web site: www.nps.gov/rocr/olst

DIRECTIONS

BY CAR: From Virginia, take Key Bridge into Georgetown, either
from Interstate 66 to Lee Highway and over Key Bridge or from the
George Washington Memorial Parkway to Rosslyn and over Key
Bridge. Turn east off Key Bridge onto M Street and continue for
four blocks. From Maryland, take the Beltway to the Key Bridge
exit. Turn east off Key Bridge onto M Street and continue for four
blocks. From Washington, take M Street west to Georgetown; just
before the intersection with Wisconsin Avenue, the entrance will be
on your right.

BY SUBWAY AND/OR BUS: From Foggy Bottom station on the
orange and blue lines walk north one block to Pennsylvania Avenue
at Washington Circle and catch a 30S Metrobus to Georgetown. Or
you can walk west on Pennsylvania Avenue three blocks, then three
more blocks as Pennsylvania becomes M Street in Georgetown.

Jefferson Memorial and Tidal Basin

Dome Sweet Dome

Few early American gardeners wrote as extensively about gardening and horticulture as Thomas Jefferson. The grounds of his home, Monticello, were filled with introductions of plants from around the world, including more than a hundred varieties of fruit trees. So it is particularly fitting that this site honoring Jefferson sits among thousands of cherry trees. Many of the trees were given as gifts by the

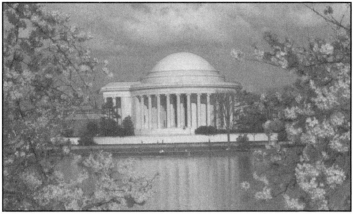

Jefferson Memorial

Japanese, a collection carefully chosen and painstakingly imported in 1912. In spring the memorial is the epicenter of the Cherry Blossom Festival—when hundreds of thousands of visitors flock to the Tidal Basin to witness firsthand the explosion of blooms. This annual pilgrimage is perhaps the most compelling testament to the success of this masterfully conceived landscape.

HISTORY

Although Jefferson, standing serenely among the columns, looks as though he has been there for centuries, the memorial itself wasn't commissioned until the 1930s—and the brouhaha surrounding its construction was anything but serene. But the story begins even earlier—with the establishment of the Tidal Basin.

In the 1800s, Washington was still a city of waterways. Much of Washington's commerce depended on the transport of goods on the Potomac River and through the network of canals that ran through the city. By the mid-1800s, however, the heavily used canals loaded the Potomac with sediment and debris, forming mud flats that rendered the Potomac more swamp than river. After much planning, the Army Corps of Engineers, under the leadership of Engineer Colonel Bingham, began a massive redevelopment of the land south of the National Mall. The Potomac River channels were dredged and the resulting fill dirt was used to build up the mud flats to above sea level, forming new, usable land areas. By the time the project was completed, more than seven hundred acres of land had been added to the city of Washington.

As Bingham was creating his "emerald setting for a beautiful city," others saw the future of the area in shades of cherry blossom pink. The construction of the new public grounds happened to take place during a period of great enthusiasm for all things Japanese. In 1856, Japan opened its doors to the world after more than two hundred years in near isolation. A rampant fascination with Japanese culture swept through the Western world as Japanese literature, art, and landscape design became widely celebrated.

During the revamping of Washington's downtown in 1885, an admirer of Japanese culture, Eliza Ruhamah Scidmore, began her quest to plant Japanese cherry trees in the city's new parks. Following a visit to Japan, Scidmore, a writer and intrepid traveler (and the first woman to sit on the National Geographic Society's board), approached the superintendent of buildings and grounds for the park service. Her ideas for planting cherry trees fell on deaf ears, yet her perseverance never waned. Wanting to open Americans' eyes to Asian culture, she approached every new superintendent during the next twenty-four years. In 1909 Scidmore decided to raise funds to purchase trees for the Potomac waterfront and contacted the new first lady, Helen Taft. The first lady, having lived in Japan herself, strongly supported the idea. Just days after receiving Scidmore's letter, Mrs. Taft was offered the gift of two thousand cherry trees by a Japanese visitor who had learned of the plans for planting Japanese cherry trees. Within a month, ninety Japanese cherry trees, purchased from a grower in Pennsylvania, were planted along the waterfront.

In 1910 the trees donated from Japan arrived in Washington, but they were diseased. Those trees were burned, and a new shipment of trees from a famous

collection in Tokyo was delivered to Washington in 1912. In March of that year First Lady Taft and Viscountess Chinda, wife of the Japanese ambassador, planted the first two cherry trees on the northern bank of the Tidal Basin—a ceremony that marked the start of the Cherry Blossom Festival. The cherry-tree-filled Tidal Basin remained open parkland until 1936 when the design for the Jefferson Memorial was approved.

The idea for the memorial came from President Franklin D. Roosevelt, who believed that Jefferson's achievements, like those of Washington and Lincoln, should be recognized in the nation's capital. In 1934 Congress passed a resolution creating a commission to oversee the planning, design, and construction of the memorial.

The memorial was surrounded by controversy from its inception. The Commission of Fine Arts thought the design was too similar to the nearby Lincoln Memorial, and the architectural elite thought the neoclassical style was outdated. Even architect Frank Lloyd Wright chastised Roosevelt during the construction of the memorial for the "miles and miles of Ionic and Corinthian columns" that were filling the nation's capital. When the ground was being cleared for the memorial, cherry tree lovers chained themselves to the trees in protest in 1938. The group's concerns were dispelled when it was explained that although more than a hundred of the existing trees would be moved or destroyed, a thousand more would be planted. Even after the memorial was completed, many ridiculed the structure as "Jefferson's muffin," and others thought the domed monument far too feminine a structure for a great man. Nevertheless, Roosevelt proudly laid the monument's cornerstone in 1939 and led its dedication in 1943, on the two hundredth anniversary of Jefferson's birth.

The area around the Tidal Basin is a cherry tree mecca best enjoyed by meandering along the many paths. Stop by the ranger station at the north end of the Tidal Basin for information and maps showing cherry tree varieties and locations. If you visit during the Cherry Blossom Festival, which runs from the end of March through the beginning of April, join the annual cherry tree walks around the Tidal Basin led by park rangers.

If you venture through the area on your own, begin your tour with the two **Original Trees** planted by First Lady Taft and Viscountess Chinda in 1912. These two Yoshino cherry trees *(Prunus x yedoensis)* stand at the northern tip of the Tidal Basin (several hundred yards west of the John Paul Jones statue located at the south end of 17th Street). Look for the large bronze plaques at the bases of the trees that mark these historic plantings. Typically, the Yoshino cherry tree species has a life span of about forty years, so it is quite remarkable that these two, more than ninety years old, along with more than a hundred other original trees, are still charming visitors with their spectacular spring blossoms.

Continue toward the Tidal Basin by crossing Independence Avenue and veering to your right. Once you pass the Kutz Bridge, look to your right to find the **Japanese Stone Lantern.** Given to the city of Washington in 1954 by Sadao Iguchi, the Japanese ambassador to the United States at that time, the three hundred-year-old granite lantern commemorates the hundredth anniversary of the first treaty (of Peace, Amity, and Commerce) between Japan and United States. The National Cherry Blossom Festival officially opens with the lighting of this twenty-ton lantern.

Along the walking path that leads away from the lantern, the arching cherry boughs provide a dramatic frame to the watery panorama of the **Tidal Basin**. The majority of the cherry trees around the basin—1,405 of the 1,678 trees—are Yoshino cherries. The Yoshinos are noted for their almond-scented single white blossoms. The Yoshino, known as *Somei-yoshino* in Japan, was first introduced in Tokyo in 1872 and is today among the most popular cultivated cherry trees. Yoshino cherry trees reach about thirty to fifty feet at maturity and are marked by their round-topped and wide-spreading growth habit.

The rose-colored view gets better—as other varieties add contrast and drama. Interspersed with the Yoshinos are smaller numbers of 'Akebono' cherry trees (*Prunus x yedoensis* 'Akebono'). The 'Akebono' trees are a mutation of the Yoshino introduced into cultivation by Californian W. B. Clarke in 1920. *Akebono* means "daybreak," and the pale-pink blossoms of the 105 'Akebonos' around the Tidal Basin provide a touch of pink to the clouds of white Yoshino blossoms during peak bloom. Six other varieties of cherry trees, with single and double flowers ranging in color from dark pink to white, are tucked around the Tidal Basin.

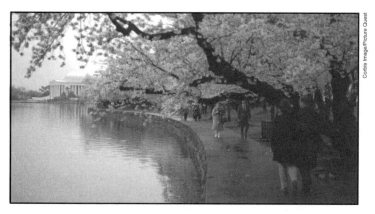

After turning the corner of the serpentine curve along the west bank of the basin, you will find the **Japanese Pagoda**. This rough-hewn stone pagoda was presented as a gift of friendship in 1958 by the mayor of Yokohama, the city in which Commodore Matthew Perry signed that first treaty in 1854.

At the southern end of the Tidal Basin, take time to explore the **Jefferson Memorial**. The nineteen-foot-tall bronze statue of Jefferson by sculptor Rudulph Evans commands the central space. A plaster version of the statue, which stood in this spot until after World War II, resides in the basement of the building, too large to be removed intact. A sculpture depicting the five members of the committee that drafted the Declaration of Independence, with Jefferson at the center, can be found along the rear of the memorial. Inscriptions line the interior walls, including excerpts from the Declaration of Independence, Jefferson's speeches and writings, and quotations about the statesman. And, if you care to, you can go up in the dome.

OFF THE BEATEN PATH

Along the Tidal Basin on the Inlet Bridge, where the basin flows into the Potomac River, you'll find a series of sculptures on the inside walls. These human-headed, spouting **Bronze Fish** are the result of an insider joke. The bridge was refurbished in the 1980s, which happened to coincide with the retirement of the park's chief, Jack Fish. The sculptor working on the bridge had some fun with the project. He used Fish's head as the model for the heads of the fish carved in the bridge. So check out the fish—aka the Fish.

If you're interested in more cherry tree viewing, take the path that leads south from the Inlet Bridge along the

Potomac River. This path loops along the perimeter of Potomac Park East, which boasts an additional 1,681 cherry trees of ten varieties—slightly more than the number around the Tidal Basin—spread over a considerably larger area. The majority of the trees are Yoshinos, but more than four hundred 'Kwanzan' cherry trees (*Prunus serrulata* 'Kwanzan') fill out the area. The 'Kwanzan' cherry trees, named after a mountain in Japan, bloom about two weeks later than the Yoshinos and bear heavy clusters of clear pink double blooms. At Hains Point, the peninsula's tip, you'll find a collection of Takesimensis cherry trees *(Prunus takesimensis)*, a species happy in wet habitats.

BIRD'S EYE VIEW

Take a ride to the top of the recently refurbished **Washington Monument**—the memorial to our first president—to see the Jefferson Memorial and Tidal Basin from the five-hundred-foot high windows of the monument's observation deck. Located just north of the Tidal Basin, the Washington Monument, which opened in 1888, is perhaps the city's most recognizable landmark. At five hundred fifty-five feet, it still holds the title of the world's tallest free-standing masonry structure. The southern windows of the observation deck provide a breathtaking view of the Tidal Basin and Potomac River, with the Jefferson Memorial at the center.

GARDEN NOTES

Symbolic Sakura — Known in Japan as *sakura*, the flowering cherry tree is a national symbol of Japan. The beauty of the blossoms represents the ephemeral glory of human life.

The Oldest Stock — In November of 1999 fifty trees propagated from the 'Usuzumi' cherry *(Prunus spachi-*

ana f. ascendens) growing in the village of Itasho Neo in Japan were planted in West Potomac Park. Emperor Keitai, the twenty-sixth emperor of Japan, is believed to have planted the original 'Usuzumi' tree fifteen hundred years ago in honor of his ascension to the throne. In 1922 the historic 'Usuzumi' was officially declared a National Treasure of Japan.

Peak Bloom — Each cherry blossom lasts for four to ten days in a blooming period of about ten to fourteen days. The peak bloom, determined as the day when 70 percent of the Yoshino cherry blossoms open, varies from year to year. The earliest peak bloom occurred on March 15, 1990, and the latest was on April 18, 1958. The dates of the National Cherry Blossom Festival are based on the average date of blooming, which is April 4th. Each year the Park Service posts its forecast for the peak bloom at www.nps.gov/nacc/cherry/index.htm.

Earliest Bloomer — The semidouble pink blooms of the 'Okame' cherry tree (*Prunus x* 'Okame') are the earliest to flower in spring. The park has only one example of this species, which can be found in East Potomac Park.

The Emerald Vision —The Tidal Basin is part of an innovative system of ponds and gates that were established to maintain the waterways and control the flow of tides and floods. The Tidal Basin was built to keep the Washington Canal clean by flushing it with fresh water from the Potomac as the tides changed. In the 1880s, under the leadership of Engineer Colonel Bingham, who headed the Office of Public Buildings and Grounds, the land around the Tidal Basin was raised in elevation, landscaped, and incorporated into a system of parks and green spaces that Bingham believed would serve as an "emerald setting for a beautiful city."

Rome's Dome — Jefferson was enthralled by Roman architecture , particularly the domed, colonnaded Pantheon. He used it as a model for the University of Virginia library and his home, Monticello. Modeled after the Pantheon in Rome, the style of the Jefferson Memorial reflects Thomas Jefferson's own architectural tastes. It honors not only this founding father's political role but also his role in shaping American neoclassical architecture. The design for the memorial was created by John Russell Pope, who was also responsible for the National Gallery of Art and National Archives buildings. The Pantheon-esque design won Pope the commission because it seemed the perfect embodiment of Jefferson's interests and his independent spirit.

Size: Nineteen acres
Hours: 8 A.M. to midnight daily, closed Christmas Day
Admission: Free
Telephone: 202-426-6841
Distance from Capitol: Less than one mile
Address: South Bank of Tidal Basin, East Basin Drive
Web site: www.nps.gov/thje

DIRECTIONS

BY CAR: Interstates 66 and 395 provide access to the Mall from the south. Interstate 495, New York Avenue, Rock Creek Parkway, George Washington Memorial Parkway, and the Cabin John Parkway provide access from the north. Interstate 66, Route 50, and Route 29 provide access from the west. Routes 50, 1, and 4 provide access from the east.

BY SUBWAY: Take Metrorail to the Smithsonian stop on the orange and blue lines. Take the Independence Avenue exit to the street level and head west down Independence to the Tidal Basin.

Kenilworth Aquatic Gardens

Marvels Out of the Muck

Aquatic plants have been around for more than a billion years. Out of the primordial ooze about 140 million years ago came the marvelous blooms of lotuses and water lilies and other flowering water plants. Now fast-forward across the eons to Kenilworth Aquatic Gardens. It is the only national park in the United States devoted entirely to the study of aquatic plants and wetlands ecology. Here, in

Lotus blooms

a mosaic of ponds, are the modern descendants of ancient water lilies, lotuses, and others. At the far southern edge of this watery world, protecting and irrigating the aquatic plants, lies Kenilworth Marsh—the last remnant of the vast marshes on which the city of Washington was built. The marsh gardens and lily ponds create a refuge on the Anacostia River for migrating and native wildlife and provide a unique tidal and botanical laboratory. The aquatic gardens and a larger seventy-acre wetland area reclaimed recently by the U.S. Park Service constitute a significant national ecological resource.

HISTORY

Kenilworth Aquatic Gardens owes its existence today to a Civil War veteran from Maine with a passion for growing water lilies. After losing his right arm in combat, Walter B. Shaw came to Washington to work as a clerk in the U.S. Treasury. In 1880 he bought thirty acres of marshland along the Anacostia River so he could tend his lilies in his spare time. He began his collection with twelve hardy American white lilies brought from his native state.

These first lilies thrived in the garden Shaw created in an abandoned pond. What began as a hobby morphed into a thriving commercial business, the W. B. Shaw Lily Ponds. Shaw dug dozens of ponds. After decades of work, he had several greenhouses and thirty-five different marsh soil types in which to experiment with hybridization. His daughter, botanical artist Helen Shaw Fowler, shared her father's zeal. The lilies, as well as the commercial enterprise, flourished. By late 1912 this duo was growing sixty-three varieties of hand-picked lilies, which they cut or packed whole in sphagnum

moss and shipped by the hundreds each week to Boston, New York, Chicago, and elsewhere. Shaw developed dozens of new varieties, including the 'Pink Opal,' the 'W. B. Shaw,' and the 'Helen Fowler' water lily varieties, all still commercially grown today. In its heyday the Shaw Gardens used its unique soil combinations to grow water lily varieties unavailable any place else in the country.

When her father died in 1921, Helen Fowler took over management of the lily ponds and agreed to open the grounds to the public on Sunday mornings during the high season. The Kenilworth Aquatic Gardens quickly became *the* place to be seen. President Calvin Coolidge and his wife, Grace, were enthusiastic supporters, along with President Wilson and his wife. These presidential partners were among the five to six thousand strollers who arrived each weekend to amble from pool to pool beneath the willows as the waxy flowers opened under the heat of the July sun.

As manager, Helen Fowler accelerated the importation of exotics, buying blue lilies of the Nile, often used in Egyptian religious ceremonies; lilies from the Orient; and specimens native to South America. Today her pastel renderings of favorite lilies decorate the Visitor Center. Some of the tropical lotus (*Nelumbo*) are exotic indeed and are fragrant night bloomers to boot.

In the 1930s a project by the U.S. Army Corps of Engineers to drain and dredge the Anacostia River and retake the marshes threatened the water lily gardens with extinction. The Corps wanted to destroy the lily ponds as part of its plan to make the Anacostia a commercial waterway capable of handling big ships and barges. Before the plan was abandoned, miles of ancient natural wild rice marshes were drained or paved over.

The once broad Anacostia River was channeled into a walled-in canal so cargo could move more easily to and from the thriving town of Bladensburg just upstream and be shipped out to other markets downstream. The Army was set to condemn the Shaw water gardens and eliminate the remaining marshes as part of this effort. Fortunately, the Interior Department stepped in, bought the lily ponds in 1938 from Helen Shaw and her brother, and renamed the gardens after the nearby farming community of Kenilworth. The United States Park Service took over preservation and management of the area. A two-acre remnant of the original marsh was left as a buffer to protect the new national aquatic park. And that was the end of the Shaw family's fifty-six-year-old commercial enterprise.

Since the 1990s the Park Service, together with a coalition of community groups, has been slowly reclaiming the marshlands and surrounding river, degraded by decades of industrial pollution and neglect. Junior rangers, schoolchildren, volunteers, and wildlife botanists and biologists now come here to learn about the life-giving symbiotic relationship between marsh wetlands and river ecology and to view the lilies and lotus blooms.

TOUR

Start with the exhibits around the **Visitor Center**. Two display tropical lilies, one holds ancient lotuses, and another aquatic plants. The tropical lilies—fresh from greenhouse overwintering—display upturned, serrated edges and huge platter-shaped leaves in late June. The luxuriously wide blooms peak in July and August. You will find more of these tropical beauties, including fragrant night bloomers, in the ponds closest to the Anacostia River.

In the **Ancient Lotus Pond**—near the Visitor Center—
you will get an up-close view of the East Indian lotus
(Nelumbo nucifera). Offspring of what are believed to
be the oldest viable seeds ever found, the East Indian
lotus grows here and throughout the park. These lotus
plants, with elegant pale pink-tinged flowers, were
germinated by Park Service botanist Horace Webster
from an ancient seed recovered in 1951 from a dry
lakebed in northeastern China. The waxy leaves of the
ancient lotus rise above the pond. Its flowers open up
pink—like all lotuses—and gradually fade to pale white.
The showy flowers drop petals to reveal flat seedpods as
dramatic as the flowers themselves.

As you proceed out to the ponds, begin with the **Hardy
Lily Ponds**. The main displays of hardy lilies are in the
two largest ponds closest to the Visitor Center. These
lilies are the remnants of the twelve original wild lilies
that W. B. Shaw brought from Maine. They were
hybridized, but over the years they have reverted to their
wild state. Only one, the 'Pink Opal', stayed true. It is
visibly different from the others with its luminescent,
almost opalescent, magenta hue. To see it, walk down
on the far left side of the ponds to a smaller pond bed
off the path to the left. You'll find the 'Pink Opal' here
in a grouping made up largely of lotuses.

Continue to the end of the ponds at the very top of the
gardens. About three-quarters of the way across this last
dike path is a large **Tropical Lily Pond**. Here you will
find the gargantuan *Victoria amazonica*—if any survive
the winter. Each year the Kenilworth curators buy a
selection of these exotic South American natives, but
they can never predict how many will make it. Known
as the grandest and largest of the night-blooming water
lilies, this extraordinary plant has leaves that extend
some six feet and resemble gigantic platters floating

Amazon water lily *(Victoria amazonica)*

along with upturned edges. The blooms, which can be eight inches at the bud stage and hold sixty petals as flowers, change in color from creamy white to pink and then to a deep purplish-red by the second night. They open at dusk and stay open all night until about 10 A.M., when they begin to fold in on themselves. Visitors are drawn to the lily not only for its color and size but also for its fragrance. The scent has been described as a cross of pineapple with a dash of apple and a hint of peach. The whole show, bloom and scent, lasts barely twenty-four hours. By the second morning the fragrance that wafted over the entire pond the night before is gone— and the mound of half-wilted petals sinks silently into the pond.

But the plants here aren't all candidates for Ripley's Believe It or Not. Throughout the ponds, other aquatic plants boast lush leaves and colorful flowers, including green, red, and black taro; yellow and red cannas; thalia, with its sword-shaped leaves and deep blue-purple flowers; green umbrella sedge; and spiky papyrus, used by the Egyptians to make paper centuries ago. Kenilworth may be all about the blooms in July, but a great deal of the interest in the park also focuses

on conservation and the restoration of the Anacostia River. Kenilworth Marsh is an important part of the Chesapeake Bay watershed—which means that the park must strike a delicate balance between the wild and the human-made environments. For park rangers that can be a tall order. Some days they are as busy as the beavers and muskrats and turtles who see water lilies as lunch. A band of muskrats that breaks through the fences can munch through a wide swath of plants in no time. (One beaver favors only pink water lilies.)

Outsmarting the beaver brigade is only one of the rangers' jobs. They maintain and repair the dikes and keep invasive species out of the marsh. They also keep a close watch on the sophisticated system of conduits that allows water to move in and out of the pools as the tidal river flushes the marsh and mud flats along its banks. In June of 2003 a devastating windstorm whipped through the area, uprooting and toppling scores of trees, clogging the dike system, and generally wreaking havoc on the natural area. It took weeks to regain access to the scenic River Trail to the tidal Anacostia through the adjacent Kenilworth Marsh and swamp forest areas. The park is always looking for volunteers. So if you're ecology minded, why not try mucking around with the rangers in the marsh.

OFF THE BEATEN PATH

Kenilworth Park, just a half mile south of the Aquatic Gardens, is an ideal spot for birding and butterfly watching, or for a pick-up game of basketball. This 180-acre recreation and picnic area is one of the District's success stories. Until the 1970s this riverfront site was an open burning pit, a dump, and a landfill operation. Then it was reclaimed and converted into multipurpose parkland with nine playing fields that

attract many local soccer, baseball, rugby, and Frisbee tournaments. The Park Service manages Kenilworth Park as part of the larger twelve-hundred-acre river shore Anacostia Park, with its network of jogging and bike trails and river access for kayakers and canoeists.

Naturalists like to come to this area early in the day to the "managed meadows" that the Park Service is establishing among the perimeters of selected playing fields. The native grasses and wildflowers in these meadows host an assortment of ground-nesting birds rare in urban settings, and butterflies in spring. Birds often spotted here are the belted kingfisher, yellow-billed cuckoo, great horned owl, Eastern bluebird, snowy egret, great blue heron, several varieties of hawk, more than two dozen different warblers, and even the bald eagle. Bring your breakfast and a pair of binoculars and catch the first lilies and the earliest songbirds.

Great blue heron

BIRD'S EYE VIEW

Don't leave the Aquatic Gardens without taking a walk on the **Boardwalk**. A raised boardwalk—a quarter mile in length—stretches over the northern edge of the ancient Anacostia marsh remnant down to the banks of the river. Here osprey scout, herons wade, and red-wing blackbirds dart among the cattails. For a real treat, come in August, when the graceful indigenous wild rice plants are dark with blackbirds busily stripping off the crunchy rice seeds. The remnant marsh is a living ecosystem, where three-foot tides, cycling through each day, flush and filter the water. It is constantly under attack from invasive nonnative plants and garbage from

humans. But it is relatively free of mosquitoes. The tides help, as does a healthy population of waterboatmen beetles, many varieties of dragonflies, damsel flies, and other natural predators that eat mosquito larvae.

Also here in the marsh is the American lotus *(Nelumbo lutea)*, glorious in summer with bright yellow flowers and plate-sized waxy leaves rising over the water. Once this wetland native was present in large stands. Photos from 1902 document its abundance. But since the river was dredged and its habitat destroyed in the 1930s and 1940s, the American lotus has disappeared from the Anacostia and its marshes. Recently, the park rangers reintroduced this beauty to the restored wetlands at Kenilworth and Benning Bridge by harvesting roots from the Potomac River where natural stands of lotus still exist.

GARDEN NOTES

Lily Pond Primer — The water lily family takes its name, *Nymphaea,* from ancient myths of graceful female spirits that inhabited lakes and streams, beguiling humans who fell under their spell. Living in all parts of the world, water lilies fall broadly into two categories: hardy and tropical. They usually sprout from tubers rooted in mud. All need slow-moving, shallow water to grow. Their leaves form under water and grow to reach the surface. Water lilies bloom for three to fourteen days, opening and closing in response to the changing light. The seedpods dip beneath the water to ripen.

Lotusland — The lotus flower was a sacred symbol centuries before the Christian era. Paintings of the Buddha often show him sitting on a lotus. Hindus believe Brahma was born from the heart of the flower. The

Chinese saw the lotus as a symbol of purity, a beautiful bloom rising from dark, murky waters. The Egyptians carved it into the columns of their temples.

Flowering Favorites — In 2003, park rangers and gardeners completed the first comprehensive list of plants in the Aquatic Gardens. Ask for it if you are looking for a special lily or lotus. Among recent tropical lily hits: 'Blue Beauty,' the dark purple 'Director Moore,' the night-blooming 'Wood's White Knight,' 'Yellow Dazzlers,' and 'Texas Shell Pink.' Mornings are the best time to come and see the night-blooming lilies before they close and the day-bloomers as they open. Best months to visit: June and July for hardy water lilies and July and August for tropical plants and lilies. August through October for late bloomers and to see the native wild rice. Weekend garden walks and weekday tours are by reservation only.

River Trail — When you enter Kenilworth Aquatic Gardens, you'll see an entrance to the River Trail. The trail is clay-surfaced and stretches between the outside of the marsh and the river.

Festival of Floating Flowers — On the third Saturday each July the Park Service and volunteers hold an open house with tours, talks, and other special events geared to families and children. The greenhouses are open, too. The festival runs all day and families are encouraged to bring a picnic. Call 202-426-6905 for details.

Winged Wildlife — Bird and butterfly lovers come to the Aquatic Gardens and Kenilworth Marsh with a purpose. Pick up a bird brochure from the Visitor Center that lists all the species spotted in these parts. You will be impressed. In fact, a recent Christmas bird count

done annually by members of the Audubon Society found more than forty different species in the park, including the red-winged blackbird, great blue heron, ground-nesting grasshopper sparrow, and the belted kingfisher. Other reliables include the Baltimore oriole, American bittern, least bittern, American woodcock, and the Virginia rail. Another recent avian success: the call of

Dragonfly on a water lily

the endangered marsh wren can once again be heard here after decades of silence. Come early in the day for the best bird-watching and go out to the far reaches of the pond and along the River Trail.

This is favored habitat for butterflies, too. The Park Service lists more than fifty on its wildlife visitor list. The names are almost as regal as the butterflies: wild duskywing indigo, blue-tailed eastern; Horace's duskywing, silver-spotted skipper, cloudless sulphur, to name a few. The butterflies are drawn by the scented lilies and the blooming indigenous plants. Come when it is hot and still. Watch and wait.

Size: Fourteen acres
Hours: Open daily, except Thanksgiving, Christmas, and New Year's Day. Gates open at 7 A.M. and close at 4 P.M. Visitor Center opens at 8 A.M.
Admission: Free
Distance from Capitol: Eight miles
Telephone: 202-426-6905
Address: 1550 Anacostia Avenue, NE, Washington, DC
Web site: www.nps.gov/nace/keaq

DIRECTIONS

Kenilworth Aquatic Park is located in northeast Washington, D.C., near the Maryland border along the tidal Anacostia River. The entrance is just west of Route 295 (Kenilworth Avenue) between Quarles and Douglas Streets, on Anacostia Avenue.

BY CAR: From Virginia, take I-295 (which becomes D.C. 295) north to the exit for Quarles Street/Eastern Avenue. Stay straight to go onto Kenilworth Avenue, NE. Make a U-turn onto Kenilworth Avenue at Eastern Avenue. Turn right onto Douglas Street, NE. Follow Douglas Street to Anacostia Avenue, turn right, and follow Anacostia Avenue to the entrance of the gardens. From Washington, D.C., take New York Avenue past the National Arboretum and South Dakota Avenue to Route 50 toward Annapolis. Stay in the right-hand lane and take the Route 201/Kenilworth Avenue/Route 295 south exit. Take the exit for Eastern Avenue and the Aquatic Gardens. Continue a short distance and turn right onto Douglas Street. Follow Douglas Street to Anacostia Avenue, turn right, and follow Anacostia Avenue to the entrance of the gardens.

BY SUBWAY: The nearest subway stop is Deanwood Station on the orange line. From the station walk north one block on Polk Street to Kenilworth Avenue and cross Kenilworth. Polk Street becomes Douglas Street here. Continue two blocks to the end of Douglas Street to Anacostia Avenue and the entrance to the gardens.

Kenilworth Park is on the westernmost end of Nannie Helen Burroughs Avenue, NE, just off Route 295 (Kenilworth Avenue) and half a mile south of the entrance to the Kenilworth Aquatic Gardens.

Lafayette Park
A Hardy Species

A stone's throw from the front door of the White House, historic Lafayette Park is as old as the Republic itself. Established as part of the larger President's Park in 1791, this seven-acre rectangle of green was originally designed by Pierre L'Enfant and envisioned by George Washington to be part of a grand formal garden with terraces and pools built to enclose the presidential "palace." But most of the President's Park was redefined by successive presidents—Lafayette Park along with it. Planned in 1821 by

Andrew Jackson in Lafayette Square

architect Charles Bulfinch, Lafayette Park was separated entirely from the grounds of the White House in 1822 when Pennsylvania Avenue first crossed the President's Park. When the park was completed several years later, it was named for General Lafayette, who had fought in the American Revolution and was the first foreign guest of state to stay in the White House. And yet, consistent with the protean character of the park, it is not Lafayette but Andrew Jackson who sits at the center of Lafayette Square. Indeed, the park has changed character many times. In the eighteenth century it was home to a slave market and a racetrack. In the nineteenth century it served as campgrounds for soldiers in both the War of 1812 and the Civil War, and for a time, it was President Ulysses S. Grant's private zoo. (When neighbors complained, the prairie dogs and deer had to go.) Whatever its vicissitudes, its grand trees and grassy knolls have always invited activity. For much of its history, it has been a landscape of specimen trees and pleasant paths designed primarily for the people. Today it retains a unique place in the nation's horticultural and landscape design history.

HISTORY

At the birth of the nation, Pierre L'Enfant, architect of the federal city, saw the White House and "President's Square"—his name for Lafayette Square—as one grand presidential park in the model of royal deer parks in Europe. In L'Enfant's design the President's Square was to be part of the White House grounds—front lawn of the presidential estate. In Washington's mind it was probably not too different from Mount Vernon—with room for formalgardens, riding paths, and shady groves. The land chosen for the presidential home and square,

which had for many years been owned by the Pierce family, was purchased and secured in 1792. When the land shifted from private home to presidential estate, the Pierce farmhouse sat at the Square's northeast corner, the family graveyard along the north end, and Edward Pierce's apple orchard filled the Square. In its first incarnation, Lafayette Park was mostly horticultural.

During the construction of what later became known as the White House, the Square was far more pedestrian than presidential. A brick kiln and workmen's quarters were built on the Square, and building supplies littered the landscape. In 1797 the Square was also the home of the city market, where slaves were traded and food vendors sold produce and meats out of ramshackle stalls and sheds. For the amusement of the area's dwellers, a horse race course was laid out along the west side of the Square.

On November 1, 1800, John Adams, the nation's second president, became the first resident of the White House. Soon the market was moved and the racetrack was shut down. When Jefferson took residence in the White House in March 1801, he dramatically changed the nature of the Square. Instead of the lawn of a grand presidential estate, the Square became a symbol of the new democracy. Jefferson emphasized the equality and proximity of citizens to their elected leader. Discarding L'Enfant's concept of an imperial park, Jefferson ordered Pennsylvania Avenue opened up. Where the avenue stopped on the southeast side of the White House grounds, he built an arch, opening this ceremonial route to the people from the Capitol steps to the president's front door. Defined by this new thoroughfare, the Square soon became a public green or commons. The War of 1812 saw the sacking and burning of the

White House by British troops, and the park was reshaped again. It wasn't until reconstruction of the White House in 1824, when improvements were made to the area, that the park was named for the Marquis de Lafayette. Visiting America as the nation's guest in 1824 and 1825, his north room in the White House overlooked the area of the park. In honor of the world-famous Revolutionary War hero, the park was dubbed Lafayette Square. In 1834, at the marquis's death, the name became official.

During Andrew Jackson's term as president, Lafayette Park became known as the "White House lobby" when Jackson flung open the doors of the White House and invited everyone to celebrate his inauguration. When the mob got out of hand, tubs of whisky and punch were rolled into Lafayette Park to lure the revelers outside. Throughout Jackson's presidency, people congregated here while waiting to be summoned to appointments with the president. Jackson also deserves much credit for his work with Capitol architect Charles Bulfinch on plans to improve the park. In the following years Lafayette Square was planted with a thick grove of trees in accordance with the Bulfinch design.

In 1850 President Fillmore hired renowned landscape designer and horticulturalist Andrew Jackson Downing to transform Washington's public spaces, including the land around the White House. One of Downing's first assignments was to tame the rowdy reputation of the park. Interest in garden design was sweeping the nation, and Downing was a fervent protagonist of public parks. He infused democratic ideals into his art, creating spaces for people of all classes to enjoy. Downing also was the first American proponent of English, or natural, land-

scaping. He preferred simple to ornate. It was Downing's vision that turned Lafayette Park into a crafted landscape appropriate not only for presidents but also for the public.

From the mid- to late 1800s the area around Lafayette Square became the center of Washington's elite, as many of the nation's political and cultural leaders built homes here. In the early twentieth century, however, the Lafayette Square neighborhood began to lose its cachet as a fashionable address. Historic homes were vacated, and the area took on a down-at-the-heels look. The Eisenhower administration was planning to demolish the existing buildings and erect a large government office complex. The neighborhood around the park today owes its charm—and its survival—almost solely to the foresight and preservation efforts of First Lady Jacqueline Kennedy, who took it upon herself to save the historic district.

Today, in our security-conscious capital, the status of Lafayette Park—and its relationship to the White House—is in flux again. In 1995, after the bombing of the Murrah Federal Building in Oklahoma City, the Clinton administration closed Pennsylvania Avenue between the park and the White House to cars. Soon concrete bunkers were installed and round-the-clock security guards posted. A new plan for Pennsylvania Avenue will soon be initiated, and Lafayette Park will once again be affected. The only thing certain is that the fate of the park is intimately tied to the preferences of future presidents. How they decide to connect their temporary home to the larger gardens outside their door will in no small degree shape the face as well as the future of Lafayette Park.

Begin at the corner of Madison and H Streets. Anchored by monuments to foreign Revolutionary War heroes on each corner, Lafayette Park is dominated on its northeast corner by the large statue of Polish statesman and Revolutionary War Brigadier General Thaddeus Kosciuszko. Dedicated in 1910, it honors his lifetime of service in both the American and Polish armies. The overall design of the park, however, reflects the design established by John Carl Warneke during the 1960s as part of his redevelopment of Lafayette Park to preserve the area's historic buildings while also incorporating new government office buildings.

The dominant species in the park is the willow oak *(Quercus phellos)*—a total of sixty-two, in fact, line the streets around the park and the paths inside the square. There are also dozens of saucer magnolias *(Magnolia x soulangiana)* and a number of American elms *(Ulmus americana)*. But it is the number and variety of trees here that makes this library of trees unique. It is rare when a stroll through a downtown park affords a view of some 200 mature native and exotic species of deciduous, flowering, and evergreen trees.

Saucer magnolia
(Magnolia x soulangiana)

Make your way into the park and walk toward the **Fountain**. On the inside of the path you'll see a fine willow oak alongside a small Nordmann fir *(Abies*

nordmanniana). Lafayette Park is a haven for willow
oaks, and this specimen is one of the finest in the park.
Pyramidal in their youth, willow oaks develop a
full rounded shape in maturity—and almost perfect
proportions, with a height of ninety to one hundred
feet in ideal conditions. This handsome mature tree
has been happy here for many decades.

Continue around the fountain to the southeast corner of
the park toward the **Monument to Lafayette.** Close to
the Lafayette statuary, two bald cypresses come into
view. With the bright green leaves of spring (which turn
to a rich orange in fall) and a straight reddish-brown
trunk, the bald cypress *(Taxodium distichum)* is one
of nature's best designs. In spring these two lofty speci-
mens standing side by side are unforgettably beautiful.
The one nearer to the Lafayette statue was planted in
the early 1930s. This deciduous conifer is said to have
gotten its name because, like other conifers, it appears
to be an evergreen, but goes "bald" in the winter. The
state tree of Louisiana, the bald cypress was native to
the Washington area—eons ago—when much of the
region was a swamp similar to parts of Louisiana today.

The memorial at the southeast corner of Lafayette
Park honors France's General Marquis de Lafayette.
Dedicated in 1891, it commemorates his life as states-
man and Revolutionary War hero. On the east and west
sides of the statue are the figures of four of Lafayette's
compatriots. On the south side of the memorial, a
bronze figure symbolizing America offers up a sword to
Lafayette. Nearby, the oldest of the park's elms *(Ulmus
americana)* adds its dignity to Lafayette's corner.
Probably at least seventy-five years old, it is a survivor
from an era before Dutch elm disease wiped out many
of America's most beloved native trees.

Continue to the center of the park toward the statue of Jackson on his horse. Along the way stop for a moment as you pass the fountain to admire the two big black walnut *(Juglans nigra)* trees with their single trunks and gray-black furrowed bark. The wood from these trees is so highly valued that "walnut rustlers" have developed sophisticated techniques for removing the trees using helicopters and pulling off heists at midnight. In fact, one was recently stolen from Rock Creek Park; these two, however—at the epicenter of national security—are probably in no danger.

At the center of the park you'll see the **Equestrian Statue** of President Andrew Jackson, sculpted by Clark Mills and erected in 1853. Although the park is named for Lafayette, the most lasting impact on it might have come from the celebrated general of the War of 1812, who helped to plan the park. The bronze used for the statue came from the cannon that Jackson captured in the War of 1812, making this the first equestrian statue designed by an American and cast in America.

Jackson's statue is surrounded by interesting trees. On the northeast side of Jackson stands a ginkgo *(Ginkgo biloba)*. Its uniquely splayed, mittenlike leaves become a mantle of yellow in fall. The medici-nal properties of ginkgoes have been touted for everything from memory loss to headaches, depression, and tinnitis—and ginkgo extracts are sold widely. Perhaps the oldest tree on Earth, ginkgoes have survived since the time of the dinosaurs 150 million years ago. Directly north of the statue, at the corner of the bed of annuals, is a Southern magnolia

Ginkgo *(G. biloba)*

(Magnolia grandiflora). At a glance, it may not look too grand. But look again and consider its massive gnarled trunk. At least eighty years old, it is one of the oldest trees in the park. Beyond the magnolia is another bald cypress. This one is a rival for the distinction of tallest tree in the park and is as impressive as the rest of the other aged bald cypresses thriving here.

Continue to the southwest corner of the park. As you start down the path, note the spreading horse chestnut *(Aesculus hippocastanum)* to your left. Another fine landscape tree, it bears showy white flower clusters in spring. This non-native has a distinguished history in Europe—where it was introduced into cultivation in 1576, four centuries before the American Revolution. It was planted at Versailles and is found today in many English parks.

At the southwest corner of the park, you'll find the figure of Major General Comte Jean de Rochambeau. Like Lafayette, Rochambeau was a French general in the American Revolution. Rochambeau commanded the Royal French Expeditionary Force. The **Statue,** which is modeled after a monument honoring Rochambeau in Vendôme, France, was dedicated in 1902 by Theodore Roosevelt. Across the path on the inside of the Rochambeau statue stands another magnificent bald cypress, which is probably a tad taller than the one near the Jackson statue. (Short of taking its measurements from a cherry picker, you'd probably have to have a second-floor view from the White House to actually confirm this.) This one, with its two dominant leaders, was probably hit by lightning early in its life and thus grew atypically with two main trunks. Nearby, along the west side of the park is a row of young ginkgoes, looking a bit gangly. While the ginkgo can be gawky in its youth, a well-developed ginkgo is an impressive eighty-

foot giant with wide-spreading, shapely branches—one reason they are extensively used in large public areas and considered one of the most spectacular of all trees.

Around the **Fountain** on this side of the park you can enjoy a small gallery of oaks. On the White House side of the fountain stands a magnificent willow oak—another octogenarian. Opposite the willow oak, beyond the fountain, you'll find a sawtooth oak *(Quercus acutissima)* of comparable beauty though not as old. Named for the bristle-like serrations (resembling the teeth of a saw) of its leaves, the non-native sawtooth oak is wide-spreading, fast-growing, and hardy. Farther along the oval path encircling the fountain (on the northwest side of the fountain) is a pin oak, another popular, wide-spreading, fast-growing giant with the classic five- to-seven-lobed oak leaf.

Just beyond the pin oak as you head toward the von Steuben statue is an upright boxwood *(Buxus semper-virens* 'Arborescens'). Usually thought of as a shrub, it is uncommon to see this taller species, which grows into a small tree. (Sometimes called true tree boxwood, it can reach a height of up to twenty feet over forty years.) On the corner is the **Monument** honoring Prussia's Major General Baron Friedrich Wilhelm von Steuben, another of the foreign generals who served in the American Revolution. Von Steuben served as aide to Washington at the Battle of Valley Forge, and this statue at the northwest corner of the park was dedicated in 1910. On your way back along the northern section of the walk parallel to H Street, enjoy the canopy of trees shading the path. Inside the island of trees to your right, you'll see several understory trees—Kousa dogwoods with their pointed starlike bracts *(Cornus kousa)*, a Japanese pagoda tree *(Sophora japonica)*, a smooth-barked yellowwood *(Cladrastis lutea)*, saucer magnolias

(Magnolia x soulangiana)—and more towering oaks. At the corner, where the path intersects with the bed of annuals, you'll find a huge red oak *(Quercus rubra)* and a young scarlet oak *(Quercus coccinea)*, the official tree of the District of Columbia, with blazing scarlet foliage in autumn. It is no accident that the oaks with high and wide growth habits are more numerous and more varied (in terms of species) than any other tree in the park. Most of them are descendants of the trees that populated our native forests throughout history. Tough, hardy, and long-lived, like Lafayette Park, they continue to stand the test of time.

BIRD'S EYE VIEW

In today's climate of heightened security, it could be hazardous to your health to try to find a rooftop view of Lafayette Park. Rather than being mistaken for a sniper, simply sit on the benches and gaze up into the branches of these magnificent old trees. Or you could rent a room on the south side of the Hay-Adams Hotel and have a really grand view.

Squirrel's eye view

If you want to continue your survey of specimen trees, walk down 16th Street to the **National Geographic Society** at 16th and M Streets. Along 16th Street, you'll find not one but two Southern magnolias almost as wide as they are tall. With fragrant, creamy white flowers in May and June, these broadleaf evergreens are the essence of southern garden

Foster's hollly (*Ilex x attenuata* 'Fosteri')

heritage. Flanking the 16th Street entrance to National Geographic, you'll also find two trios of just-about-perfect American hollies *(Ilex opaca)*—columnar specimens that are remarkably large and mature and probably eighty to ninety years old. Two more tall, slender, cone-shaped trees, about thirty feet high, edge the terrace at the corner of 16th and M Streets. These are Foster's hollies (*Ilex x attenuata* 'Fosteri'). With bright red berries in winter and glossy green leaves all year long, this slender holly is one of the most popular in cultivation. Accompanying the Foster's hollies is another American holly. For shape and grace, these three are among the best hollies in the entire city.

GARDEN NOTES

A sort of extended front yard for the White House since its earliest days, the landscape of Lafayette Park is a reminder both of the constant change and the continuing stability of our ship of state.

1791 — Pierre L'Enfant's plan for the city reserved eighty-two acres for a President's Park
1822 — Pennsylvania Avenue cut through on the north side of the square

1824–25 — Park named to honor Lafayette
1853 — Statue of Andrew Jackson unveiled
1923 — First national Christmas tree placed in park
1962–72 — Preservation of Lafayette Park through efforts spearheaded by Jacqueline Kennedy
1995 — Pennsylvania Avenue between Lafayette Park and the White House closed to traffic

Size: Seven acres
Hours: Open dawn to dusk daily
Admission: None
Distance from Capitol: Two miles
Telephone: None
Address: 16th and H Streets, directly across from the White House
Web site: None

DIRECTIONS

BY CAR: Lafayette Park is on H Street between 15th and 17th streets, NW. From the north, take 16th Street south until it dead-ends at the park. From the south, take 14th Street north to H Street and look for parking. (H Street is one-way.) Turn left on H Street. The park is one block west.

BY SUBWAY: Take Metrorail to McPherson Square station. Then walk one block south to H Street and one block west to Lafayette Square. From the Metro Center subway stop, exit on 13th Street and walk east along G Street, then one block north on 15th Street. Turn west onto Pennsylvania Avenue. Walk past the Treasury Department. Lafayette Park is directly across from the White House.

BY BUS: Buses run up and down 16th Street frequently and from Wisconsin Avenue in Maryland all the way south to 15th and F.

Meridian Hill Park

International Past and Present

Meridian Hill is a national park with an international twist. Imagine a Parisian park in an Impressionist painting, or the Villa Borghese overlooking Rome, or a Tuscan hillside filled with picnickers near Siena. Now add a drum circle, a game of pick-up soccer, and a rock band. Today this neoclassical hardscape is filled with urban dwellers seeking shade, community, and space in twenty-

The Cascades

first-century terms. Where fashionable Washingtonians once strolled among overlooks and lily pools, now residents in fast-changing neighborhoods mix it up on weekends. Water and shade have always set the stage. It's just the players that keep changing. Today the current players—the black, white, and Hispanic dwellers of Columbia Heights and Adams-Morgan—are once more redefining the international spirit of the place.

HISTORY

The story of Meridian Hill Park embodies much of Washington's geologic, political, and social history. Located at the center of what was once the city's most international district, Meridian Hill was modeled after European city parks that invite Sunday strollers to pause and take in concerts, dance and puppet performances, or small theatrical pieces.

The name Meridian Hill comes from a proposal by Thomas Jefferson to establish, on this spot, the world's prime meridian, or longitudinal base point, from which to calculate international time and make maps. But Washington—not ready for prime time—lost out to Greenwich, England. A plaque at the park's upper 16th Street entrance notes the 1816 meridian marker. This meridian path proposed by Jefferson would have run down 16th Street from the plaque, through Lafayette Park, dead-ending at the White House.

Some 100 million years ago, the Atlantic Ocean crashed against the banks of the southern boundary of the park's promenade. The park, in fact, sits on an important geologic fall line: the divide between the hard rock of the Appalachian Piedmont and the softer sediments of the Atlantic Coastal Plain. That explains the precipitous

266

drop between its upper and lower sections. (The park rises some sixty feet in elevation from south to north.) It took the U.S. Congress one hundred years after Pierre L'Enfant finished his design for the Federal City to envision an integrated park system for the nation's capital. The 1901 McMillan Commission envisioned a park on both sides of 16th Street—then the city's emerging "embassy row"—to take advantage of the site's panoramic views and important position at the northern end of L'Enfant's plan for the city.

Mary Foote Henderson had other ideas. The wife of Missouri Senator John Henderson, she bought some of the land where Meridian Hill Park sits, and lobbied to have both a Beaux Arts White House and the Lincoln Memorial built here. When those grand schemes failed, she sold the land to the federal government, which modeled the park after Italian gardens as well as the wide and open performance spaces in vogue in France. In 1936 Meridian Hill Park opened to the public.

Through the war years, concerts were held here, and the plantings, then at their peak, complemented the site. The Meridian Hill neighborhood was among Washington's most coveted addresses for foreign embassies and the city's politically well connected. Theodore Roosevelt, Lyndon Johnson, and the young Senator and Mrs. John F. Kennedy all lived just off the park. Many members of Woodrow Wilson's cabinet lived at the Envoy apartments just across 16th Street, still operating today.

A combination of severe funding cuts following World War II and drug markets of the 1970s pushed the park into a long period of neglect. Still unofficially known as Malcolm X Park, in the 1970s and 1980s the park gained a reputation for protests, black power activism, and dan-

gerous characters. In the 1990s a group of local heroes and gardeners began to reclaim this city jewel. Thanks to years of dedicated volunteerism, citizen patrols, lobbying for funds by Friends of the Park, and funding for repairs and preservation secured by the National Park Service, Meridian Hill Park is once more a lively urban oasis.

TOUR

The most dramatic place to begin a tour is the lower 16th Street entrance just north of W Street. Walk toward the center of the **Lower Plaza** and gaze up the hill: This view alone is a reason to visit the park. A three hundred-foot, thirteen-level cascading staircase water feature, with symmetric stairways on either side, puts Meridian Hill Park in a design class by itself. From late June through October the large reflecting pool at the base of the Cascades blooms with water lilies, as do the smaller, interconnected water bowls up either side. About twenty urns planted with yuccas encircle the reflecting pool plaza and add dimension and greenery along the stone walls. Both these ornate walls and the urns are the work of mason John J. Earley, whose Potomac River pebble mosaics are one reason for the park's landmark status. Earley's mix of Potomac pebbles and concrete—cheap but elegant—gave the bounty of the river an interesting new twist. The park was singled out as a National Historic Landmark in 1994 as a model of neoclassical design unique in North America.

The Lower Plaza plantings have changed much since their 1940s heyday. Originally designed as a series of plant-enclosed rooms framed by formally clipped American hornbeam trees *(Carpinus caroliniana)*, the plaza is now entirely open. In the 1970s, plantings of columnar buckthorn (*Rhamnus frangula* 'Columnaris')

were installed to replicate the original sense of enclo-sure—but with plants that would require less care and pruning. But even these proved too difficult to maintain, and these beds are now planted with grass. Presiding over the Lower Plaza on the eastern, or 15th Street side, is President James Buchanan, America's only bachelor president. As if to compensate for the lack of space devoted to him in the history books, his bronze memorial stretches eighty-two feet across the eastern end of the Lower Plaza. One of a motley crew of statues in the park (Dante, Joan of Arc, and others turn up in nearby sites), these personal memorials were contributed by donors who had a special interest in these particular figures. Flanked by statues of Law and Diplomacy, the seated Buchanan is encircled by elmlike Japanese zelkova trees *(Zelkova serrata)*. Native redbuds *(Cercis canadensis)* along with clusters of spirea shrubs (*Spiraea* 'Anthony Waterer'), Japanese barberries *(Berberis julianae* and *thunbergii)*, and shade-loving rhododendrons spread across this side of the plaza. A backdrop of Carolina hemlocks *(Tsuga caroliniana)* frames the statue.

Continue to the central **Cascades** area. On either side of the long verti-cal Cascades pools, stately red cedars (*Juniperus virginiana* 'Emerald Sentinel') form a screen backed by solid stands of American hollies *(Ilex opaca)* giving the area the look of a wooded hillside. These dramatic plantings are among the few survivors of the original elaborate landscape plan. In summer the small planting pockets adjacent to the Cascades' pools contain water lilies and masses of yellow flag iris *(Iris pseudacorus)*.

Yellow flag iris
(Iris pseudacorus)

Alongside the red junipers, they add color, contrast—
and the toughness of the flag iris that flourishes in ditch-
es as well as ponds.

A walk along the eastern side of the Cascades takes you
on a meandering path through two of the four **Hillside
Gardens**—popular spaces for Sunday afternoons. All
through the park there is a natural interplay between
the formal garden, the concert grove, and these wilder,
Italian-style groves. In mid- to late spring, stands of
azaleas and dogwoods *(Cornus florida)* provide back-to-
back bloom, along with several types of small, medium,
and large magnolias *(Magnolia stellata, soulangiana,*
and *grandiflora)*. Here the Poetry Corner, with its
bronze statue of Italian poet Dante Alighieri donated
on behalf of Italian Americans, looks a bit forlorn. But
a major replanting effort associated with construction to
preserve and protect the park, which was begun in
2003, will enhance the architecture of the park and help
to combat the overall neglect of the last few decades.

Emerging from the curving path through the grove, you
arrive at the **Great Terrace**. Two rows of American elms
(Ulmus americana) in raised planters frame the area,
where an equestrian statue of Joan of Arc greets visitors.
Though she is missing her sword and the horse is miss-
ing a part of its bridle, Joan looks ready for battle. The
only sculpture of a woman on horseback in Washington,
she was a 1922 gift of French women living in America,
given to salute the suffragettes' victory in gaining the
vote. She presides over a great view—and a great place
to contemplate the international acres of Meridian Park.
Leave Joan to guard the lower park and turn around to
face the grassy **Mall**. Now you are in the French-influ-

enced portion of Meridian Hill. Central to this design concept is a formal mall lined with trees and a concert grove built into a formal plaza. This was the first portion of the park constructed. Meridian Hill's Concert Grove has been the sight of many performances. Today many musical groups, from Andean flute players to local school kids, perform on a raised stage near the Cascades overlook. And on the Fourth of July, Meridian Hill is a favorite spot for watching the fireworks on the Capitol Mall. The park's French-style Mall originally served as a grand promenade offering panoramic views of the Federal City of long ago and the historic mansions adjacent to the park. But the promenade and plaza, surrounded by huge white oaks *(Quercus alba)*, have been transformed into a playing field where soccer players call each other by the names of the countries they've come from ("Brazil! Colombia! Ghana!"). It is also a place to throw Frisbees and a shady setting for the Afro-Cubano rhythms of the Sunday drum circle.

Joan of Arc on the Great Terrace

Though Meridian Hill didn't pan out as the prime marker of international time zones, Jefferson's bigger dreams of an immigrant nation are alive and well here.

OFF THE BEATEN PATH

Another notable view is from within the **Linden Allée**. Looking south, you can make out the Washington Monument and other aspects of L'Enfant's original Federal City. In June linden blossoms perfume the air. The breezy canopy, within earshot of the water spilling down the Cascade, is one of Meridian Hill Park's true delights in midsummer. Many of the original American lindens were replaced in 1982 with littleleaf lindens, but the Linden Allée remains a cool pleasant lane and an icon of the park's neoclassic design.

BIRD'S EYE VIEWS

Seek out the statue called Serenity, about halfway down the park's upper level facing 16th Street. From her feet, visitors have an excellent view of the escarpment plantings, which include blooming redbud trees, azaleas, and star magnolias in spring, as well as a portion of the sycamore groves.

To experience something of the view nineteenth- and early twentieth-century visitors would have had, arrive an hour before sunset and look south as you cross 16th Street at Euclid. In the distance is the White House, the

Star magnolia
(*Magnolia stellata*)

dome of the Jefferson Memorial, and the Washington Monument obelisk. Park lovers and preservationists lament that the lax oversight by the city fathers in the 1960s and 1970s permitted high-rise buildings on the park's southern boundary—topped with unsightly satellite dishes and air conditioning units—to mar this historic view. To imagine the vision of Jefferson and the Federal City plan of L'Enfant—with 16th Street as the center of the universe—walk the 1.5 miles up 16th Street from the White House to Meridian Hill.

GARDEN NOTES

Optical Illusions — Plantings and architectural structures were used throughout Meridian Hill Park to create what landscape designers call forced perspective. These design tricks make the park appear to be of equal width for its entire two-block length. But it's not. Clever positioning of plantings and trees is part of the illusion.

Stunning Stonework — The ingenuity and sheer craftsmanship of its masonry work is an important reason why Meridian Hill Park is designated a historic landmark. Almost all the elements in this highly formalized landscape—its terraces, fountains, walls, walks, balustrades, niches, and planting urns—were rendered in precast or cast-in-place concrete treated in a variety of novel ways. The genius behind this exceptionally labor-intensive stonework was concrete contractor John J. Earley. He took exposed aggregate and Potomac River pebbles and stones, sorted by size and color, which he then embedded into wet sculpted concrete in mosaic-like patterns. In the late afternoon or after a rain, the patterns glisten. Many park paths are gray stone flecked with brick red.

Size: Twelve acres
Hours: Open daily, 9 A.M. until 9 P.M., November through April,
and 9 A.M. until midnight, May through October.
Admission: Free
Distance from Capitol: Six miles
Telephone: 202-895-6000 (National Park Service); 202-462-7275
(Washington Parks and People)
Address: Sixteenth Street between Euclid and W Streets, NW,
Washington, DC
Web sites: www.nps.gov/rocr;/mehi or washingtonparks@aol.com

DIRECTIONS

BY CAR: From Maryland or the north, take Georgia Avenue/MD
Route 97 south to 16th Street, continuing on 16th Street, NW, in the
District, to Euclid Street, NW (the northernmost point of Meridian
Hill Park) or to W street, NW, (the southernmost point of the park).
From Virginia or the south, take I-395N across the Potomac River into
Washington, continuing north on 14th Street, NW, to Thomas Circle.
Go west onto Massachusetts Avenue, NW. Proceed a short distance to
Scott Circle and bear right onto 16th Street, NW, on the east side of
the park.

Pershing Park

A Peace of Downtown

T he pool at the center of the park reflects sky and trees—and a lunch crowd taking a break from the workaday world of Pennsylvania Avenue. The park's soft green pool and grand waterfall command center stage. Raised beds define the perimeter of the park. But this quiet setting belies the park's strategic location on one of the most historic corners in the nation. In fact, this little piece of real estate was a hot spot long before it was a park. Here at the nexus of 15th Street and Pennsylvania Avenue a Victory Arch two stories tall welcomed World War I troops home

The Waterfall

from France in 1919—which is how the park got its name and its memorial to World War I General John J. Pershing. As the nation's Ceremonial Way, Pennsylvania Avenue has been the parade route honoring presidents and national heroes throughout our history. It's not easy being a hot spot. But Pershing Park is doing a great job.

HISTORY

Pierre L'Enfant, the French-born military engineer hired by George Washington to plan the nation's capital, designed Pennsylvania Avenue to be the "Grand Avenue" between the "Congress House" and the "President's House." But L'Enfant's grand vision for the avenue quickly fell apart. A stroll down this street in the late 1700s was hazardous. The roadway lacked a drainage system, rendering it a muddy pit that made the trek from the Capitol to the White House both messy and arduous.

Although far from L'Enfant's ideal, the Grand Avenue did become the capital's first downtown street and a mecca of citizen activity during the early and mid-1800s. It was home to the city's first financial district, the Center Market, and to a variety of businesses, including butchers, tanners, glassworks, and even woolen mills.

Sweet success, however, soon turned sour. By the late 1800s the City Canal—instead of becoming the thriving commercial route linking the city's waterfront to the C&O Canal—became an open sewer. Butchers at the Center Market dumped rotten fish and animal parts into its waters. Human and animal wastes from the area's

boarding houses, hotels, and stables also went into the canal. The result was a stench that caused many of the avenue's south side merchants to move. Even President Lincoln fled the White House for the Old Soldier's Home on hot summer nights.

During the 1900s, Pennsylvania Avenue experienced a multitude of changes. The Federal Triangle, the largest office building project in the capital's history, and many other federal buildings rose up along Pennsylvania Avenue after the wrecking balls cleared out many old buildings. Then the Great Depression and World War II caused a halt in building construction over the next decades. The 1950s and 1960s saw the exodus of many businesses to uptown locations, as Washingtonians began moving to the suburbs.

President Lyndon Johnson created a commission to revitalize the area in 1965. But not until 1972, when Congress passed the Pennsylvania Avenue Development Corporation Act in 1972 did improvements finally bring business back. Pershing Park was created in 1981, stemming from an extensive revitalization effort to spruce up Pennsylvania Avenue after many ups and downs. Today Pershing Park is at the core of this thriving area.

TOUR

There are many ways to enter Pershing Park, but the best place to begin your tour is through the park's east side, at 14th Street. As you enter the park, the buildings lining the downtown area seem to disappear. Tall trees rising from the ground-level terrace shade your passage, and round, stone picnic tables invite you in.

Step up to your left and you enter the area devoted to the park's namesake, John J. Pershing. The **Pershing Memorial** is a tribute to his vision. Binoculars in hand, he looks over your shoulder as if assessing a distant sight beyond the boundaries of the park. The memorial offers a brief but illuminating history of World War I. Of particular interest is the magnitude of America's commitment of men, matériel, and logistical support. Their accomplishments are etched in stone just yards away from where they marched in a victory parade.

An **Elevated Walk** spans the park's southern edge. These steeply graded slopes, or berms, provide a better view of the park—and a sense of separation from the street. Beyond the memorial, the park expands into a water-scape among stands of trees. The park's centerpiece is a huge slab of granite over which water flows and falls into a large rectangular pool—cool, green, and inviting. A network of square and rectangular terraces create defined areas. The design is minimalist and geometric in form—rectangular terraces and square beds, circular picnic tables, and serpentine park benches.

The plantings are an integral part of the park's effective-ness. These tough plants—cotoneasters (*Cotoneaster dammeri skooghoum* 'Christmas Carpet') in planter beds and thornless honeylocust (*Gleditsia triancanthos* f. *iner-mis* 'Halka') along the walks and berms—are up to the task of surviving in a city park. In spring, daffodils light up the beds. The great summer-blooming crape myrtles with their watermelon-pink, purple, and white crinkly flowers make the park a colorful spot for months on end. The soft aquamarine of the pool and the seasonal changes of the trees contrast with the hard angles of the stone terraces. The ornamental grasses along with the sharp yuccas and the soft sedums grace the garden from

Black-eyed Susans (*Rudbeckia fulgida* var.
sullivanti 'Goldsturm')

spring to fall. Bright gold black-eyed Susans add summer color. You can best appreciate the park's overall design from the **Waterfall**. Steps cascade down to the right and left, letting you get close enough to feel the spray. The steps descend into an amphitheater-like public space at the center of the park.

The **Lower Terrace** stretches across the park's northern side. Here you'll find stands of river birch (*Betula nigra* 'Heritage') that provide a canopy for the picnic tables on the terrace. As you come all the way around the square—back toward the 14th Street entrance—a large glass structure dominates your view. The glasshouse concession stand is perfectly integrated into the garden, looking more like a greenhouse than a snack bar. In winter the park's pool becomes a skating rink. From December through mid-March, the stand serves up hot chocolate and skate rentals for ice skaters.

Pershing Park weds past and present—national history and local use—in a seamless design. Versatile as it is sleek, the park is memorial and ice skating rink, urban oasis and minimalist city landscape, public meeting place and private contemplation space. A newcomer on the two hundred-year-old avenue, the park is the latest chapter in the saga of the Ceremonial Way.

OFF THE BEATEN PATH

Near the concession stand toward the 14th Street side of the park, you'll find a number of willow oaks *(Quercus phellos)* that are a treat for oak enthusiasts. Take time to observe these stalwarts. Chosen for their adaptability to parks and city streets, willow oaks are one of the best oaks for overall texture and form, and splendid trees for boulevards and avenues. Their fine-textured

Willow oak
(Quercus phellos)

narrow leaves go from bright green in spring to dark green in summer and bronze, orange, yellow, and red in fall. Another oak, which you will find along the park's western side (along 15th Street) is the northern red oak *(Quercus rubra)*. It combines fast growth with stellar street and urban performance. As its name suggests, the red oak's leaves are pinkish to reddish when unfolding, green in summer, and bright red in fall. Their glossy pointed leaves display the classic oak leaf shape with many deep lobes. These giants can grow as wide as they are tall, with a spread of sixty to seventy-five feet. Both of these oak species are on the National Park Service's A-list of tough city trees.

A view across Pershing Park can be captured from the White House grounds on the west side of 15th Street. Atop the hill is the statue by Carl Rohl-Smith that celebrates Civil War general William Tecumseh Sherman. From this hill you can take in a panorama of Pershing Park, particularly between late fall and early spring, when trees don't obstruct the view. From this vantage point you can even see beyond Pershing Park—down Pennsylvania Avenue to the Capitol dome. In Sherman Park you can also view a choice population of willow oaks—one of the best in the city.

Once the trees have leafed out, the best aerial view of the park is from the top floor of the Washington Hotel, on the northern side of Pershing Park. Take the elevator up to the rooftop terrace (just press "R") and you can look down on this little gem of a park with its aqua-marine center. Get a table at the southern end of the terrace and you can size up all over again how much the park has to offer.

GARDEN NOTES

Waterfall Woes — Amateur gardeners often fancy themselves the only sufferers of landscape design woes. But even the best designers in the country find that some plants fail. Due to the moist microclimate of the park—resulting from its enormous waterfall—the trees at Pershing Park have experienced problems. European river birches *(Betula pendula)* originally planted in 1981 had to be replaced soon after the park opened. Nearly twenty years ago a new variety *(Betula nigra* 'Heritage') took their place—and they have proved hardy and

River birch (*Betula nigra* 'Heritage')

insect-resistant in their watery setting. The crape myrtles, particularly the blossoms, are susceptible to powdery mildew. They are slowly being replaced, as they decline, with three new mildew-resistant hybrids: 'Muskogee' (lavender), 'Tuskegee' (pink), and 'Natchez' (white). These hybrids *(Lagerstroemia indica x faueri)* were developed by the National Arboretum.

Freedom Plaza — Across 14th Street is another site planned by the Pennsylvania Avenue Development Corporation, and it provides another look into the area's past. L'Enfant's plan for the city is shown on the stone surface of the plaza—an urban archaeology of the capital. Quotes, in the stone, present ideas of architects, city planners, presidents, and congressional leaders.

Size: One city block
Hours: Open dawn to midnight
Admission: Free
Distance from Capitol: Two miles
Telephone: Pershing Park Ice Rink – Operating season and hours:
outdoor skating mid-December through March (weather permit-
ting). Visitor information: 202-737-6938
Address: Pennsylvania Avenue, NW (between 14th and 15th
Streets), Washington, DC
Web site: None

DIRECTIONS

BY CAR: From Virginia, take Interstate 66 and continue to
Constitution Avenue. Follow Constitution and turn right (north) on
14th Street to Pershing Park, which is on the west (left) side of the
road. From areas south of Washington, take Interstate 395 North to
US-1 North (becomes 14th Street). Continue north on 14th to
Pershing Park, which is on the west (left) side of the road, past
Pennsylvania Avenue. From Maryland, take Interstate 495 to exit 33,
Connecticut Avenue south. Continue on Connecticut to I Street (also
called Eye Street). Turn left (east) on I to 14th Street. Turn right on
14th to Pershing Park, which is on the west (right) side of the road.

BY SUBWAY: Take any line to Metro Center and exit toward 13th
and G Streets. Once at the top of the Metrorail escalator, continue left
(west) down G Street to 14th. Turn left onto 14th for about two
blocks. At the corner of Pennsylvania and 14th, you will see Pershing
Park on your right.

SOURCES

Bailey, Liberty Hyde, and Ellen Bailey. *Hortus Third*. New York: Macmillan, 1976.

Brickell, Christopher, and Judith D. Zuk, eds. *The American Horticultural Society A-Z Encyclopedia of Garden Plants*. DK Publishing, Inc., 1996.

Brown, Melvin L., and Russell G. Brown. *Woody Plants of Maryland*. Baltimore: Port City Press, 1984.

Brown, Melvin L., and Russell G. Brown. *Herbaceous Plants of Maryland*. Baltimore: Port City Press, 1992.

Dirr, Michael. *Manual of Woody Landscape Plants*, 5th ed. Champaign, Illinois: Stipes Publishing, 1998.

Eyler, Ellen C. *Early English Gardens and Garden Books*. Charlottesville: University Press of Virginia, 1963.

Griswold, Mac. *Washington's Gardens at Mount Vernon: Landscape of the Inner Man*. Boston: Houghton Mifflin Company, 1999.

McGuire Diane Kostial, ed. *Beatrix Farrand's Plant Book for Dumbarton Oaks*. Washington, D.C.: Dumbarton Oaks, 1980.

National Park Service, National Capital Region. *Meridian Hill: Cultural Landscape Report*. Washington, D.C.: National Park Service, 2001.

Peterson, Roger Tory, and Margaret McKenny. *A Field Guide to Wildflowers of Northeastern and North-central North America*. Boston: Houghton Mifflin Company, 1968.

Seale, William. *The White House Garden*. Washington, D.C.: Archetype Press, 1996.

Tamalevich, Susan. *Dumbarton Oaks: Garden Into Art*. Washington, D.C.: The Monacelli Press, 2001.

Wyman, Donald. *Wyman's Garden Encyclopedia*. New York: Macmillan, 1971.

INDEX

ash
>Korean prickly, 110
>white, 60

Asimina triloba. See pawpaw tree
aster, 11, 121, 139, 168, 226
astilbe, 50
aucuba, 10, 34
Aucuba japonica. See aucuba
avocado tree, 134
azalea, 120, 149
>at Brookside Gardens, 106, 109, 114, 116
>at Dumbarton Oaks, 6
>flame, 52, 125
>at Franciscan Monastery Gardens, 216
>at Hillwood, 34, 36, 37, 41
>at McCrillis Gardens, 43, 44, 45–46, 51–52
>at Meadowlark Botanical Gardens, 120
>at Meridian Hill Park, 270, 272
>photo of, 106
>at River Farm, 87–88
>at U.S. National Arboretum, 150, 155, 156–58, 161

Azalea Society of America, 87
bamboo, 12
barberry, 269
Barr, Brian, 45
Bartholdi, Frederic Auguste, 133, 145
Bartram, John, 59, 93, 159
basil, 80
bearberry, 125
beautyberry, 110
bee balm, 80, 169, 218, 226
beech, 119
>American, 7, 159
>copper, 7, 16, 172
>English, 19
>weeping, 182

begonia, 38, 48, 50
>wax, 37

Begonia grandis. See begonia

287

Carter, George, 72–75, 82
caryopteris, 112
Castanospermum australe. *See* black bean tree
castor bean plant, 122, 153
Catharanthus roseus. *See* periwinkle, Madagascar
Cathey, H. Marc, 91
catnip, 90, 111
cattail, 130
cedars, 78, 115
 blue atlas, 65, 119, 154, 164
 deodar, 4, 15, 32
 Japanese, 36, 151
 red, 223, 269
Cedrus atlantica. *See* cedar, blue atlas
Celosia cristata. *See* cockscomb
Cedrus deodara. *See* cedar, deodar
centaurea, 170
Ceratostigma plumbaginoides. *See* leadwort
Cercidiphyllum japonicum. *See* katsura tree
Cercis canadensis. *See* redbud
Chaenomeles. *See* quince
chain tree, golden, 172
chamomile, 153, 206
cherry tree, 66–57, 120, 226, 230–39
 Akebono, 235
 black heart, 25
 Kwanzan, 237
 Takesimensis, 237
 Usuzumi, 237–38
 weeping, 16, 109, 181, 198
 Yoshino, 12, 34, 36, 121–22, 234–35, 237–38
chervil, 223, 226
chestnut, 159
 horse, 41, 103, 260
Chilopsis linearis. *See* willow, desert
Chionanthus pygmaeus. *See* fringetree, pygmy
Chionanthus virginicus. *See* fringetree
Chionodoxa luciliae. *See* glory of the snow
chives, 80
chocolate tree, 134

chrysanthemum, 8, 37, 111

cicely, sweet, 223

cimicifuga, 76, 126

Cimicifuga racemosa. See cimicifuga

Cinnamomum camphora. See camphor tree

clematis, 9, 185

cliff green, 125

cockscomb, 64

coffee tree, Kentucky, 89

coleus, 180, 186

Collins, Lester, 179

columbine, 144

coneflower, 112, 153

conifer tree, 154–55, 217

Consolida ambigua. See larkspur, rocket

Convallaria majalis. See lily-of-the-valley

Convention on International Trade and Endangered Species (CITES), 138–39

cordyline, 76

Cordyline imperialis. See cordyline

coriander, 171

cork tree, Amur, 198

Cornus controversa 'Variegata.' *See* dogwood, variegated pagoda

Cornus florida 'Pendula.' *See* dogwood, weeping

Cornus kousa. See dogwood, kousa

Cornus sericea. See dogwood, golden twig

Corylopsis sinesis. See winter hazel

Costus afer. See ginger plant

Cotinus coggygria. See smoke tree

cotoneaster, 278

crabapples, 13, 161, 227

Crataegus phaenopyrum. See hawthorn tree

Crinum augustum. See lily, crinum

crocus, 10, 18, 93, 94

crown imperial, 64

Cryptomeria japonica 'Yoshino.' *See* cedar, Japanese

Cunnningham, Ann Pamela, 57, 65

Cunninghamia lanceolata 'Glauca.' *See* fir, blue China

Cyanara cardunculus. See cardoon

cycad, 135

karoo, 138
Cycas revoluta. See sago palm
Cymbidium 'Flirtation', 39
 sketch of, 39
cypress, 155
 bald, 115, 258, 260
 false, 36
 moss, 154
Cypripedium. See lady's slipper
Cyrtomium sp. See fern, Japanese holly
Cystopteries fragilis. See fern, fragile
daffodils
 at Brookside Gardens, 116
 at Dumbarton Oaks, 18
 at Folger Shakespeare Library, 205
 at Franciscan Monastery Gardens, 213
 at McCrillis Gardens, 53–54
 at Meadowlark, 121
 at Oatlands, 77
 in Pershing Park, 278
 at River Farm, 89-90, 93
 sketch of, 10
 at U.S. National Arboretum, 161
daisies, 81, 168, 208
dandelion, 154
daphne, 89, 167
 lilac, 161
 variegated white, 47
Daphne genkwa. See daphne, lilac
Daphne odora. See daphne
Daphne odora 'Variegata.' *See* daphne, variegated white
Davidia involucrata. See dove tree
Davies, Joseph, 30
Deckert, Emile, 44–45
Delphinium sp. See larkspur
deutzia, 109
dianthus, 77, 90, 111, 203, 208
Dicentra eximia. See bleeding hearts
dill, 171
Dirca palustris. See leatherwood

Oehme, Wolfgang, 191–3, 197
Old Stone House, 219–29
oleander, 63, 99, 216
olive tree, 134
oranges, 63
 Mandarin, 5
 mock, 98
 Osage, 84, 92
 photo of, 84
 sketch of, 92
orchids, 38–40, 138, 146
oregano, 80, 111
orris, 154
Osmorhiza claytonii. See chervil
Osmunda cinnamomea. See fern, cinnamon
oxalis, 184
Oxydendrum arboreum. See sourwood tree
Paeonia japonica. See peony, Japanese woodland
Paeonia suffruticosa. See peony, tree
palm, 141
 betel nut, 137
 date, 136, 216
 kona, 138
 Washington, 136
Panama hat plant, 134
Panicum virgatum. See switchgrass
pansy, 170, 171, 179, 180
papyrus, 136, 245
paradise plant, 104
parsley, 223
Paterak, Dan, 38, 40
Paulownia tomentosa. See empress tree
pawpaw tree, 48–49, 94, 128
Paxistima canbyi. See cliff green
peach tree, 66–67, 226
pear tree, 67, 226
 Kieffer, 9
pecan tree, 70, 98
penstemon, 112
peony, 37, 76, 82, 121, 161

Spirea x vanhouttei. See spirea
spruce, 155, 212
> Alberta, 36
> Colorado blue, 31
> Norway, 113, 115
> Serbian, 50, 115

squills, Siberian, 7, 10, 18, 212
St. John's wort, 153, 196
Sternbergia, 82
stewartia
> Japanese, 51, 54
> Virginia, 48, 53

Stewartia malacodendron. See stewartia, Virginia
Stewartia pseudocamellia. See stewartia, Japanese
Stout, Arlow B., 124
Strelitzia reginae. See bird of paradise
Styrax japonica 'Carillon.' *See* styrax, weeping.
styrax, weeping, 167
summersweet shrub, 115
sunflower, 81, 179
Sweden, James van, 191–3, 195
sweet flag, 129
sweetbox, 37, 114
sweetspire, Virginia, 86, 125
switchgrass, 144–45
sycamore, 9, 94, 126
Syringa vulgaris. See lilac
Tamalevich, Susan, 14
tansy, 171
taro, 245
tarragon, 80
Taxodium distichum. See cypress, bald
Taxus baccata 'Aurea.' *See* yew
Taxus baccata 'Stricta.' *See* yew, Irish
Taxus brevifolia. See yew, Pacific
Taxus x media 'Hicksii.' *See* yew, Hicks
Teucrium chamaedrys. See germander
Texas mountain laurel, 139
Texas skeleton plant, 139
Tiarella cordifolia. See foamflower